POP ART

LUCY R. LIPPARD

POP ART

WITH CONTRIBUTIONS BY
LAWRENCE ALLOWAY
NANCY MARMER
NICOLAS CALAS

NEW YORK AND TORONTO
OXFORD UNIVERSITY PRESS

The author wishes to thank *Dædalus*, the Journal of the American Academy of Arts, for permission to use the quotation from *A Sad Heart at the Supermarket* by Randall Jarrell.

Library of Congress Catalogue Card Number 66-21787

Printed and bound in Singapore by FEP International Ltd

Contents

'Painting relates to both art and life. Neither can be made.
(I try to act in that gap between the two.)'

<div align="right">ROBERT RAUSCHENBERG</div>

'The Medium is half life and half art, and competes with both
life and art. It spoils its audience for both; spoils both for its
audience.'

<div align="right">RANDALL JARRELL</div>

Preface

This book comprises several essays by different authors because it was felt that no one person could be intimately acquainted with a new movement boasting such multiple beginnings. Each of the contributors lives or has lived in the place of which he writes and has been involved in the art there. This may be the sole similarity; each of us has a decidedly different background and approach; our points of view often conflict, and no attempt has been made to reconcile them. Since Pop Art has suffered from critical banalities often more apalling than the visual clichés from which it departs, this varied attack seemed valuable.

My first thanks go to Nancy Marmer, Lawrence Alloway, and Nicolas Calas for their contributions; my second to Joseph James Akston of The Art Digest, Inc., who originated the idea of a Pop Art book and encouraged its execution. James Rosenquist has been helpful in many ways, and also designed the cover for the American edition. Bruce Glaser, David Whitney, Robert Indiana, G.R. Swenson, Brenda Gilchrist, Alvin Demick, Gail North, Max Kozloff, Irving Sandler, James Hardy, Nancy Reynolds, Claes Oldenburg, Jack Wesley, Tom Wesselmann, Richard Bellamy, Philip Leider, Christo, and many others provided ideas or materials, as did the galleries representing the various artists – in particular Leo Castelli, Stable, Fischbach, Alexander Iolas, Richard Feigen, Robert Elkon, Bianchini, and Sidney Janis. Finally, I am, as usual, indebted to the staff of the Library and Photo Services of the Museum of Modern Art, and to my husband, Robert Ryman.

L. R. L.

New York
January 1966

Photo Credits Andrei Andersson, 184; Attilio Bacci, 84, 159, 164, 169, 170, 173, 175, 176, 177; Oliver Baker Associates, 43, 48, 49, 59, 87, 88, 118, 123, 124, 146, 168; Tito Barberis, 167; Brompton Studio, 32; Buckley, 57; Rudolph Burckhardt, 15, 17, 18, 21, 22, 61, 63, 67, 73, 75, 90, 91, 95, 104, 105, 106, 112, 113, 117, 145, 149, 150, 154, 155; Geoffrey Clements, 4, 81, 86; John Donat, 42; Richard P. Eells, 12, 16, 142; Gnika, 180; Howard Harrison, 111; Herrington-Olson, 139; Michael Katz, 72, 128; Walter Klein, 183; Robert McElroy, 9, 13, 85, 89; John Mills, 47; Peter Moore, 158; André Morain, 172; O. E. Nelson, 1, 40, 71, 80, 110, 151, 153; Eric Pollitzer, 34, 35, 64, 69, 70, 78, 83, 96, 99, 102, 103, 109, 116, 130; Nathan Raban, 29, 74; John Reeves, 161, 185, 188; Seymour Rosen, 125; Oscar Savio, 178; John D. Schiff, 53, 76, 79, 101; Lawrence Siegel, 11; Soichi Sunami, 55, 152; Universal Photo Service, London, 41, 45; Mike Zwerling, 115

Introduction

Pop Art is an American phenomenon that departs from the cliché of big, bold, raw America that became current when Abstract Expressionism triumphed internationally. It was born twice: first in England and then again, independently, in New York. At its second birth, Pop proved instantly appealing to young people the world over, who reacted enthusiastically to both the hot and the cool implications of such a direct idiom; it attracted a middle-aged generation that looked anxiously to youth for its excitement in the arts and entertainment, as well as those of all ages who recognized its formal validity. Pop Art itself was not a product of the discothèque era, but its reception was. More important, Pop is a hybrid, the product of two abstraction-dominated decades, and, as such, is the heir to an abstract rather than a figurative tradition. Pop Art has more in common with the American 'post-painterly abstraction' of Ellsworth Kelly or Kenneth Noland than with contemporary realism. When Pop first emerged in England, America, and Europe, raised eyebrows and indignation were accompanied by a profound disappointment on the part of many artists and critics. This unexpected outcome of a decade of Abstract Expressionism (or *Tachisme, art autre, l'art informel*) was hardly a welcome one, since it dashed hopes for the rise of a 'new humanism', known as the 'New Image of Man' in America and 'New Figuration' in Europe. Man might make an occasional appearance in Pop canvases, but only as a robot remotely controlled by the Consumers' Index, or as a sentimentalized parody of the ideal. For other observers, however, such a brash and uncritical reflection of our environment was a breath of fresh air.

Pop was not a grass-roots movement in any country, nor was it an international fusion of styles. Its guise was quite different in each incarnation, as will be clear from the essays in this book, but its standards were not determined by regionalism so much as by a widespread decision to approach the contemporary world with a positive rather than a negative attitude. Despite

9

its carnival aspects, its orgiastic colour and giant scale, Pop Art's alternative to the emotional and technical impastoes of its immediate predecessor was clearly based on a tough, no-nonsense, no-preciosity, no-refinement standard appropriate to the 1960's. The choice of a 'teenage culture' as subject matter contains an element of hostility towards contemporary values rather than complacency; it marks a new detachment from the accepted channels of art. Yet Pop is nowhere a nihilist trend. In Europe the manifestations related to Pop tend to have sociological intentions frowned upon in America and England, but the underlying mood everywhere seems one of determined optimism – optimism against odds, an optimism not always recognizable to those viewers who do not share it. Andy Warhol was criticized in the early days of Pop because he said he wanted to be a machine. This was misunderstood by a society whose long-standing values are threatened by mechanization. Warhol's statement, like his art, is a challenge rather than a defeat, articulately accepted by G.R. Swenson, who wrote, 'Art criticism has generally refused to say that an object can be equated with a meaningful or aesthetic feeling, particularly if the object has a brand name. Yet, in a way, abstract art tries to be an object which we can equate with the private feelings of an artist. Andy Warhol presents objects we can equate with the public feelings of an artist. Many people are disturbed by ... the trend towards de-personalization in the arts.... They fear the implications of a technological society.... A great deal that is good and valuable about our lives is that which is public and shared with the community. It is the most common clichés, the most common stock responses which we must deal with first if we are to come to some understanding of the new possibilities available to us in this brave and not altogether hopeless new world.'[1]

Yet for the individual artists, the Pop style was simply a way to embark upon a personal artistic expression that would owe little to prevailing modes. At first, largely unaware of their colleagues in the same city or in other countries, several isolated New York artists hit upon a common style by accident. It was in the air. They had not heard of their British counterparts, and the European developments seemed to have little bearing on their activities. John Coplans is correct in saying that Pop Art devices 'derive their force in good measure from the fact that they have virtually no association with a European tradition'.[2] Despite the eventual rapport between artists in Europe, America, and England, the mature Pop idiom is special to America

– particularly New York and Los Angeles. Hard-core Pop Art is essentially a product of America's long-finned, big-breasted, one-born-every-minute society, its advantages of being more involved with the future than with the past. Iconographically, however, there were a great many precedents – European as well as American – for Pop subject matter. Some fifty years had passed since the seeds of Pop were sown by Cubist collage; in retrospect it is amazing that commercial subject matter had not been 'discovered' as the total basis for fine art long before this.

Folk artists of all nations – including Africa – have made use of commercial materials and emblems. In Europe, leading fine artists have included them since at least 1912. Nevertheless, Pop is not related to the extravagant 'modernism' of the Futurists, the sterile formalism of Purists Ozenfant and Le Corbusier, or the 'object portraits' of Picabia published in *291* (an *American Girl* as a spark plug, or generator of fire; Alfred Stieglitz as a camera), or Max Ernst's slightly altered pages from a wholesale hat catalogue (*The Hat Makes the Man, The Sandworm Ties her Sandal*). Kurt Schwitters produced one of the most convincing Pop prototypes in 1947 with his *For Käte* collage, which featured comic-strip images (*Ill. 1*). However, it is much more convincing in reproduction than in the original; very small, delicate, and pale, with gauzy pink paper veiling one area of the comic, it bears little resemblance to the immense, undoctored images of the Pop artists. Picasso, who in one way or another has predicted most of the major twentieth-century advances, tossed off a few isolated examples of proto-Pop, among them the 1914 sculpture *Glass of Absinthe*, the *Plate with Wafers* drawing of the same year (*Ill. 2*), and, especially, the wooden cigar resting on a box of matches, made in 1941. Giorgio de Chirico was one of the first to reproduce *in toto* a brand-name item with his biscuits and matchboxes, in the *Metaphysical Interiors* and *Still Lifes* of 1916–17. The Surrealist objects and found objects of the 1930's, like Jean Dubuffet's *Little Statues of Precarious Life* of the early 1950's, were selected for their resemblance to something else – a dream, a figure, or a subconscious image; eventual recognition was important to their existence, but immediate comprehension would have detracted from them. Pop Art is instantly to the point, extroverted rather than introverted.

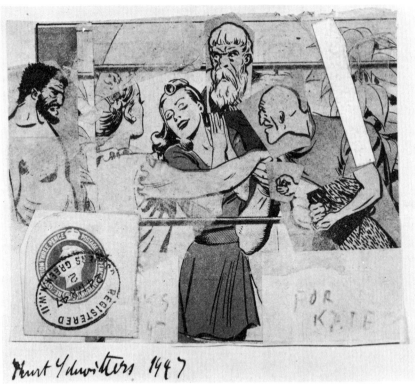

1 KURT SCHWITTERS *For Käte* 1947. Collage, $4^{1}/_{8} \times 5^{1}/_{8}$

Among the American forebears, the flag gates (*Ill. 10*), nineteenth-century trade signs (*Ill. 16*), whimsies, and weather-vanes of folk art provide amusing counterparts to Pop Art but are unimportant as sources. American artists have a long history of involvement with the American scene, primarily in its regional and picturesque aspects. Yet Pop is in no way a 'new American realism' and it bears only the most distant relationship to the romantic realism of Edward Hopper and Reginald Marsh, the social expressionism of Ben Shahn and Philip Evergood, or the 'classicism' of Charles Demuth and the Immaculates. Signs were used by the artists of the 1930's, both by painters and by photographers like Walker Evans and Rudolph Burckhardt (*Ill. 22*), either as detail or documentation. Gerald Murphy, Scott Fitzgerald's friend, painted a few very precisely rendered brand-name objects in the 1920's (*Ill. 3*). But the most direct parallel is Stuart Davis, whose *Lucky Strike*

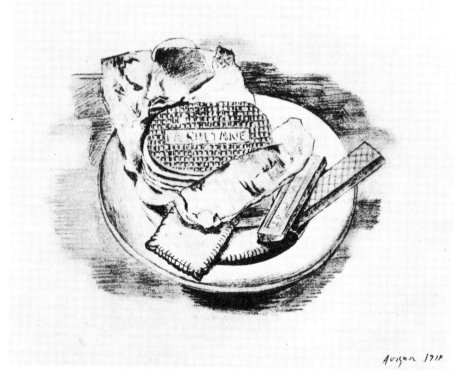

Avignon 1914

2 PABLO PICASSO *Plate with Wafers* 1914. Pencil, 11³/₄ × 18⁷/₈

package of 1921 is the most widely mentioned prototype. It presents a single commercial image as its entire subject, but it is rearranged in a stylized Cubist framework. More to the point, and more direct, is his 1924 *Odol* (*Ill. 4*), its labelled disinfectant bottle plainly visible and inscribed: 'It Purifies.' As Davis' art matured, he further abstracted the signs and lettering of an urban environment and put them to the service of a more forceful and generalized scheme. His abstract painting style, rather than his early work, may well have been a catalyst for the American Pop artists, along with the late cut-outs of Matisse, also shown in New York around 1960.

It is a mistake to attribute the emergence of Pop – in England and America at any rate – wholly to historical influences. The impetus is a contemporary one, as is the style. Nevertheless, in theory the ideas of two European masters are probably the most valid prototypes. If Fernand Léger and Marcel

3 GERALD MURPHY *Razor* 1922. Oil on canvas, 32 × 36.
Like Stuart Davis at this time, Murphy was under the influence of Léger, but the three common objects dominate the vaguely Cubist background

Duchamp did not directly influence the younger artists, they helped to mould the aesthetic situation in which Pop was possible. Their arts are diametrically opposed, but their bond is their supposed lack of, or de-emphasis of, sensitivity. As Katharine Kuh has pointed out: 'Like the Dadaists, Léger is sometimes considered an anti-artist.' [3] The inheritors of the Duchamp and Léger traditions diverged into two streams, which could be said to make up a superficial division of modern art, and it was the meeting of these two streams in New York in the late 1950's that decided the new trend. Léger, once a Purist, represents the 'clean', or neat, classical stream, while Du-

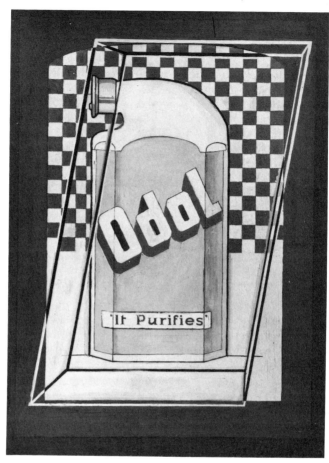

4 STUART DAVIS *Untitled (Odol)* 1924. Oil on board, 24 × 18

champ's successors – the Dadaists, Surrealists, Assemblagists, and *Nouveaux Réalistes* – represent the 'dirty', or conglomerate, romantic stream. Actually, Duchamp himself is as 'clean' as possible, but his ideas, and specifically his ready-mades, gave rise to a more involved and less pure idiom. As intellectually impersonal as Léger was emotionally impersonal, from 1913 Duchamp showed his Olympian detachment by the selection of ready-made objects that were neither very attractive (at that time) nor very shocking (with the exception of R. Mutt's 1917 *Fountain* urinal and the mustached and goateed Mona Lisa entitled *L.H.O.O.Q.*). Many of his heirs went to

extremes, but Duchamp has remained aloof. The ready-mades were given little formal attention at the time they were conceived; they were pawns in a cerebral exercise in which potential art status was conferred, or imposed, by Duchamp through sheer force of will. Time has since made the transformation that he refused to make, and objects originally intended in defiance of the prevailing domination of abstraction and formalism now seem as abstract as any contemporary work (*Ills. 5, 84*).

Léger, on the other hand, was nothing if not *engagé*, despite the purist bias of his style. Viewing the machine as significant form – unlike the Futurists (and perhaps Duchamp too), for whom it was a love object – Léger expressed a great and modern interest in such things as superhighways, window display, advertising art, and that epitome of Americanism: Chicago. 'Every day modern industry creates objects which have an uncontestable plastic value', he wrote, paralleling Duchamp's instinct for the ready-made. 'The spirit of these objects dominates the period.'[4] In another article he discussed 'the seductive shop windows where the isolated objects cause the prospective purchaser to halt: the new realism' (*Ill. 8*). Noting that in the *bals musettes* in Paris one found airplane propellers hanging on the walls for decoration, he prophetically stated: 'It would require no great effort for the masses to

16

5 (*opposite*) MARCEL DUCHAMP
Traveller's Folding Item 1917.
Ready-made, 9 in. high.
The original has been lost, like most of
Duchamp's ready-mades, but the artist
has from time to time replaced them
with new objects and has permitted the
Galleria Schwarz to reproduce them in
small editions. In this Duchamp parallels
the mass-production principle of Andy
Warhol

6 (*above*) CLAES OLDENBURG
Soft Typewriter 1963.
Vinyl, kapok, cloth, and plexiglass,
$27^{1}/_{2} \times 26 \times 9$

7 EDWARD KIENHOLZ
Black Widow 1964.
Mixed media, $36 \times 22 \times 14$. No longer
exists

8 FERNAND LÉGER
Pair of Pants c. 1931.
Pen and ink. One of a series of
drawings of common objects alone,
rather than as still-life; often these
fill the entire page to give an im-
pression of large scale

9 (*opposite*) ▶
CLAES OLDENBURG
Giant Blue Pants 1962.
Canvas, acrylic paint, *c.* 54 in. long.
Despite the grotesque size of this
garment, a writer once stated that
Oldenburg had gone out and
bought an ordinary pair of pants
and shown it, therefore making a
purely Dada gesture. On the con-
trary, this is a 'hand-made, genuine'
work of art

be brought to feel and to understand the new realism, which has its origins in modern life itself, the continuing phenomena of life, under the influence of manufactured and geometrical objects, transposed to a realm where the imagination and the real meet and interlace.'[5]

In his film *Ballet mécanique* (1924), Léger even anticipated the technique of Pop Art: 'To isolate the object or the fragment of an object and to present it on the screen in close-ups of the largest possible scale. Enormous enlargement of an object or fragment gives it a personality it never had before and in this way it can become a vehicle of entirely new lyric and plastic power.'[6] Still, the time was not yet ripe, and for all his intuitive understanding of urban art, and his own belief that he was the most 'American' of painters, Léger remained a Cubist, and French. While his robust forms, metallic surfaces, mechanical line, garish colour, and clear, schematic, often heavy-handed style are reflected in Pop Art – above all, in Lichtenstein's painting – conceptually they are miles apart. Léger's statement that

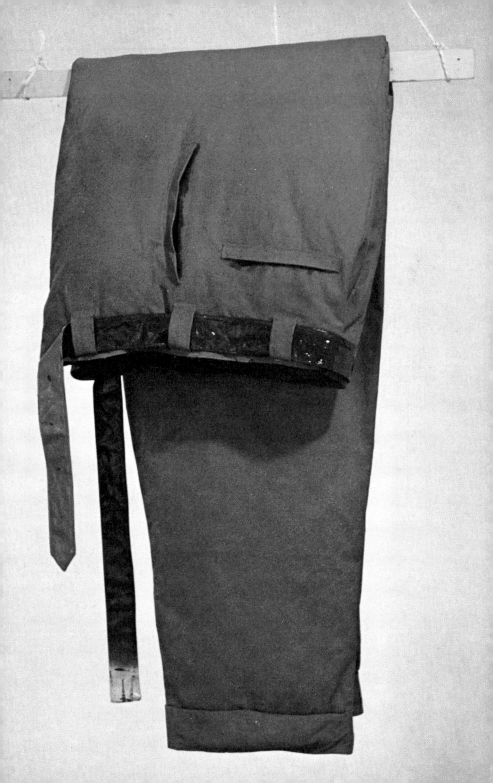

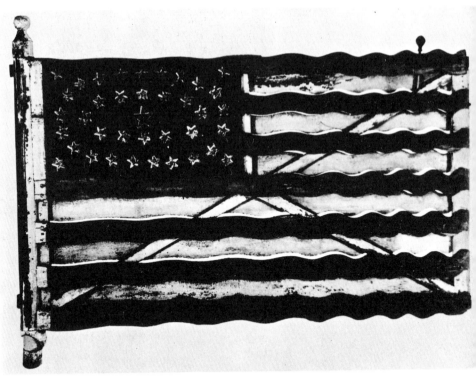

10 ANON. *Flag Gate c.* 1870. Carved and painted wood, 56 × 40

'for me the human figure is no more important than keys or bicycles' is often misunderstood. Actually he elevated objects to a level of interest equal to the figure rather than ignoring humanity. It was his kind of humanism. Despite his talk about depersonalization, Léger was a naïve idealist, even a social realist. Duchamp's irony and metaphysical cynicism hold much more attraction for the artists of the 1960's. Whatever Léger did he still considered himself an artist; Duchamp, for a time, was outside of art, closer to the 'real world' that the Pop artists extol.

Just because Duchamp has been influential in the formation of the Pop attitude is no reason to call the current trend Neo-Dada. The publication of Robert Motherwell's anthology *Dada Painters and Poets* in 1951 affected only a few artists directly – notably Johns and Dine – and it has been over-emphasized as a crucial event. Only the bastard New York brand of Dada (1914–21) – significantly Duchamp's – used motifs at all similar to Pop's.[7]

1 JOHN WESLEY *Service Plaque for a Small Legion Post* 1962. Oil on canvas, 40 × 30

2 WILLIAM COPLEY (CPLY) *Model for 'American Flag'* 1961. Oil on canvas, 24 $^1/_2$ × 31 $^3/_4$

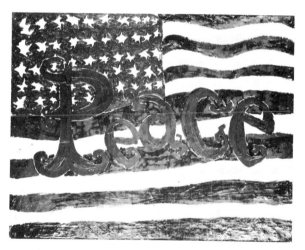

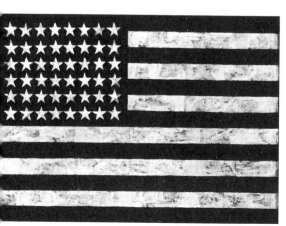

13 CLAES OLDENBURG *Flag Fragment* 1961. Enamel on plaster, 42 × 30

14 WALLY HEDRICK *Peace* 1953. Oil on canvas, 30 × 40

15 JASPER JOHNS *Flag* 1954. Encaustic, collage on canvas, 42 × 60

In addition, several writers have handed on the misconception that Dada was a political movement, saying that this marks the difference between Dada and Pop. On the contrary, only in Berlin during 1918–21 were the Dadaists politically active, although by nature they were always anti-political and anti-social in the commonly accepted senses. Surrealism, which had a strong political cast by the 1930's, represented a taming of the forces of Dada. Dada was a broad idealist anarchy with an immense intolerance for pomposity of all forms. It was especially applied to the false notion of culture rampant in post-World War I Europe. The Dada demonstrations, even in Berlin, followed a pattern of murder by ridicule; the arts were the enemy – as well as the weapon – not the government, which would presumably fall in Dada's wake. Devoted to a total and impossible *tabula rasa* rather than to specific political and social reforms, Dada's real contribution to modern art, and therefore, indirectly, to Pop, was that it opened wide the doors unlocked by Cubism. These doors led to an 'anything goes' freedom of materials and subject matter. By destroying the barriers of self-consciousness and self-importance that threatened to freeze the Cubist breakthrough, Dada gave painting a new lease on life.

Around 1958 the ideas of Duchamp and orthodox Surrealism as sifted through Abstract Expressionism began to merge. The initial result was the motley Assemblage trend in America, and Pierre Restany's *Nouveau Réalisme* and its offshoots in Europe. In New York, where Duchamp had been living off and on since 1914, Robert Rauschenberg and Jasper Johns had significant one-man shows at the Leo Castelli Gallery, providing the links, in that order, to Pop Art. Neither of these men is a Pop Artist in style or subject matter, though they are still considered to be such in Europe and by the mass media, and they have influenced and sympathized with Pop. Both of them were more or less affected by close association with the composer John Cage, who has been given credit (often exaggerated) for being the primary source of Pop Art. (As Jim Dine has observed, 'Some people *want* so hard to be influenced by him',[8] though most were not, except through Rauschenberg and Johns.) Rauschenberg had been at Black Mountain College when Cage was there, and had participated in what is now called the 'first Happening'. Cage's ideas owe a good deal to Zen Buddhism and much less to Dada; his breakdown of distinctions between chosen and accidental sounds (perfectly applicable to either phrases or images) was undoubtedly the source

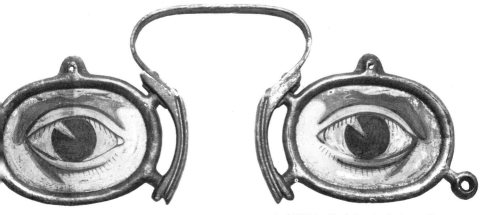

16 ANON. *Trade Sign in the Form of Spectacles,*
American nineteenth century. Painted and gilded metal, 31×23

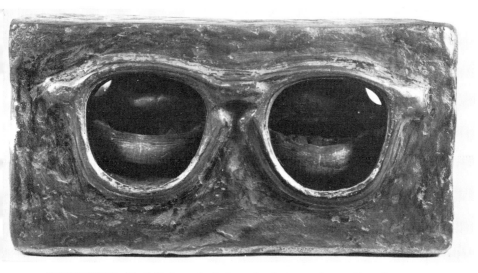

17 JASPER JOHNS *The Critic Sees* 1964. Sculpmetal and glass on plaster, $3\,^1/_4 \times 2\,^1/_8$

of Rauschenberg's widely quoted remark that he wanted to work 'in the gap between life and art', as well as of his fondness for iconoclastic gestures. The most famous of these gestures were the duplication, to the last detail, of an 'Eisenhower combine'; the acquisition from de Kooning of a de Kooning drawing which was then erased, with some difficulty, and exhibited as 'Erased de Kooning by Robert Rauschenberg'; and the cabled reply to a request to make Iris Clert's portrait, which read: 'This is a portrait of Iris Clert if I say so.'

23

Rauschenberg's gestures span both Duchamp's exacting conceptualism, and statements of Cage's like: 'Ideas are one thing and what happens another.'[9] In addition, he approaches the object with a distinctly New York School aesthetic. By incorporating into his abstract oils outrageously incongruous objects – a stuffed angora goat ringed by a tyre, a quilt and pillow, radios, Coke bottles (*Ill. 18*), birds, signs, electric clocks and fans, to mention a few – he discovered one solution to the second generation's dilemma: where could Abstract Expressionism go from here? Later, when Warhol began to use commercial silk-screen techniques of reproducing photographs on canvas, Rauschenberg also employed them to replace his more awkward frottage transfer process, and most of his work from 1962 has been flat and non-sculptural (*Ill. 149*). Yet his art has remained highly personal, rough, and abstract. Commercial images, photographs, and signs are not used specifically but are left in poetic suspension. Rauschenberg's importance to the further development of the art of common objects was his demonstration that the presence of blatantly descriptive images, intact, need not preclude an abstract solution.

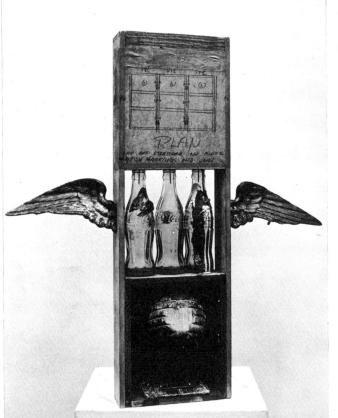

18 ROBERT RAUSCHENBER
Coca-Cola Plan 1958.
Construction, 27 × 26
(for a later Rauschenberg,
see *Ill. 149*)

19 H. C. WESTERMANN
White for Purity 1959–60
Plaster, glass, wood
and metal, 44 1/2 in. high

20 ALLEN JONES *Curious Woman* 1964–65. Oil on wood, 49 × 40

The Development of British Pop

Lawrence Alloway

Pop Art has been linked to mass communication in facetious ways as well as in straight arguments: references to the mass media in Pop Art have been made the pretext for completely identifying the source with its adaptation. It is supposed to follow from this that the Pop artists are identical to their sources. There is a double flaw in the argument: an image in Pop Art is in a new context, at the very least, and this is a crucial difference; and, in addition, the mass media are more complex and less inert than this view presupposes. The quick fame of *some* of the artists has been compared maliciously[1] with the here-tonight, gone-tomorrow public life of *some* performers, such as singers on 45-records or the blankest of starlets. In the late 1940's and early 1950's, American abstract art created new references for art and for its spectators, whereas in the subsequent decade this normative function has belonged to Pop Art. Instead of such influential propositions that have been generally absorbed ('When is a painting finished?' 'How little can a painting be made of?'), other propositions have arisen from Pop Art: How close to its source can a work of art be and preserve its identity? How many kinds of signs can a work of art be at once?

The subject is one I feel close to because I was around during the development of English Pop Art and a witness to the expansion of American Pop Art in the 1960's. I have no great desire to write in the first person, but as the literature on the subject is incomplete (and rarely consulted), and as I knew the artists, a first-hand chronicle is probably the best way for me to write about a less-than-charted scene. The term 'Pop Art' is credited to me, but I don't know precisely when it was first used. (One writer has stated that 'Lawrence Alloway first coined the phrase "Pop Art" in 1954';[2] this is too early.) Furthermore, what I meant by it then is not what it means now. I used the term, and also 'Pop Culture', to refer to the products of the mass media, not to works of art that draw upon popular culture. In any case, sometime between the winter of 1954–55 and 1957 the phrase acquired currency in conversation, in connection with the shared work and discussion among members of the Independent Group (see below).

Misrepresentation of British Pop Art has been widespread. Critical lethargy apparently prevents a check of the events of the 1950's. Take the following sentence by Martin Friedman:[3] 'Peter Blake (along with Richard Hamilton) was one of the British progenitors of Pop Art which evolved during the mid-1950's *more or less* simultaneously in England and America' (my italics). In fact, Blake and Hamilton, as Pop artists, are in every way unlike one another: they have different sources, different references, a different speed. Furthermore, they are not even 'progenitors', they *are* Pop artists, whereas an artist who *is* a 'progenitor' of great importance, Eduardo Paolozzi, is not even mentioned by Friedman. Another quotation that shows lack of contact with the subject comes from Alan Solomon:[4] 'One of the most unfortunate and destructive accidents, destructive because it has caused so much public confusion, is the attachment of the term "Pop Art" to this group. The term Pop Art originated in England, in reference to a group of artists who were much more committed to a consciousness of their own social restlessness and to a sense of the need for alteration of established values' than 'American painters, who simply take life as they find it; who, instead of derogating and rejecting our vulgar civilization, set out optimistically to celebrate it on a basis of their own devising.' Aside from Solomon's strange belief that the label rather than the works of art themselves caused 'public confusion', he is clearly inattentive to the realities of British Pop Art which are subordinated crudely to his thesis. The fact is that the term Pop Art did not originate 'in reference to a group of artists', nor were English artists in opposition to popular culture (as we called it, rather than 'vulgar civilization').

A potent preliminary move in the direction of Pop Art in England occurred from 1949 to 1951, the period in which Francis Bacon began using photographs in his work. A series of screaming heads was derived, partially, from a still from the film *Battleship Potemkin*: the image of the nurse wounded in the eye, with broken pince-nez, in the Odessa steps sequence. Though mixed with other elements, the photographic reference was conspicuous and much discussed at the time. Bacon followed it up by using other photographic sources, particularly the motion studies of people and animals made in the 1890's by Eadweard Muybridge.[5] Bacon's use of mass-media quotations differs from earlier uses by painters, in that recognition of the photographic origin of the image is central to his intention. In fact,

his art at this time depended on being stretched between the formal painting style of the grand manner and topical, photographically derived episodes of motion or violence. It should be remembered that Bacon was the only British painter of an earlier generation who was regarded with respect by younger artists in London. Moore, Nicholson, Pasmore, Sutherland (the equivalent in age of de Kooning, Newman, Pollock, Still) were considered to be irrelevant to any new art in the 1950's.[6] The use of the photographic source, its quotation and partial transformation, is, of course, central to later developments in Pop Art, though Bacon himself is clearly not a Pop artist.

The photograph, as a document of reality and a source of fantastic imagery, was to be taken far beyond Bacon's use of it to evoke the texture of reality. There existed, perhaps, some feeling that admirable as Bacon was, *Potemkin* was an old movie and not a new one, and Muybridge, though magical, was a period figure. In an exhibition called 'Parallel of Life and Art', a collection of 100 images at the Institute of Contemporary Art in London, in 1953, the range of photographic sources was suddenly exploded. The show included a motion study (Marey instead of Muybridge, a nude man on a bicycle) and also X-ray, high-speed, and stress photographs, anthropological material, and children's art. The images were blown up photographically and hung on the gallery walls, from the ceiling, and as screens to surround the spectator environmentally. The maze form made it possible to create a non-hierarchic profusion of images from all sources. The show was organized by Paolozzi, photographer Nigel Henderson, and architects Alison and Peter Smithson, all of whom were subsequently connected with the study of Pop culture in England. Henderson contributed technical knowledge, but also his own photographs of graffiti and detritus. (His photographs of street games, though not included in the exhibition, expressed a growing interest in activity rather than in theory, in records rather than in ideals.) Similarly, the Smithsons went some way to replace Palladian Man and Modular Man by glamorous images of the home from slick magazines,[7] though it is doubtful that, in the long run, this seriously modified the professionalism of the trained architect.

The Institute of Contemporary Art was, at this time, a meeting place for young artists, architects, and writers who would not otherwise have had a place of contact, London having neither a café life like that of Paris nor exhibition openings such as in New York. A small and informal organiza-

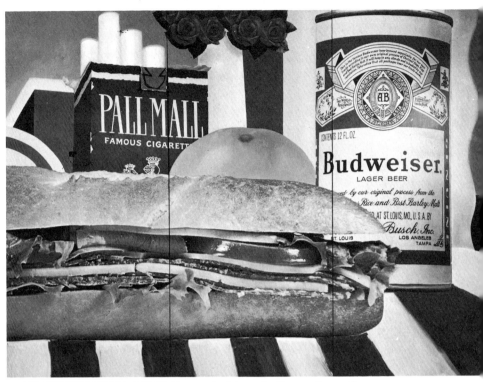

21 TOM WESSELMANN *Still Life No. 33* 1963. Paint and collage, 11 ft × 15 ft

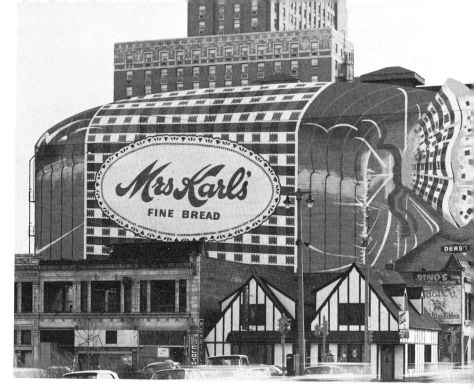

23 BERNIE KEMNITZ *Mrs Karl's Bread Sign* 1964. Billboard, 60 ft × 150 ft. Since Pop Art, an actual billboard looks more like a Wesselmann than the real thing, and a Wesselmann (*Ill. 21*) to many people still looks more like a billboard than a painting

tion, the Independent Group (IG), was set up within the Institute for the purpose of holding exploratory meetings to find ideas and new speakers for the public programme. It was first convened in winter 1952–53 by Peter Reyner Banham; the theme of the programme was techniques. The one meeting that I was invited to (I didn't go) was on helicopter design. The IG missed a year and then was reconvened in winter 1954–55 by John McHale and myself on the theme of popular culture. This topic was arrived at as the result of a snowballing conversation in London which involved Paolozzi, the Smithsons, Henderson, Reyner Banham, Hamilton, McHale, and myself. We discovered that we had in common a vernacular culture that persisted beyond any special interest or skills in art, architecture, design, or art criticism that any of us might possess. The area of contact was mass-pro-

◀ 22 (*below, opposite*) RUDOLPH BURCKHARDT *Signs* 1939. Photographed by the artist. Walker Evans as well as other American artists and photographers from the 1930's shared this fascination with the 'found collages' of store walls, billboards, and gas stations

duced urban culture: movies, advertising, science fiction, Pop music. We felt none of the dislike of commercial culture standard among most intellectuals, but accepted it as a fact, discussed it in detail, and consumed it enthusiastically. One result of our discussions was to take Pop culture out of the realm of 'escapism', 'sheer entertainment', 'relaxation', and to treat it with the seriousness of art. These interests put us in opposition both to the supporters of indigenous folk art[8] and to anti-American opinion in Britain.

Hollywood, Detroit, and Madison Avenue were, in terms of our interests, producing the best popular culture. Thus expendable art was proposed as no less serious than permanent art; an aesthetics of expendability (the word was, I think, introduced by Banham) aggressively countered idealist and absolutist art theories. Subjects of the IG in the 1954–55 season included: Banham on car styling (Detroit and sex symbolism); the Smithsons on the real dreams of ads versus architectural ideals; Richard Hamilton on consumer goods; and Frank Cordell on popular music (he actually made it). In one way or another, the first phase of Pop Art in London grew out of the IG. Paolozzi was a central figure, as were William Turnbull, Theo Crosby, and Toni del Renzio. Meetings were always very small, and by the end of the season we all knew one another's ideas so well that one of the last meetings turned into a family party with everybody going to the cinema instead. There was always a line out of the private IG to the public programme of the Institute. In the mid-1950's I gave public lectures on 'The Human Image' (mixing fine-art and mass-media images) and on science fiction, and Toni del Renzio lectured on fashion.[9]

The first phase of English Pop Art (1953–58) was strongly linked with themes of technology, as opposed to the pastoral and primal ideas of British neo-Romanticism. Three influential books were Ozenfant's *Foundations of Modern Art*, Sigfried Giedion's *Mechanization Takes Command*, and Moholy-Nagy's *Vision in Motion*. These books were being *read* by the British constructivists at the time (Victor Pasmore, for example), but the artists around the IG valued the illustrations more than the texts, which carried too many slogans about a 'modern spirit' and 'the integration of the arts' for their taste. It was the visual abundance of these books that was influential, illustrations that ranged freely across sources in art and science, mingling new experiments and antique survivals. I know that what I liked about these books, and other people then in their twenties felt the same way, was their

24 RICHARD HAMILTON Cover of Catalogue, *Man Machine and Motion,* IC A, London 1955

acceptance of science and the city, not on a utopian basis, but in terms of fact condensed in vivid imagery.

In 1955 'Man Machine and Motion', another exhibition at the ICA, this time by Richard Hamilton (*Ill. 24*), explored the visual explosion of the twentieth century as a source of marvellous images. ('Image', a powerful word by this time, was used to describe evocative visual material from any source, with or without the status of art.) In his exhibition Hamilton explored the intimate contact of men and machines, using photographs not solely as documentary records, but also as fantasy rooted in human fact. Thus, imaginative properties usually reserved for the fine arts were associated with photographs. In place of Roger Fry's 'disinterested contemplation', in place of Sir Herbert Read's elaborate theoretical schemes, which were the only available aesthetic systems at the time (unless one went on a Surrealist-Freudian kick), something both more simple and more intimate, more common and

more fantastic, was being sought. Hamilton approached me to do a text for the catalogue for 'Man Machine and Motion', but I failed to come up with a usable formulation. At this time, despite an increasing acceptance of mass-media images and of technology, there was no clear formulation of their function in relation to art, only a conviction of their connectibility. Finally, the introduction was done anonymously, by Hamilton and Lawrence Gowing, with technical notes by Banham, of which the following is a good example: 'The way in which technical progress eventually overtakes and satisfies the wish-dreams of science fiction is aptly demonstrated in yet another application of the aqualung. The figure swimming in front of the camera is Richard Fleischer, director of Disney's production of *20,000 Leagues Under the Sea*, Jules Verne's pioneer submarine novel of nearly a century ago, which it has now become possible to film *on location*.'[10] In 1955, I wrote a catalogue text for the work of Magda Cordell, who applied action-painting techniques to figurative images. The text included a word list suggested by the paintings which stressed connotations of a science-fiction nature: 'solar, delta, galactic, amorphous, fused, far out, viscous, skinned, visceral, variable, flux, nebular, irridescence, hyper-space, free-fall, random, circulation, capacious, homeomorphism, variegated, reticular, entanglement, multiform, swimming pool, contra terrene.'[11] The words derive not from technical or sociological science fiction, as represented at the time by *Astounding Science Fiction*, but from the organic and exotic stories of Theodore Sturgeon and *Galaxy Science Fiction*. However roughly, I was struggling in my art criticism to draw references from popular culture rather than from traditional sources.

In 1955, Reyner Banham first publicly proposed the term 'The New Brutalism'[12] in an ambitious attempt to provide a general theory that would cover 'Parallel of Life and Art', the paintings of Magda Cordell, Paolozzi's sculpture, and the Smithsons' architecture. The term never really caught on, though it agitated British architectural discussions for some time, which was probably Banham's main purpose. His proposal to unite a geometric architecture with Pollock's paintings, Burri's textures with Henderson's photographs of graffiti, on the grounds that each was 'a clear exhibition of structure', was too thin. He punned on Brutalism, as an architectural term, and Jean Dubuffet's *art brut*, in one of those curious linkages that are possible while everything is in motion and nothing settled.[13] In the mid-1950's, how-

ever, there were links between English interest in popular culture and Dubuffet, who influenced Cordell's figures as he also influenced John McHale's. McHale's collages (exhibited in the ICA library in 1955) depended on a capacious Dubuffetesque human contour, which could incorporate whatever was thrown at it. He used colour reproductions from mass-circulation glossy magazines; postwar printing improvements had made available a wide colour range, unlike the sober printed materials available to earlier collagists. The figures were in a sense democratically Arcimboldesque; whereas Arcimboldo's figures consisted of their occupational tools or seasonal attributes, McHale's were portraits of consumers, full of the good things of postwar abundance.

By 1954 Paolozzi had established a rugged human image, and one associated, in various ways, with technology (*Ill. 25*): the 1955 drawings of a man with a camera, the camera embedded in the face as if it were part of the head, are characteristic. In a lecture he gave in 1958, Paolozzi summed up ideas that were relevant to his own development and to ideas current in the 1950's. He said: 'It is conceivable that in 1958 a higher order of imagination exists in a SF pulp produced on the outskirts of L. A. than [in] the little magazines of today. Also it might be possible that sensations of a difficult-to-describe nature be expended at the showing of a low-budget horror film. Does the modern artist consider this?'[14] Another quotation concerns his idea that any object is rewarding, because it is a multi-evocative image. 'SYMBOLS CAN BE INTEGRATED IN DIFFERENT WAYS. The WATCH as a calculating machine or jewel, a DOOR as a panel or an art object, the SKULL as a death symbol in the west, or symbol for moon in the east, CAMERA as luxury or necessity.'[15] The semantic spread of all objects and images figures in his art in terms of amorphous and dissolving detail, the rough textures of which imply flux and also ruin.

> Twisted and pulled still recognizable crashed JUNKER
> part of the anatomy fuselage exposed like a wounded beast
> zinc-alloy piece filled with Scottish clay
> Fragment of an autobiography[16]

The memory of a crashed Nazi plane in World War II is evoked in terms analogous to the surfaces of his sculpture, which carry traces of the imprints of manufactured objects, from bombsights to polyethalene toys.

Thus we find in Paolozzi a full statement of the ideas that were necessary for the development of Pop Art: a serious taste for popular culture, a belief in multi-evocative imagery, and a sense of the interplay of technology and man. His own work is not straight Pop Art: for one thing, his insistence on translating all found objects into one final material, bronze, separates him from later artists. Nevertheless, in his ideas about the function of imagery, in his meshing of art and life, in his possession of talent checked by casualness, he is the contemporary of Rauschenberg. Both artists share a sense of abundance and an awareness of the encroaching environment. The terminal date of 1958 proposed for the first phase of English Pop Art is approximate only. It does not mean that this kind of work ended abruptly or trailed on sadly, any more than Paolozzi's contribution to the development of English Pop Art in the 1950's exhausts the significance of his art. What happened was that the field of Pop Art became more crowded, the alternative moves more numerous, though without shifting the premises of the first phase.

All the members of the IG were basically in the humanities; we were not sociologists or anthropologists, although our interests extended into areas where they worked. We assumed an anthropological definition of culture, in which all types of human activity were the object of aesthetic judgement and attention. In 1958 I published a piece on 'The Arts and the Mass Media'[17], written the preceding year, which is typical in this respect: wanting to extend the limits of art (or encourage overlaps between what are called 'art' and 'life'), I was impelled to argue with an art critic, which is something only another art critic would have felt was necessary. Discussing Clement Greenberg's article, 'Avant-Garde and Kitsch',[18] I objected to his reduction of the mass media to 'ersatz culture... destined for those who are insensible to the value of genuine culture.... Kitsch, using for raw material the debased and academic simulacra of genuine culture welcomes and cultivates this insensibility'. Greenberg's attitude seemed symmetrical to a B-movie about a schoolteacher whom nobody could see until she took off her glasses: his anti-populism and Pop Art's anti-intellectualism (when it occurs) were both inadequate. I attempted to define 'the popular arts of our industrial civilization' on the basis of acceptance. 'The new role for the fine arts is to be one of the possible forms of communication in an expanding framework that also includes the mass arts.'[19] The idea was of a fine art–Pop Art continuum, in which the enduring and the expendable, the timeless and the

25 EDUARDO PAOLOZZI Work sheet collage *c.* 1954 ▶

RUSSIA'S THIRD SATELLITE. A photograph and explanatory diagram published yesterday in Pravda, organ of the Soviet Communist party, showing Russia's third Sputnik, which was launched on Thursday. The satellite weighs one ton 6cwt. and is 11ft 8in high and over 5ft in diameter at the base. It is carrying over half-a-ton of instruments for scientific research in the upper layers of the atmosphere.

1. Magnetometer to measure the corpuscular irradiation of the sun; 2. photo multipliers to measure gravity; 3. solar batteries; 4. apparatus to register photons in cosmic rays; ... electrical fluxmeter; ... Geiger counter; 8. Mass spectrum meter tube; 9. apparatus to register heavy nuclei in cosmic rays; 10. apparatus to measure the intensity of primary cosmic irradiation; 11. apparatus to register the impact of micro-meteors.

OPEN NEW ERA

Druckfehler

Titelblatt, Gedanken über Anarchismus
(**nicht**: Gedanken über den Anarchismus)

Se... ...äuber-Arp

...ev)

...nden)

...ardsley)

Seite 30

Seite 32 Ba... Saint-Laurent (**nicht**: Saint-Laurents)

Seite 36 Dr. H. Koechlin
nicht: Dr. H. Köchlin)

Seite 38 PARIS 6ème
(**nicht**: PARIS 6ême)

Seite 43 Mitarbeiter (**nicht**: Mittarbeiter)

Paul Celan (aus Versehen doppelt gedruckt)

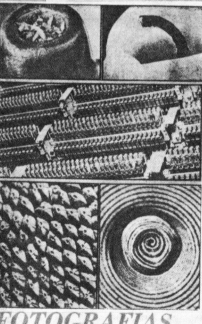

FOTOGRAFIAS
MISTERIOSAS

Que representarão estas cinco fotografias?... Cá estamos mais uma vez a pôr à prova a sagacidade do leitor... Ora, da esquerda para a direita e de cima para baixo, vejamos: será um ninho de qualquer ave ou um cinzeiro? A seguir: Uma maçã com o seu pé ou uma vela? Ao meio: A parte central de um tear, o interior de um piano ou ainda a aparelhagem de uma central telefónica? Em baixo: Cabeças de sardinha, sementes de girassol ou tâmaras? A seguir: Um pneu, um salva-vidas ou um chapéu de palha?... Como habitualmente, desfaremos as dúvidas em próxima página de «Miscelânea».

Soluções das últimas «fotografias misteriosas» que publicámos: Uma chinesa; um abissínio; uma árabe; uma malesiana; uma indiana; e uma «índia» do México.

timely, coexisted, but without damage either to the senses of the spectator or to the standards of society. The original sense of 'Pop Art' is clear from this article: it was a friendly way of saying mass media. In 1960 I wrote: 'It is noticeable that no significant differences have yet emerged in the definition of Pop Art's role in the environment between the early and the later 1950's. TIT, *Ark*, and "Talk" rest on the original unrevised hunches and research of the IG.'[20] This was not an attempt to make the IG all powerful, merely an acknowledgment that change was not continuing at the hoped-for rate. Thus, it was possible to write in 1960 that 'the Cambridge Group at the New Vision ... shows that a polemical use of Pop is still possible without going soft'.[21]

'This Is Tomorrow' (*Ill. 27*) has become a celebrated incident in English art and one that can be related to the development of Pop Art in London. The exhibition, an anthology of twelve separate displays, was held at the Whitechapel Art Gallery in 1956 (staged at a time when the director was absent, as I remember, though, of course, with his agreement). It began as a proposal from the French *groupe espace* to arrange an English exhibition

demonstrating the synthesis of (abstract) art and architecture. Even the English abstract artists, however, dissented; eventually, thanks to Theo Crosby, the exhibition occurred, but in a totally fresh form. Areas in the large gallery space were allocated to various groups which then worked on their own, though under Crosby's monitoring. The results ran a spectrum from pure architectural pavilions through department-store displays to one ebullient carnival piece, which is the best remembered.

Essentially what happened at 'This Is Tomorrow' is that the latent environmental interests of artists (stated in 'Parallel of Life and Art' and 'Man Machine and Motion', for example) were brought into the open. In 1953, for instance, both the preliminary national event and the international finals of 'The Unknown Political Prisoner' sculpture competition were held in London. Most of the people I knew were in agreement that the best works were not the sculpturesque projects, but the environmental ones.[22] The total effect of the crammed gallery of TIT made even the most reticent and pure exhibits participate in a drama of competing elements, analogous to the street outside.

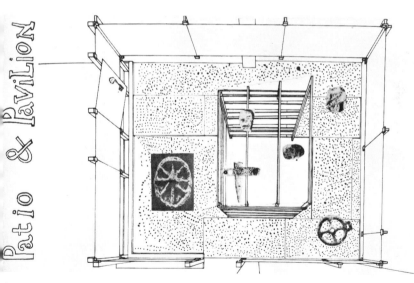

PATIO &
PAVILION
REPRESENTS
THE FUNDAM
ENTAL
NECESSITIES
OF THE
HUMAN
HABITAT IN
A SERIES
OF SYMBOLS
THE FIRST
NECESSITY
IS FOR A
PIECE OF
THE WORLD
THE PATIO
THE SECOND
NECESSITY
IS FOR AN
ENCLOSED
SPACE
THE PAVILION
THESE TWO
SPACES
ARE
FURNISHED
WITH
SYMBOLS
FOR
ALL
HUMAN
NEEDS

(opposite) RICHARD HAMILTON *Just What Is It that Makes Today's Homes so Different, so Appling?* 1956. Collage, 10 1/4 × 9 3/4. As part of the 'This Is Tomorrow' exhibition, a photomural of this image was one of several references to Pop culture. *Ills. 21, 22,* and *23* show other parallels, old and new

Pages from Catalogue, *This Is Tomorrow,* Whitechapel Art Gallery, London 1956; 'Habitat', by nderson, Paolozzi, and Smithson

Hamilton, McHale, and John Voelcker constructed a piece of fun-fair architecture: false perspective, soft floor, and black light within; the exterior covered with quotations from popular culture, including Marilyn Monroe, a giant beer bottle, and a seventeen-foot-high cut-out robot with a girl from a movie marquee advertising *Forbidden Planet*.[23] The catalogue included a collage by Hamilton, *Just What Is It That Makes Today's Homes So Different, So Appealing?* (*Ill. 26*), that was an inventory of popular culture: moon ceiling, muscle-man, nude girl, an image of Al Jolson as *The Jazz Singer*, a technological innovation in movies ('The Coming of Sound'), and another innovation, magnetic tape, in the foreground. The collaged items are presented as an environment, a room space. Thus, the participative space that preoccupied various artists in the 1950's[24] was closely related to popular culture, either as samples of the physical environment of the city or as simulations of the environment of the street or carnival. Thus, artists were revealing a sense of the city neither as a means to reform society (Mondrian) nor as the topical form of Ideal Form (Léger), but as a symbol-thick scene, criss-crossed with the tracks of human activity. The feeling is not an easy one to set down, but it was a kind of subjective sense of the city, as a known place, defined by games, by crowds, by fashion.

The pleasurable filling of a role in urban life (instead of protesting or looking for more favourable circumstances) separated London artists both from the working-class bias of Richard Hoggart and from the angry young men. Most of the artists I knew considered these positions old-fashioned and held in bad faith. The only activist among the artists was Richard Hamilton, whose politics were declared in a 1964 portrait of Hugh Gaitskell as 'a famous monster of film land'. He put labour leader together with horror comic-book title because, as he recorded, 'I regarded him, personally, as the major obstacle to adoption by the Labour Party of a reasonable nuclear policy, at a time when the will of a majority within the labour movement in Britain had been expressed in condemnation of our continuing nuclear attachment.'[25] However, this is his only painting with a political or satirical point, and he is the only British artist to use Pop Art for such a purpose. So much for Alan Solomon's assertion that 'social restlessness' and a 'need for alteration of established values' underlie English Pop Art. The truth is the reverse: the artists accepted industrial culture and assimilated aspects of it into their art.

Hamilton's first painting with sources in Pop culture is *Hommage à Chrysler Corp*, 1957 (*Ill. 28*), and the artist has noted its origins thoroughly.[26] 'The main motif, the vehicle, breaks down into an anthology of presentation techniques'; 'Pieces are taken from Chrysler's Plymouth and Imperial ads, there is some General Motors material and a bit of Pontiac. The total effect of Bug-Eyed Monster was encouraged in a patronizing sort of way.' In addition, find 'the Exquisite Form bra diagram and Voluptua's lips'. This compound of styling and sex, which referred to Banham's ideas on auto-styling, occurs again in *Hers Is a Lush Situation*, 1957, Hamilton's second car and Pop Art painting. The references mesh like intersecting words in a crossword puzzle and constitute signs as oblique as a crossword's clues. Headlights, fenders, vents, and a curved reflection of the UN in the windshield evoke a mechanomorphic eroticism, cued by the centrally placed lips of the lady driver. *She* (*Ill. 29*) substitutes domestic technology for automotive. Hamilton's position, that of knowing consumer, is a drastic departure from both the high-art ideals claimed by many modern artists and the bohemian distrust of possessions (being a bad consumer) that often goes with it.

Though Hamilton's art departed from the Frankenstein monster proportions of Paolozzi's and McHale's figure (and of Frankenstein's Bride, as painted by Cordell), his art was figurative. Elipsis in the form of detail, silhouette, or switches in coding, did not change that fact. The second phase of British Pop Art, on the other hand, which took form between 1957 and 1961, was abstract. Richard Smith, who was central to this development, is on record as saying that he 'considers himself "second-generation Independant"' (*sic*).[27] Apropos the IG, he told Lucy Lippard that 'in general it tended to be too sociologically inclined and hardly any art came out of it'.[28] What the IG achieved, I think, was an extension of aesthetics into the manmade environment and a consequent shift both in the iconography and space of art. Space became defined as intimate, occupied by known objects or images, a world in close-up, with aesthetic distance drastically reduced.

The conceptual basis of the IG – to live with the culture one has grown up with, and not reject it in the name of snobbishly defined 'maturity' – has been not seriously modified. Subsequent Pop Art in London did not resemble the works of Paolozzi or Hamilton, but neither did it have a different ideological premise. Both Paolozzi and Hamilton, incidentally, had

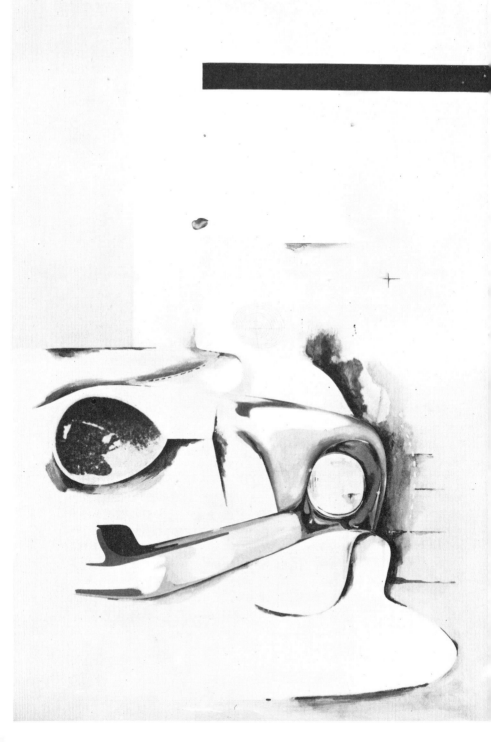

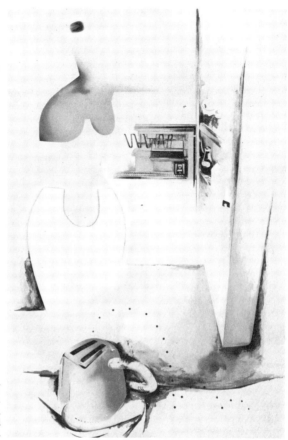

28 RICHARD HAMILTON
Hommage à Chrysler Corp. 1957.
Oil, metal foil,
collage on panel,
48 × 32

29 RICHARD HAMILTON
She 1959–60.
Oil, cellulose,
collage on wood
$102^1/_2 × 82$

short-term teaching jobs at the Royal College of Art, which was the chief
source of the second phase of Pop Art. The Royal College of Art became
important in this respect as the result of spontaneous activity among the
students, and not as the result of staff influence. Smith and William Green
were there (though not close); Robyn Denny and Peter Blake were there
and inseparable from Smith and Coleman. Denny's contact with Pop Art
was marginal, but Blake was central and so was Roger Coleman. As 1956–57
editor of *Ark*, the magazine published by the College, Coleman radically
reshaped it away from Staffordshire pottery and painted barge boards and
into IG-influenced Pop Art channels. His three numbers (18–20) of the mag-
azine were serious and lively, instead of only lively, as subsequent issues
became under other editors. He drew on the IG and on the new generation
of art students at the College for contributions.

43

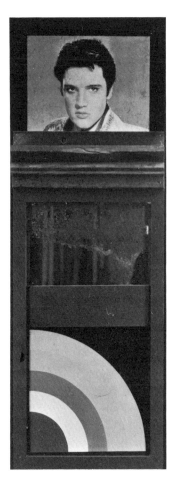

30 PETER BLAKE *Elvis Mirror.*
Collage, oil on board, 44 × 16

31 (*opposite*) PETER BLAKE *Self Portrait* 1961. ▶
Oil on canvas, 69 × 48

The switch from the figurative to an abstract basis, characteristic of the second phase of Pop Art, had a precedent in the first. The *art brut – art autre* elements possessed, even at the heart of the first phase, a potential for abstract art. The influence of American abstract art increased through the 1950's, and in 1957, at the 'Young Contemporaries', an annual exhibition organized by art students, Smith exhibited a painting which was influenced both by Sam Francis and by American popular culture. It was called *Blue Yonder,* a phrase which turned the soft, liquid, paint marks of a tall abstract painting into an image of the sky. The reference to the US Air Force song is not an obscure one and was certainly recognized by anybody alert to then current entertainment (for example, war films of the 1950's).

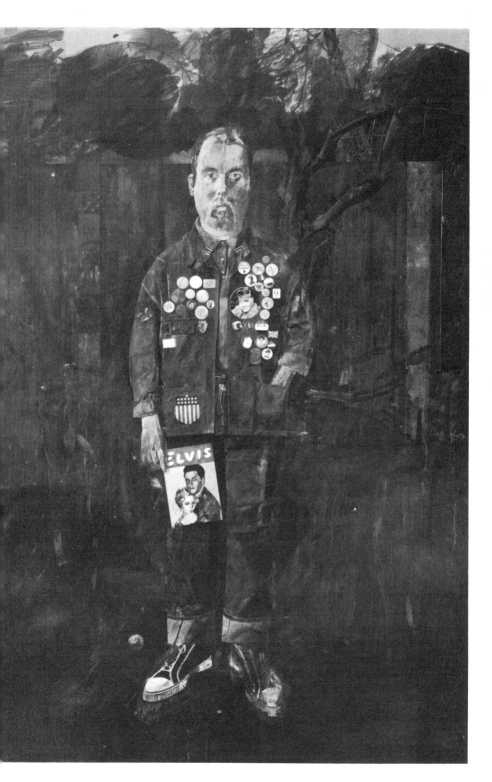

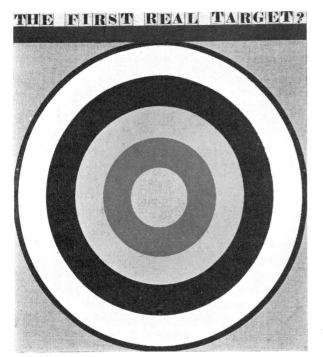

32 PETER BLAKE
The First Real Target? 1961.
Collage on board, 20 × 18.
The cryptic reference could be to
Jasper Johns' targets of the late 1950's,
famous by 1961

 The reference to common experience, which both Bacon and Paolozzi
had shown to be possible within a highly personal art, was preserved by
artists like Smith, who did not, however, specify their sources so clearly.
There seems to have been no question of abandoning 'humble sources', only
of introducing them in another way; existing memories and present affilia-
tions were to be aroused by apparently non-figurative paintings. Most of the
artists who contributed to the second phase of Pop Art were fairly regular
movie-goers, for example. The impact of big-screen films (from 1954 on)
continued through the 1950's in England, despite the pessimism of the film
critics. Thus, a standard idea of that time was an equation of the big screens
with Monet's *Nympheas* in the Orangerie or with Pollock's large paintings,
in terms of involvement, immersion, spectator participation. Large abstract
paintings were considered to be a way of cutting down aesthetic distance;
a big picture meant a close-up, not a step back. What is a fact about the view-
ing of certain large American abstract paintings, for example, was known
and discussed in terms that derived from Pop Art.
 The artists of the first phase used popular material objectively and by this
means modified the image of man with which they were all concerned. The

33 JON THOMPSON
*Do It Yourself
Flag Painting* 1962.
Oil on board, 64 × 60.
About this time Andy
Warhol was also making
'do-it-yourself
paintings', based on
follow-the-dots pictures
and diagrams from
books (see *Ill. 72*)

artists of the second phase (most of whom were friendly with their immediate predecessors) shifted their attention to the environment itself. A basic assumption was that perception of the world had changed because of the bombardment of our senses by signs, colour and lights of the mass media. Hence, it should be possible to activate our experience of these scenes, and of objects in them, by means of an imagery that is non-verbal but topical. For example, in 1961, Smith painted a Marilyn Monroe, called *MM*, which he derived from the cover of *Paris Match*.[29] Panels at the top of the page, a sensual blur of flesh, a curve that does not abandon her smile, make the connection. (This is one of the few Marilyn paintings to precede her death, incidentally: most of the others were the product of sentimental and elegiac reflexes.) 'Current technology, gossip-column hearts or flowers, Eastman colour features, have no direct pin-pointable relation to my work of the moment, but they are not alien worlds.' Smith wrote these words in the late 1950's; a little later he asked me to write a catalogue text for him, which I did, and referred to the translation of the glamorous soft and blurred colour of high-fashion photographs into abstract art. I named Richard Avedon as a source, but Smith changed it to Bert Stern (whom I hadn't even heard of

then).'[30] In 1963, he wrote himself: 'In annexing forms available to the spectator through mass media there is a shared world of references. Contact can be made on a number of levels. These levels are not calibrations of merit on a popular-fine art thermometer (aesthetes look at this, social scientists note that), but of one aspect seen in terms of another.'[31] The titles of some of Smith's paintings show what is annexed: *McCall's, Revlon, Tissue, Flip-Top, Lubitsch, Soft Pack* (*Ill. 35*). Their transformation into paintings with polyvalent imagery does not depart from IG ideas. Paolozzi's concept of multi-evocative imagery is unquestioned, as well as the idea that I developed at IG meetings of a continuum of communications (as opposed to a pyramid or a thermometer) within which all the arts coexist, with equal accessibility to the spectator. The threshold of legibility has been Smith's constant interest, from the evocation of objects and products by flat painting (1961–62) (*Ill. 34*), to the fusion of three-dimensional form with painted surfaces in which literal volume and painted space were irreducibly contradictory (1963–64) (*Ill. 36*). In both, illusionism is important, as a dimension of reference in the earlier works, as flirtatious shifts of emphasis later. The environment, either echoed by the paintings or constructed by it, is essential; that is to say, the environment, conceived as our world, as it arouses the spectator to a game of contacts and suspensions.

34 RICHARD SMITH
Time Piece 1962.
Oil on canvas,
68 × 72

35 RICHARD SMITH ▶
Soft Pack 1962.
Oil on canvas, 84 × 69.
One of the more
realistic of Smith's
inventive variations
on the cigarette
package motif

The environmental phase of English Pop Art depended on an acceptance of the large scale of American abstract art and, at the same time, on an affiliation with American popular culture. American popular culture was, in this respect, more imaginative and more proficient than the British; it was more fully industrial. This, and not nostalgia for another place, made it attractive. The relation between American abstract art and American popular culture has been pursued constantly by Smith, and with varying degrees of intensity and for varying lengths of time by other artists. Sometimes the Pop element may be indicated merely by a title, as in Denny's *Baby Is Three*, 1960, or *Gully Foyle*, 1961, both of which refer to science fiction.[32] The popular art references could, also, overwhelm every other element, as in the case of William Green, who became celebrated in 1957 for his large paintings made by riding a bicycle over them when wet and by burning them. The first works done in this way had titles like *Napoleon's Chest at Moscow*, 1957, that reveal the influence of Georges Mathieu. In 1958 Green entitled two large black bituminous paintings *Patricianne*, after an American car, and *Patricia Owens*, after a film actress; Mathieu's historical play had been replaced by evocations of popular culture. In 1959, Green held a show called 'Errol Flynn' (New Vision Gallery) in which the paintings were not about Errol Flynn in any referential sense. The works exhibited were not even the ones prepared for the show, which suffered from technical production problems.[33] Declaring that any meaning is possible, he prearranged the title to his exhibition. Green was a hero of the mass media (TV, magazines, and newspapers were full of him), but he did not survive the media's inevitable switch to other heroes.

Another environmental show, at the New Vision Gallery in 1960, featured gold panels (fragile gilded wafers with broken edges, as if nibbled by white mice) by Blake, and grass by Tony Gifford (real name, Tony Mackley). The grass was just that, areas of artificial grass, as used in store-window displays, with whitewashed lines on it, as on a soccer field. Slices of English lawn (marked for a traditional game) were thus lifted up on to the wall. It was a one-shot gesture of Mackley's, but representative of the going idea of art as a sample of a continuous environment. The most important environmental show was 'Place', 1959, in which Denny, Ralph Rumney, and Smith collaborated to make a unified space of paintings in two sizes, standing like screens on the floor. It was a maze of man-size paintings, with the

6 RICHARD SMITH *Quartet* 1964. Acrylic on canvas, 56 × 72 × 20 ¹/₂

three artists' work arranged systematically. Rumney wrote in 1958: 'Bausch
and Lomb have changed the painter's head. The two most significant fac-
tors in the present evolution of the human image are CinemaScope lenses
and applied science fiction (as opposed to applied science).... CinemaScope
has made of the human image a form in the sea of bright colour' and 'close-
ups of faces six feet high on screens forty feet wide; this is the stuff of which

heads are made.'[34] In the catalogue of 'Place', Coleman pointed out: 'Important is the idea of participation in this environment, for example, the movies – CinemaScope, Cinerama (note Rumney's CinemaScope heads). The identification with the environment of the mass media is a significant decision for these painters.'[35] Rumney's works were hard and two-tone in colour, influenced by Ellsworth Kelly, but forming silhouettes of heads, elongated like the 'Scope screen or rounded at the edges like TV.

Another example of implicit environmental reference occurs in the elaborate bilateral symmetries, usually with two rings each side of centre, of Bernard Cohen (1960–61). Some were named after hotels, many were reminiscent of between-the-wars jazz-moderne movie palaces. These references to architecture reveal a nostalgia and admiration for that part of the recent past which has not yet been reduced to history. Although the style references are not immediately apparent, they become so when placed next to pure abstract art: the blunt curves, the rounded ends, and the semi-anthropomorphic eye-rings are very quirky when compared, say, to Denny's equally symmetrical designs composed of unspecific forms. Cohen views styles as possessable at will, as his subsequent adoption (1962) of Art Nouveau linearism shows; his original proposal of abstract form as survivals of yesterday's ornament has been developed since 1962 by Patrick Caulfield (Ill. 51). It is important to separate this use of hard and awkward period forms, in a kind of balancing act with one's own art, from other revivals. There is no nostalgia about this, of the kind that John Betjeman, like Blake, evokes as frivolous souvenirs of amusing times.

In 1960 Pop Art appeared unexpectedly from Cambridge (the University, not the town). The New Vision Gallery housed a group of four artists – George Corral, James Mellor, Tim Wallis, and Raymond Wilson – stage-managed by Robert Freeman.[36] Accepting the fact that abstract art is an ambiguous container for Pop culture, the gallery showed not only the work of the artists but also a mass of pin-up material.[37] Thus, news of the ambiance that the artists liked came along with the paintings, to steer the spectator. One of the artists used top-twenty tune titles; another painted polished silver panels (out of Yves Klein and/or Peter Blake). Knowledge of the ambiguity of interpretation of any stimuli has reduced the confidence artists were once able to have in a one-to-one communication with their audience. The artist today knows that he cannot count on an accurate reading of his

art; abstract and figurative imagery are equally subject to the psychology of rumour and to variable responses. The problem (raised in a provocative form by Mathieu, who is one of the few artists other artists always attack) is how to influence the spectator towards the kind of meaning that the artist wishes – although no artist can control the interpretation of his work. The Cambridge Group did not get Pop references into their art, but they put it into a setting of throwaway and technical material. The meaning is the result of contextualizing the paintings, a development of Green's 'Errol Flynn' show, and of the new validity conferred on expendable material by the IG.

The third phase of Pop Art, which emerged decisively at the 'Young Contemporaries' exhibition of 1961, consisted mainly of a new group of artists from the Royal College of Art. Where the first group had been born in 1930–32 and graduated around 1957, the new group was born in 1937–39. I was one of the jurors in 1961 and contributed a note to the catalogue suggesting three main tendencies, one of which was the following: 'A group, seen here for the first time, is of artists (mainly at the Royal College) who connect their art with the city. They do so, not by painting factory chimneys or queues [a reference to an earlier College group, called by David Sylvester the Kitchen Sink School], but by using typical products and objects, including the techniques of graffiti and the imagery of mass communications. For these artists the creative act is nourished on the urban environment they have always lived in. The impact of popular art is present, but checked by puzzles and paradoxes about the play of signs at different levels of signification in their work, which combines real objects, same-size representation, sketchy notation, and writing.'[38] I did not use the term Pop Art to refer to the artists; on the contrary, I went out of my way not to sloganize the new work. The artists were Barrie Bates (now Billy Apple) (*Ill. 52*), Derek Boshier, Patrick Caulfield, David Hockney, Allen Jones, R. B. Kitaj, Peter Phillips, and Norman Toynton (Phillips was president and Jones secretary of that year's 'Young Contemporaries').

To see this new work more clearly it is necessary to consider two artists at the Royal College. Peter Blake, who graduated in 1956, was a close friend of the second-phase abstract Pop artists, though his own work (*Ills. 30–32*) was based either on a detailed draughtsmanship or on the collection of photographs, postcards, buttons, and toys which he freely combined on

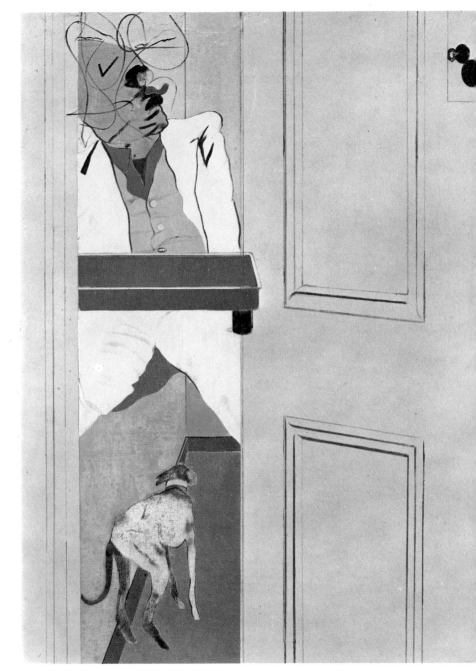

37 R. B. KITAJ *An Urban Old Man* 1964. Oil on canvas, 50×40

38 PETER PHILLIPS *Custom Painting No. 3* 1964–65. Oil on canvas, 84 ×

doors, in a cupboard, on a table. His art, crowded with references and quotations, may have predisposed younger artists to a renewed figurative Pop Art. Another influence, the crucial one, is R. B. Kitaj, an American, who was at the College under the G.I. bill; since 1950 he had studied at the Cooper Union, New York, the Academy of Fine Arts, Vienna, and the Ruskin School of Drawing, Oxford; he had also served in the Merchant Marine and the US Army. Allen Jones has recorded: 'I learned more, I think, about an attitude to painting merely from watching him. I didn't speak to him very much, but suddenly I thought this was something vital in comparison to everything else at the College. In other words, the influence wasn't one of imagery but of a dedicated professionalism and real toughness about painting.' [39] Aside from his presence at the College, however, Kitaj exerted a strong influence through his paintings, which from 1957 explored problems of representation even as they stood as completed paintings. (It is only since 1962, however, that Kitaj has produced paintings that satisfy him, he has said.)

39 R. B. KITAJ *Untitled* 1963.
Pencil and collage, 12 × 10

40 R. B. KITAJ *The Murder of Rosa Luxemburg* 1960. Oil on canvas with collage, 60 × 60

Kitaj's preference as a painter is for art that is not bound completely to the marks on the canvas. The world outside the canvas, and the routes and chances of connectivity with the painting, is his preoccupation. Iconography and the transformations that occur in successive transmissions of images provide him with a content that is as manipulable as colour. He developed a pictorial code of diagrammatic statements and elliptical condensations of events, set down as a scatter of discrete, ideographic centres, rather than as one smooth discourse (*Ill. 39*). His paintings include references to ancient cosmogonies, American Indian drawings, Canova, the figure of the Maenad. Kitaj has a deep sense of the endless permutations of word and image, of source and modification. For example: 'Some books have pictures and some

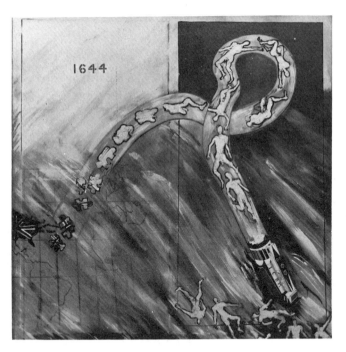

41 DEREK BOSHIER
Re-think, Re-entry 1962.
Oil on canvas, 72 × 72

pictures have books.' He suggested that the artist, by continuing 'to asso-
ciate peripheral material with a work after the work has left him ... may be
said to still be working on the painting ... [which] would help to leave the
question of "finishing" a painting open'.[40] A case of this is the title added
to a 1958 life drawing: *Already, in the Third Decade of the 19th Century.*
Kitaj's influence was not in the direction of the continuities and echoes of
visual traditions, but functioned mainly to encourage visual jumps in pres-
entation techniques. Pop Art elements in his art, when they occur, are
simply a bit of the treasury of forms and communication available to human
beings; he deplores their isolation, at the expense of other areas of meaning.
The smeared head of *The Murder of Rosa Luxemburg* (1960) (*Ill. 40*) recurs
in *Urban Old Man* (*Ill. 37*) of 1964 and appears as an image of eruptive vio-
lence in Phillips' and Jones' earlier work.

Third-phase Pop Art is the second wave of figurative Pop Art and the
new artists revelled in a post-Kitaj medley of techniques. Phillips used sym-
bols of the pinball machine, the leather-jacket set, and playing-card eroti-
cism in a hard, urban mood. Derek Boshier mingled images of cereal packets,
weather maps, and transfers to make flighty images of the space race (*Ill. 41*).

42 DAVID HOCKNEY *Alka Seltzer (The Most Beautiful Boy in the World)* 19
Oil on canvas, 72 ×

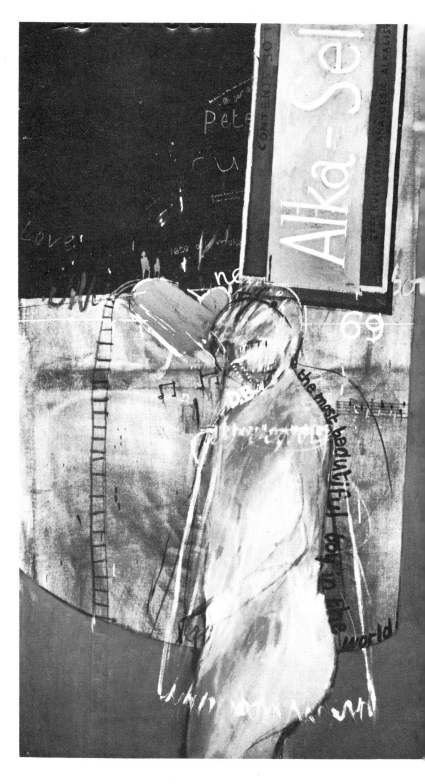

David Hockney overlaid children's art, primitive painting, and graffiti (*Ill. 42*). Paolozzi observed, some years earlier: 'The evolution of the cinema monster from Melies onwards is necessary study for the fabricator of idols or gods containing elements which press in the direction of the victims' nerve sense.'[41] The study of Pop culture, growing out of Paolozzi's spontaneous enjoyment of it, is to aid in the fabrication of 'idols or gods'. Thus, a traditional role of the sculptor, the forging of divine or heroic figures, is not abandoned; rather the base of references has been widened. Kitaj, like Paolozzi, has a comparable sense of popular culture (they collaborated on two works, 1960–62). Phillips, for example, has written: 'My awareness of machines, advertising, and mass communications is not probably in the same sense of an older generation that's been without these factors.... I've lived with them ever since I can remember and so it's natural to use them without thinking.'[42] It is not simply exposure to the media that separates Phillips from, say, Paolozzi, but his readiness to accept the material objectively.

A problem at the start of the third phase was that of unifying different kinds of signs drawn from diverse sources. One reason for this is that the art of Hockney and Boshier was more graphic than painterly. In graphic art, loose series of imagery and flips in scale are unchecked except by a mobile standard of vividness and charm. The pressure of dense organization is

43 DAVID HOCKNEY
Two Trees 1964.
Acrylic on canvas,
$28^{1}/_{2} \times 30$

44 ANTHONY DONALDSON *It Won't Be Long* 1964. Oil on canvas, 66 × 66

higher in painting, and English artists do not have a firm tradition by which to measure their performance. In the United States, on the other hand, the formal level of abstract art often persists into Pop Art. There are continuities between abstract art's formality and image-bearing Pop Art. In 1963, Boshier adopted a more rigorous kind of painting, but to Hockney, fey elements of the romantic and the graphic have remained joined to Pop Art. He has written: 'I paint what I like, when I like, and where I like', and listed some of the occasions of his painting: 'landscapes of foreign lands (*Ill. 43*), beautiful people, love, propaganda, and major incidents (of my own life).'[43] Given such a programme, a rambling and discursive kind of art is likely to follow, and it has. Boshier, in turn, wrote of his later work: 'All the images I use

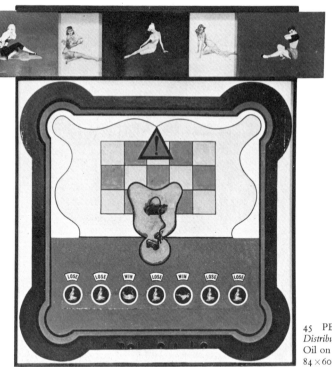

45 PETER PHILLIPS
Distributor 1962.
Oil on canvas,
84 × 60

in this new work are very much to do with "presentation", the idea of projection – rather like the phrase "20th-Century Fox presents" in the movies.'[44] Thus, though the figurative elements have disappeared, he maintains a contact with the mass-produced environment – 'I liked Dick Smith's ideas of the largeness of things around us'[45] – and his paintings echo Smith's ambiguous thresholds, except that Boshier's work is harder and sharper in touch. This characteristic of Boshier's painting is found in other British Pop Art, such as the work of Anthony Donaldson (*Ill. 44*). Visual patterns and legible imagery are contrasted so that his erotic images (stressing stockings and garters, like Allen Jones' images) emerge. What has happened is that the style of hard-edge abstract art has become connected with environment-conducive (Boshier) or image-making (Donaldson) painting. Donaldson's sources and references are the customary Pop Art ones: 'Recognition, both inside the painting under its own terms and outside through associative references, is important to me. I find cinema performances and the cinematographic image a help.'[46] (Typical of the later ramifications of British Pop Art

are such artists as Gerald Laing [*Ill. 49*], Joe Tilson [*Ill. 50*], Jon Thompson [*Ill. 33*].)

In 1961 Phillips (*Ills. 38, 45–46*) began painting in his characteristic style – elaborately compartmented structures, half-way between a games board and a Sienese altarpiece in its combination of regular subdivisions and copious secretions of small forms. Two of these works, at least, contained references to Batman comics; for example, 'just the thing for taxide mists and batmen', in a speech balloon. He developed gradually towards a less tight handling: the turning point was *Motorpsycho Tiger*, 1961–62, in which freer and larger, though as ever solidly painted, forms emerged. The references to motorcycles, girls, and lettering on pinball machines, are faithfully if only partially, transcribed. The signs confront one another grittily in a context of hard visual probity. He is, with Caulfield, the toughest of the younger Pop artists.

46 PETER PHILLIPS *For Men Only, MM and BB Starring* 1961. Oil and collage on canvas, 108 × 60
47 ALLEN JONES *Hermaphrodite* 1963. Oil on canvas, 72 × 24. Kitaj's influence is plain here, although Jones' style is more painterly and his iconography less *recherché*

48 ALLEN JONES *Green Dress* 1964. Oil on canvas, $49^{7}/_{8} \times 38$

Allen Jones developed recurring themes in painterly elaboration during the 1950's. In 1962 he made a series of paintings of buses, on rectangles staggered at the sides to imply movement as well as the identification of the object with the canvas. Since 1963 (but indicated as a thematic possibility in *The General and his Girl*, 1961) he has painted couples who merge, either hermaphroditically or otherwise (*Ill. 47*). Erotic imagery first appeared in two bikini close-ups (one up, one down, one front, one back) in 1962, though mainly in a decorative sense. Subsequently he has emphasized eroticism more, in thigh and groin paintings (the first in 1964), and in prolonged, unzipped stretches of girl (*Ills. 20, 48*). He has used, too, shaped canvases, which in earlier cases are structurally analogous to the depicted form, but which in later uses mask as well as substantiate the image. Jones has referred to a recurring form in his work, 'a head with a tie under it', as a 'phallic totem image' and thus not part of 'a popular iconography'.[47] He has also recorded 'a relative lack of interest in the images I use'. However, I should say that 'phallic totem' imagery is nothing if not Pop Art (in the original sense) at this late date and that he cannot really talk his bright, sexy paintings out of their historical context.

49 GERALD LAING *Lotus I* 1963. Oil on canvas, 45 × 56

It can be said that Pop Art in England developed as an aesthetic proposal made in opposition to established opinion.[48] As the idea spread, however, its absorption by various painters led to a series of adaptations. It was qualified by its use in relation to painterly abstract art. It has been treated as a renewal of figurative art, Campy in the case of Hockney, sophisticated in the case of Jones. In reply to the question 'So Pop Art is seen as a vitalizing of figuration in England?' Jones replied 'Yes'.[49] Compare Larry Rivers and David Hockney in a taped discussion: Rivers worked hard to keep the show going, dragging the ailing dialogue on; Hockney was strictly the passenger, happy in his nonchalant separation from ideas. It may be due to this tendency of the British to modify ideas, to assimilate prudently, to balance forces, to postpone full commitment, that English Pop Art does not possess the density and rigour of New York Pop Art. The English Pop artists were historically prompt, which is admirable; but some fear of being simple (as if it were not enough to do one hard thing well at a time) seems to have blocked the full realization of the style, diverse and rich as the area is.

50 JOE TILSON
Painted Vox-Box 1963.
Painted wood relief,
60 × 48

51 PATRICK CAULFIELD
Still Life with Dagger 1963.
Oil on board, 48 × 48

52 BILLY APPLE
2 Minutes, 3.3 Seconds 1962.
Painted bronze, *c.* 5 ½ high.
The artist took his name from
his subject matter,
although he has since
turned from his apple obsession
to making neon rainbows

53 ANDY WARHOL *Dick Tracy* 1960. Casein on canvas, $70^{1}/_{8} \times 52^{1}/_{2}$

New York Pop

There are so many misconceptions about what is or is not Pop Art that for the purpose of the following discussion I should say that I admit to only five hard-core Pop artists in New York, and a few more on the West Coast and in England. They all employ more or less hard-edge, commercial techniques and colours to convey their unmistakably popular, representational images, but what they do stylistically with these characteristics is not necessarily similar. The New York five, in order of their commitment to these principles, are: Andy Warhol, Roy Lichtenstein, Tom Wesselmann, James Rosenquist, and Claes Oldenburg. After five years of public exposure, the issues that arose in 1961 have been somewhat clarified. If Pop Art is not a movement, with manifestoes and group demonstrations, it is at least a relatively cohesive tendency. It has broadened since its emergence, causing observers to write it off prematurely. The artists who originated the idiom are still the leading practitioners; the influence has spread, and Pop boasts not only a valid second wave, but also a generally imitative and incompetent third wave, not to mention the varied related European manifestations discussed in a later chapter. The major trend is, inevitably, toward the abstract, and as Pop Art begins to mingle again with styles that helped produce it in the first place, we are already able to look back with some objectivity at its beginnings. Such 'instant art history' [1] is especially fitting for an art so determinedly of the present.

The real point of departure for Pop Art in New York was the work of ✓ Jasper Johns. His sense of pictorial irony is related to that of Duchamp, but like the majority of the best American painters, Johns is a painter first and an ideologist second. 'My idea has always been that in painting the way ideas are conveyed is through the way it looks and I see no way to avoid that, and I don't think Duchamp can either', he said in 1964. [2] Closely associated with Rauschenberg – who lived in the same building as he in the mid-1950's – Johns departed from his colleague's fusion of real, three-dimensional object and abstraction by depersonalizing his own action-painting techniques. A

54 STEPHEN DURKEE
Small Canticle 1962.
Oil on canvas, 60 $^1/_2$ × 49 $^1/_2$

regular, almost patterned (though still delicate) brushstroke was used to veil the single flag (*Ill. 15*), target, or numbers depicted. Through the 'crisis of identity' raised by a two-dimensional painting portraying a two-dimensional object, Johns encompassed three major streams of abstract art: the Abstract Expressionist surface, the simplified composition of non-relational or emblematic art, and the post-Surrealist Assemblage. Duchamp had made the ready-made object into art; now Johns went further and made the object into a painting, challenging the mainline collage tradition in which the actual common object or picture was added to the surface, fragmented, disguised, or otherwise subjugated to a foreign aesthetic. He invaded the previously inviolate area of 'pure painting'. Whereas assemblages of all kinds, in their imperfect synthesis of motif and treatment, *had* acted 'in the gap' between life and art, Johns neutralized that gap. Once it was realized that the question 'Is it a flag or is it a painting?' had no answer – was not important – the way was wide open to Pop Art.

56 *(right)* GEORGE BRECHT
Repository 1961.
Movable objects in constructed cabinet,
$40^3/_8 \times 10 \times 3$. The contents are: pocket
watch, tennis ball, thermometer, plastic
and rubber balls, baseball, plastic per-
simmon, 'Liberty' statuette, wood
puzzle, toothbrushes, bottle caps, house
number, pencils, preserved worm,
pocket mirror, light bulbs, keys, hard-
ware, coins, photographs, playing cards,
postcard, dollar bill and a page from a
thesaurus

55 ROBERT INDIANA *Cuba* 1961.
Painted wood and metal,
$44^3/_8 \times 5^5/_8 \times 14^5/_8$

Between Johns' initial employment of single two-dimensional popular motifs and the emergence of hard-core Pop Art, came Assemblage, a secondary phenomenon which has served to blur the distinctions between a wide-ranging group of divergent manifestations. Still confused with Pop Art, Assemblage is a broad term for three-dimensional collage or collage sculpture, using objects instead of pasted papers. It took its name and its cohesiveness from William C. Seitz's 'Art of Assemblage' exhibition at the Museum of Modern Art in the fall of 1961. A comprehensive and historical round-up of the many aspects of 'junk culture', the broad collage concept, and aspects of post-Abstract Expressionism, it was received as the beginning of a trend when in fact it was the end. By presenting an exhaustive survey of the additive tradition, the exhibition virtually killed Assemblage and prepared the way for a new art. Most of the work in the show could have been validly called 'Neo-Surrealist'. Contributors included Americans such as Bruce Conner, Edward Kienholz, George Cohen, and Robert Moskowitz, whose work at that time had indirect connections with Nouveau Réalisme; the Englishman John Latham; the Italians Baj and Rotella; and Pierre Restany's New Realists themselves: Hains, Arman, de la Villeglé, Raysse, Spoerri, Saint-Phalle, Christo, and Tinguely. Durkee (*Ill. 54*), Marisol, Watts, and Samaras – all of whom have been vaguely connected with Pop – were represented by non-Pop items.

What Seitz called our 'collage environment' – dizzying signs, lights, advertisements, commercials, automobile graveyards, slum detritus, and 'new antiques' – had fascinated artists and poets since Apollinaire's day. It emerged as a major instead of a minor trend during the 1950's. In New York, Willem de Kooning superimposed a collage mouth from a magazine (the T-zone of a Camel cigarette ad) on one of his oil *Women* studies in 1950. In Chicago, H. C. Westermann was among the first to eschew nostalgia and make such popular objects look new (*Ill. 19*); Oldenburg, who lived there at the time, has acknowledged the influence of Westermann's laminated wooden structures containing bottle tops and Times Square trivia, as well as of George Cohen's and June Leaf's interest in popular culture.[3] As far back as 1948, William Copley (Cply) had painted flat American flags that filled the canvas (*Ill. 12*). Since then he has made witty and erotic use of cartoon balloons and narrative techniques. In 1958 Johns had painted over the comic strip 'Alley Oop', and on the West Coast others were heading the same way.

57 CLAES OLDENBURG *Mug* 1960. Cardboard, 72 in. high

58 JEAN DUBUFFET *Moss Gatherer (Ramasse mousse)* 1960. Mountain stone, 6 ¹/₄ in. high.
This is a found sculpture, paralleling Duchamp's ready-mades and the Surrealist *objet trouvé*, but
visually inseparable from Dubuffet's own *art brut*

Integral to this increasing emphasis on the non-picturesque and non-
associative aspects of commercial raw materials was a growing disdain for
sentiment, and even for sensitivity, which, with anecdotalism, was a plat-
form for the so-called humanist schools – from the social realism of the
1930's to the current Bacon-derived figuration. Jim Dine announced that
he had stopped dealing with found objects because 'there was too much of
other people's mystery in them'.[4] In part this attitude arose from the rest-
lessness of a younger generation forced to follow in the giant footsteps of

Pollock, Kline, and de Kooning. When Pop first arrived, it was pointed out that the reigning New York School had also felt strongly about Pop subject matter. Elaine de Kooning said of Kline in 1962: 'The American style as he saw it – with a fan's zest and expertise – had an element of the comic; the big brash breezy gesture that, carried to its extreme, becomes a not-unconscious parody of itself, as in the design of a Cadillac or the cut of a zoot-suit... the forceful sentimentality of Tin Pan Alley songs.' [5]

Pop was indeed a fulfilment of such attitudes, couched in the unexpected vocabulary of a new generation. After the first burst of anti-Abstract Expressionist diatribes early in 1962 (often exaggerated or oversimplified statements put into the Pop artists' mouths by earnest critics), it became evident that this withdrawal from the principles of Abstract Expressionism was largely based on admiration and respect for that movement: it had been done too well to continue. None the less, abstraction was the mode of the times and it was up to the artists to discover new angles from which to approach it. While the older painters were generally repelled by the rise of Pop, the 'cool' strain of Abstract Expressionism – Rothko, Still, and especially Barnett Newman – had become the main force in the new abstraction; aspects of this style seemed equally applicable to the depiction of anonymous objects with no history and no evocative impedimenta.

Included in the 'Assemblage' exhibition were Lucas Samaras and George Brecht from the downtown Reuben Gallery, which also represented Oldenburg, Red Grooms, Jim Dine, Rosalyn Drexler, and Robert Whitman. The cradle of Pop and avant-garde art on the Lower East Side, the Reuben specialized in an impermanent, perishable gutter art that went beyond Surrealism in its involvement with urban industrial subject matter for its own sake. Some of the first Happenings (environmental syntheses of theatre and the visual arts) were performed there, and the group was closely associated with the prolific father of that medium – Allan Kaprow – and with other artists then teaching at Rutgers University: Watts, Segal, and Lichtenstein. Many of them had been active in the 1952–59 Hansa co-operative gallery which, through Richard Bellamy's later Green Gallery, also had ties to Pop Art's origins. The Reuben inherited much of its ambiance, as well as its members, from the Hansa, and its artists formed the heart of two uptown exhibitions held at the Martha Jackson Gallery: 'New Forms, New Media' (1960) and 'Environments, Situations, Spaces' (1961). Lichtenstein has said that he was

more influenced by Kaprow and this trend than by Johns and Rauschenberg.[6] In 1959, Oldenburg's *The Street*, together with Dine's *The House* – both environments – were presented at the Judson Gallery, another early headquarters. In the spring of 1961, Robert Indiana, Stephen Durkee, and Richard Smith held an obscure exhibition of 'premiums' at the Studio for Dance. It was reviewed only by G. R. Swenson, who noted that they 'took the world too seriously not to be amused by it'.[7] Included were Indiana's wooden constructions from raw beams with stenciled letters and 'American' insignia (*Ill. 55*), inspired by a circular stencil found in his former sail loft on Coenties Slip. Durkee, whose connection with Pop was tenuous and brief, employed some commercial motifs, including a hand painted by a professional sign painter – an act of disavowal also made by Duchamp in his famous *Tu m'* of 1918. Smith, an Englishman living in New York, worked in a fundamentally abstract style based on enlarged images of objects – a watch or a cigarette packet (*Ills. 34–36*). His work owed its glamorous colour and shimmering surface to chic photographic magazine advertising, its scale and approach to Newman and Rothko.[8] While these three artists were ultimately non-objective painters, they were among the strongest exponents of the pre-Pop message. Others using popular objects in their work at that time were George Brecht, who filled his boxes and medicine chests with plastic toys and miscellany (*Ill. 56*), and Ray Johnson, who sends and receives his collage materials through the mail, thereby using the US postal service as his medium for communicating a conglomeration of ideas – some of them related to Pop. Dan Flavin mounted crushed tin cans on painterly grounds; Yayoi Kusama anticipated Warhol's repeated rows of soup cans, money, green stamps, and photographs with her own repeated rows of mailing stickers used non-objectively (*Ill. 59*); Robert Watts (*Ills. 114, 156*) and Robert Morris employed objects in a complex, conceptual manner more closely related to Duchamp. By 1959 Andy Warhol was concentrating on single comic-book characters in a drippy New York School technique (*Ill. 53*), Lichtenstein was working from animated cartoon strips, Rosenquist had made his single transitional painting between a greyed Abstract Expressionist mode and the billboard style, Oldenburg had made the phallic Ray Guns commemorating his Ray Gun ('sounds like New York backwards') Manufacturing Company, and Wesselmann, who had shared a show at Judson with Dine in 1958, was making his 'portrait collages'.

59 YAYOI KUSAMA *Air Mail Stickers* 1962. Collage on canvas, 71 $^1/_2$ × 67 $^1/_2$

With these and other events in the air, by the time of the 'Assemblage' exhibition the perceptive observer began to notice a gradual shift from the rusty, peeling, aged, and mellowed surface to a cleaner cut, simpler, more blaring, ordered, and 'cool' expression within the Assemblage trend. It also appeared in non-objective art with exhibitions of Ellsworth Kelly, Frank Stella, and Kenneth Noland, among others. In 1958–59 Jasper Johns had made a flashlight (*Ill. 157*), light bulb, 'teeth' brush, and mouthed spectacles (*Ill. 17*) of sculpmetal; and flags, a light bulb, and painted Savarin can with brushes in it of bronze; in 1960 he made two hand-painted bronze Ballantine ale cans (*Ill. 61*), in reply to de Kooning's crack that Leo Castelli could sell anything – even two beer cans. By 1961 these cans looked like the harbingers of a full-fledged trend. But by the beginning of 1962, they looked like antiques in comparison with the newly emerged Pop Art. For the ale cans were

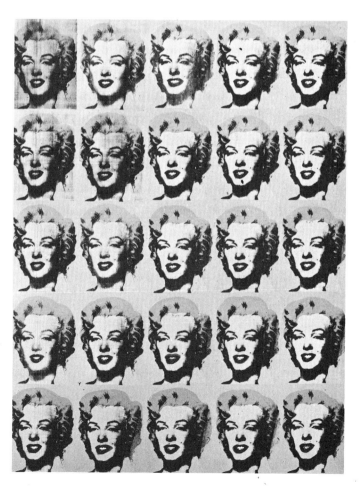

60 ANDY WARHOL
Marilyn Monroe 1962.
Oil on canvas,
81 × 66 ³/₄

clearly hand-painted, and in no way did they attempt to reproduce exactly the commercial labels, or even the exact size and shape of the actual cans; still more significant, they were on a bronze base – set apart as art. The ale cans share the technical ambiguity of Johns' early flags (*Ill. 15*) – the conflict of quasi-expressionist technique and commercial motif. Larry Rivers' paintings of Camel cigarette packages, money, and early and present-day Americana share this double existence – products masked by painterly treatment (*Ill. 153*). Rivers had been among the first to use 'vulgar' subjects in a larger context, but he has developed the theme little since 1960, and denies any 'super visual strength and mystery in the products of Mass Culture. ...I have a bad arm and am not interested in the art of holding up mirrors'.[9]

The next step was to bring these cans or similar objects still closer to reality by further eradicating the 'artistic' remnants. Johns himself did not go this far. One of the many reasons Johns is not and never was a Pop artist is that his subjects are not brand new. Their painterly surface rids them of the newly minted mass-produced aura typical of Pop. The patina of Johns' objects is neither sentimental nor picturesquely evocative, like that of some arsenic-and-old-lace Assemblagists, but it does connote use. Use in turn connotes the past, and the past, even the immediate past, evokes memories. Pop objects determinedly forgo the uniqueness acquired by time. They are not yet worn or left over. Every Campbell's soup can looks like every other Campbell's soup can since it has had no time to acquire character; every TV commercial on one channel at a given moment is the same, whether it is seen in Saugatuck or in Sioux City. The broad and instant appeal of Pop Art in America may indeed have been because the exposure to popular images is an experience shared by all Americans – young and old, urban and rural, from all backgrounds and all regions. The man in the White House is a Pop Art President – big, sentimental, plainspoken, and tough; 'See America First' is one of his dicta. For the sophisticated, even the new has a nostalgic attraction, recalling those palmy days when bicycles, baseball games, drive-ins, hot dogs, ice-cream sodas, and comics were the low-brow facts of life, uncomplicated by intellectual responsibility.

The works of Oldenburg, Wesselmann, Indiana, Smith, and Dine had been shown often, and group exhibitions had yielded glimpses of others moving in a similar direction. Around the spring of 1961, Richard Bellamy of the Green Gallery, and Ivan Karp and Leo Castelli of the Castelli Gallery

61 JASPER JOHNS *Painted Bronze* 1960. $4\,^3/_4 \times 5\,^1/_2 \times 8$

(which already represented Rauschenberg and Johns) saw the works of Rosenquist, Lichtenstein, and Warhol, and, recognizing their importance, they also understood that these artists provided the missing link between Assemblage and hard-edge abstraction, and had independently arrived at something new. As well acquainted as anyone with what was going on in studios and galleries in New York, Bellamy, Karp, and Castelli were able to tie in their discoveries with other isolated instances. Robert Scull bought a Rosenquist and became the first collector to concentrate on Pop Art; he was soon followed by the Burton Tremaines, Philip Johnson, Harry Abrams, and others. By the beginning of 1962, Lichtenstein, Dine, and Rosenquist had had one-man shows, and the new art was in the open. It was called Neo-Dada, Commonism, OK Art, Common Image Art, Pop Culture, and various other labels – few complimentary. Finally the British term – Pop

62 Clipping from resort section of the Sunday *New York Times* 1963

63 *(opposite)* ROY LICHTENSTEIN
Girl with Ball 1961.
Oil on canvas, $60\,{}^1/_2 \times 36\,{}^1/_2$

Art – triumphed, although it had been coined by Lawrence Alloway with reference to the sources of Pop Art (the comics, billboards, cowboy movies, etc.) rather than to their fine-art progeny.

It is rare that collectors and general public, *Life* and the *Ladies Home Journal* accept a new art before many critics and museums. Pop Art has given rise to a cult of liking that obscures the contribution it has made. Because it is easy to look at and often amusing, recognizable and therefore relaxing, Pop has been enjoyed and applauded on an extremely superficial level. This does not do justice to the five major artists discussed here, who are constantly reminding the public that they are not just Pop artists, but artists. 'Some of the worst things about Pop Art have come from its admirers', Tom Wesselmann complained in 1963. 'They begin to sound like some nostalgia cult – they really worship Marilyn Monroe or Coca-Cola. The importance people attach to things an artist uses is irrelevant.... I use a billboard picture because it is a real, special representation of something, not because it is from a billboard. Advertising images excite me mainly because of what I can make from them.' And James Rosenquist has insisted that for him 'the subject matter isn't popular images, it isn't that at all'.[10]

80

Pop chose to depict everything previously considered unworthy of notice, let alone of art: every level of advertising, magazine and newspaper illustration, Times Square jokes, tasteless bric-à-brac and gaudy furnishings, ordinary clothes and foods, film stars, pin-ups, cartoons. Nothing was sacred, and the cheaper and more despicable the better. Nor were the time-honoured methods of creating art respected. Lichtenstein and Warhol did not even 'invent' their images, and it was generally agreed that they did nothing about them once they had selected them. The former used a projector to enlarge his sources, filled in the Ben Day dots with a screen, and had his baked-enamel paintings produced in multiple editions. Warhol hand-painted his 'products' at first but then began to silk-screen them by commercial techniques, hiring others to duplicate and even to execute his work; it too has appeared in editions. Wesselmann has a carpenter to complete his constructions, and Oldenburg's wife still does all the sewing, though now she has helpers. Rosenquist's industrial painting techniques, unpleasantly soft surfaces, and sweet white-based colours further enraged the *cognoscenti*. He was known as 'the billboard painter', and at first it was inferred (by *Time*) that he was not an artist at all, but an outdoor advertiser who had fallen on to a good thing. Roy Lichtenstein was called the 'comic-strip man' and *Life* billed him as 'the worst artist in the US'. Andy Warhol was 'the Campbell's soup guy' and titillated the experts by nonchalantly signing ordinary soup cans and selling them as souvenirs.

This was all a bitter pink pill for many people to swallow. They assumed that the intention in subjecting the viewer to such indignities could only be satirical. What else could it be? Surely there was no other reason to paint such vulgar images, from which all sensitive souls recoiled in horror. Critics and curators who endorsed Pop Art as an aggressively optimistic and original style were accused of jumping on the commercial bandwagon and trying to make their suspect allegiance respectable.

There is still a great hue and cry about the public being 'put on' by a diabolic artist-dealer-critic-collector cartel. At the same time, critics with reservations about the Pop contribution were accused by its protagonists of being reactionaries. Observers mistook the hard-sell techniques of the paintings' prototypes as representative of the artists' goals, and Pop was a sitting duck for much philistine and some genuinely witty adverse comment.

In the course of 1962, New York Pop really arrived. By autumn, Wes-

64 TOM WESSELMANN *Great American Nude No. 10* 1961.
Oil on canvas with collage, 47$^{1}/_{2}$ in. diameter

selmann, Oldenburg, Segal, Marisol, and Warhol had had uptown exhibitions. Max Kozloff's mordant commentary on 'the new vulgarians' appeared in *Art International* in February; G.R. Swenson, one of Pop's earliest enthusiasts, wrote the first sympathetic article on 'the new sign painters', published in *Art News* in September. *Time*, *Newsweek*, and *Life* covered the new

scandal in the spring of 1962 and have continued to give it space ever since. In the autumn, Pop was consecrated as fashionable by the Sidney Janis Gallery's 'New Realists' exhibition, an uneven, international conglomeration to which critical response was far from mild, and journalistic response delirious.[11] Here the hard-core American Pop artists stood out from the Neo-Surrealist Europeans (from whom the exhibition title was borrowed), and it became clear that anything innovatory was provided by American – specifically New York – artists, with the British close behind. The 'Neo-Dada' label was applicable to much in this show but it was unfortunately imposed on Pop Art as well, since the assumption was that Pop's goal was satire.

It is still not widely understood that what seems to be satire and is often dismissed as complacent acceptance is in fact a new way of dealing with life and art. From the nineteenth-century realists to the Ash Can School, humble subjects were depicted; their humbleness was means to an anecdotal end. For each of the individual Pop artists the goal is different, yet for all of them

65 JAMES ROSENQUIST *Pushbutton* 1960–61. Oil on canvas, 83 × 105 ¹/₂

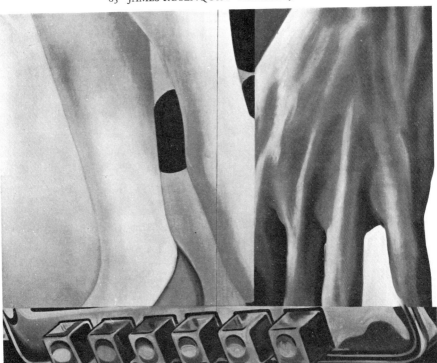

66 JAMES ROSENQUIST *In the Red* 1963. Oil on canvas, 72 × 84

it is divorced from story-telling or social comment. Some seek a high level of fantasy, some abstraction, some a strictly conceptual triumph. 'For me,' says Oldenburg, 'I have a very high idea of art. I'm still a romantic about that, but this process of humbling it is just to test it, to reduce everything to the same level and *then* see what you get.' These artists do not see themselves as destroyers of Art, but as the donors of a much-needed transfusion to counteract the effects of a rarified Abstract Expressionist atmosphere. 'Art since Cézanne has become extremely romantic and unrealistic, feeding on art; it is utopian,' said Lichtenstein. 'It has had less and less to do with the world; it looks inward.... Outside is the world. Pop Art looks out into the

85

world; it appears to accept its environment, which is not good or bad, but different, another state of mind.' Indiana says of his Eat signs: 'The word "eat" is reassuring, it means not only food, but life. When a mother feeds her children, the process makes her indulgent, a giver of life, of love, of kindness.'[12] Thus despite the toughness of their approach, several of these artists consent to the metaphor that lurks behind even the most unyielding motifs. In a symposium at the Museum of Modern Art in 1962, Dore Ashton accused the Pop artists of banishing metaphor, but replied to her own complaint by adding that 'not an overcoat, not a Coca-Cola bottle, can resist the onslaught of the imagination. Metaphor is as natural to the imagination as saliva to the tongue'.[13]

Far from constituting laziness on the part of the artist who chooses such new-born objects to depict, an insistent emphasis on a single object, the present alone, takes both discipline and ingenuity. It is not easy to adhere to a stringent reduction of means without falling back into conventional beauties and emotions. As Roy Lichtenstein has said of his shift from animated cartoons to comic books 'with a more serious content, such as *Armed Forces at War* and *Teen Romance*, it was very difficult not to show everything I knew about a whole tradition. It was difficult not to be seduced by nuances of "good painting"'. To the charge of impersonalism levelled pejoratively at Pop Art, he replied: 'We think of the last generation as trying to reach their own subconscious while supposedly Pop artists are trying to get outside of the work. I want my work to look programmed or impersonal but I don't believe I'm being impersonal while I do it. Cézanne talked about losing himself. We tend to confuse the style of the finished work with the methods in which it was done. Every artist has disciplines of impersonality to enable him to become an artist in the first place.' Claes Oldenburg added that 'making impersonality the style characterizes Pop Art in a pure sense'.

The New York Pop artists are often asked whether or not they *like* their subjects. This, as Dorothy Seckler has noted, is as irrelevant as asking whether Cézanne liked apples, Géricault corpses, or Picasso guitars. Warhol alone benignly accepts everything; he has said that 'Pop Art is liking things'. Parody in Pop Art largely seems to depend upon the viewer's response, and is seldom the artist's intention; or if the satirical humour is intentional, it may be secondary to the point of the painting. If the viewer dislikes the subject matter, he will be repelled initially no matter how the artist has depicted it.

67 ROY LICHTENSTEIN *Big Painting* 1965. Oil and magna on canvas, 92 $^1/_2$ × 129
(Brushstrokes series)

The artist can only isolate the subject, present it in a hitherto unforeseen way
so that the viewer has a chance to 'see it through new eyes' – a principle to
which the Surrealists adhered by means of juxtaposition rather than pure
isolation. Many of the Pop artists are excited about the jazzy, blaring, glar-
ing, hectically 'fun' urban environment, about Times Square, Fourteenth
Street, Coney Island, and cowboy movies. Enjoyment, however, does not
mean wholesale endorsement any more than indifference means wholesale
condemnation. I suspect that, like Lichtenstein, most of us like aspects of his
subject matter. 'In parody,' he says, 'the implication is the perverse, and I
feel that in my own work I don't mean it to be that. Because I don't dislike
the work that I'm parodying.... The things that I have apparently parodied
I actually admire.'

Nevertheless, the Pop artists do not naïvely idealize their subjects. They
know what they are handling since they all have backgrounds in commer-

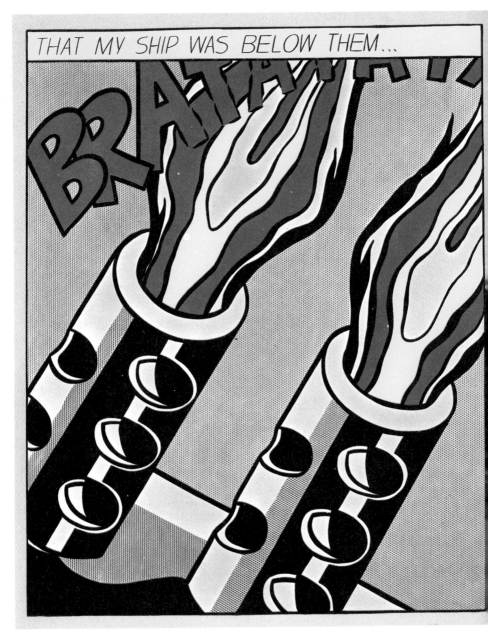

68 ROY LICHTENSTEIN *As I Opened Fire...* 1964. Magna on canvas, 68 × 56.
The third of three panels depicting an isolated narrative sequence

69 ROY LICHTENSTEIN *Woman with Flowered Hat* 1963. Oil on canvas, 50 × 40

cial art. Warhol was a successful fashion illustrator of shoes; Rosenquist learned billboard painting as a trade; Lichtenstein worked in design and display, Oldenburg in magazine illustration and design; and Wesselmann studied to be a cartoonist. Yet all of them were artists first and foremost, devoting their energies to serious painting. They are aware of the continuing ambiguous relationship between commercial and fine art, and that there are still areas they have not touched in their work. They have all steered away from the slick advertisement that imitates the modern fine arts. The comics used by Lichtenstein are not up-to-date, as cartoonists have noted[14], and are closer to the comics of the 1950's than to the less brash recent variety. Warhol (*Ill. 77*) does not utilize the tasteful advertisements of the sort that he himself once produced. The Brillo box, for instance, was designed by an Abstract Expressionist artist – James Harvey – but its effective design is directed at saleability rather than attractiveness. Wesselmann, like Warhol, is particularly fond of Del Monte labels because of their strong, simple, and slightly old-fashioned emblems. The 'clever' ads like Levy's Bread, the pretty ones like Modess, the chic ones like Smirnoff and Volkswagen, and the elegant ones from *Vogue* or *Harper's Bazaar* have not been used, because they have been created by men who can claim to be artists in their own right – Avedon, Stern, or Hiro. Such 'beautiful' and witty ads are usually based on exactly what Pop Art is getting away from: expert art-school design, striking but tasteful colour, asymmetrical composition, and Bauhaus to Abstract Expressionist iconography. It should be noted, incidentally, that some 'modern' advertisers are now returning to the stronger, old versions because of Pop.

Unlike Chardin, Courbet, and other realists who have been mentioned as prototypes, the Pop artists do not simply portray common objects or take stylistic leads from folk cultures, but operate at one remove from actuality. Life as represented in the comic strips or advertisements bears little resemblance to real life. Already separated from life by the cellophane barrier of commercialism, Pop Art can function with detachment and still retain a hold on the emotional or sensorial reactions of the viewer. As Lichtenstein has said, 'the closer my work is to the original, the more threatening and critical the content'.[15] At the same time, it is the narrow distance between the 'original' and the Lichtenstein that provokes the tension and the great drama of his best work. For some reason, the problem of 'transformation' has been

70 ANDY WARHOL *12.88* 1962. Oil on canvas, 72 × 60

raised more often in regard to Lichtenstein than to Warhol, perhaps because Warhol's work is so ultimate in its rejection of involvement that it must be accepted as a *fait accompli*, while Lichtenstein's is still 'art' and therefore all the more irritating. Derived from small images in the first place – comic strips and the badly drawn, low-brow advertising images – Lichtenstein's work suffers even more than that of the other artists in reproduction, not because scale is the only change he has made from the original, but because the abstract use of space and colour as well as the immediate effect are drastically diminished and often totally invisible in reduced black-and-white illustrations. People have found his work especially odious in reproduction who might have had a far more favourable reaction to the painting itself. But Lichtenstein's is also a difficult art in that his humour and use of the found image is unexpectedly subtle for its obstreperous vehicle: at times it is 'in' humour – based on references to friends or to other paintings. Examples are his four identical portraits of a grinning man, each of which bears a different title: *Portrait of Ivan Karp*, *Portrait of Allan Kaprow*, etc.; or the 1965 *Big Painting (Ill. 67)*, with the gestural swathes rendered in commercial harshness as a parody of action painting. And there are the notorious Lichtensteins in which impassive translations are made of well-known modern masterpieces – Cézanne's *Man With Folded Arms*, Picasso's *Woman With Flowered Hat (Ill. 69)*, a non-objective Mondrian. Even more extreme, and typically Pop, was a twice-removed painting – *after* a published diagram *after* a Cézanne canvas (*Ill. 73*), whereby Lichtenstein went further than Duchamp did in 'decorating' the *Mona Lisa* (and provoked two irate articles by the author of the diagram – Erle Loran).[16] In a 1961 comic painting, a uniformed officer 'thinks': 'I am supposed to report to a Mr Bellamy. I wonder what he's like'; a sinister helmeted face glares out from another canvas, saying: 'What? Why did you ask that? What do you know about my image duplicator?'; in another, a limpid blonde gushes to her painter boyfriend: 'Why Brad, darling, this painting is a masterpiece! My, soon you'll have all of New York clamouring for your work!' Most of the Pop artists have injected similar sight gags or amusing verbal comment at one time or another, but humour is never paramount in their work, as it is not in Lichtenstein's. It is only to be hoped that the majority of their public is able to enjoy these moments without being too weighed down by the terrible possibility that it may not be Art if it's funny.

71 ANDY WARHOL *Four Campbell's Soup Cans* 1965. Oil and silk-screen on canvas, ▶
36 × 24 each. Warhol's early soup cans, for which he was initially notorious, were the
'natural' red-and-white colours: the recent ones are 'fauve' in their arbitrary colouring

START

72 ANDY WARHOL
Fox Trot 1961.
Liquitex and silk-screen
on canvas, $72 \times 54^{1}/_{2}$.
This painting does not
hang but lies on the
floor

Many people have no doubt shared Leo Steinberg's experience when he was first confronted with the comic book paintings in January of 1962. 'In Lichtenstein's work', said Steinberg, 'the subject matter exists for me so intensely that I have been unable to get through to whatever painterly qualities there may be.'[17] Lichtenstein is excited by the 'highly emotional content, yet detached impersonal handling', of love, hate, or war in these cartoon images (*Ills. 68, 106*), but he finds their pictorial structures outweigh emotive considerations. To those who complain about lack of 'transformation', Lichtenstein has replied that art does not transform, 'it just plain forms. Artists have never worked with the model, just with the painting'. In a published comic-strip or book, the images have 'shapes but there has been

94

ROY LICHTENSTEIN
...rait of Mrs Cézanne 1962.
Magna on canvas,
68 × 56

no effort to make them intensely unified. The purpose is different; one intends to depict and I intend to unify'. Unification is in fact the key to his work. He omits distracting details, lines, figures, or words that destroy form in his sources, and presents that form, rearranged, in its ultimate clarity. He makes of a confusing narrative sequence a clear-cut well-knit design in which the 'story' is so blatant that it can be instantly appreciated for its humour, or horror, and as instantly dismissed. For the professional comic artists, stylization is a short-cut, not an abstracting device; where they interpret naturalism by shorthand only to make that naturalism more rapidly legible, Lichtenstein generalizes, reduces, and simplifies. It is not necessary to compare canvas and source to enjoy the painting, but when one does, the differences are explicit and enlightening (*Ills. 62, 63*).

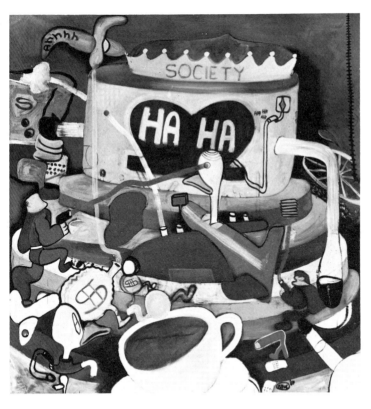

74 PETER SAUL
Society 1964.
Oil on canvas,
78 $^1/_2$ × 74 $^3/_4$

75 (*opposite*) ▶
ANDY WARHOL
Electric Chair 1965.
Silk-screen on
canvas, 24 × 28
(Death and Disaster
series)

Perhaps the closer the Pop artist is to real life (as opposed to the artificial life of the mass media), the more he verges on satire and humanism. Lichtenstein and Warhol keep their distance. But Oldenburg, who is 'for an art that takes its form from the lines of life, that twists and extends impossibly and accumulates and spits and drips and is sweet and stupid as life itself',[18] combines in his work an affection for and a certain cynicism about his subjects that can be considered the basis of strong parody. By making painterly objects rather than paintings, Oldenburg was able to carry this direction further, while Peter Saul – a frequently expatriate Chicago painter whose style is also expressionist-derived (Gorky) – retains a de Kooningesque technique and acrid colour despite his subject matter: cartoon balloons, toilet seats, daggers, guns, dollar signs, and ubiquitous phallic protuberances (*Ill. 74*). His intention is totally different from that of the hard-core Pop artists, though he was bracketed with them in the early days of the movement. For Saul really is a new humanist, as evidenced by his statements, and

a broad satirist, as evidenced by his work. He has cited those 'strong facts' found in magazines and newspapers – the horrors and sensations that have such appeal for everyone today. In this he parallels Warhol's Death and Disaster series, depicting the dogs of Birmingham; automobiles, plane, or train wrecks; the tunafish catastrophe; electric chairs (*Ill. 75*). Saul attempts to intensify the experience: 'These are not tender times. It seems very difficult to make anything happy convincing. But I am soft-hearted. I want to show that human beings are really okay.' [19]

Warhol, on the other hand, refuses to comment, and aligns himself with the spectator who looks on the horrors of modern life as he would look at a TV film, without involvement, without more than slight irritation at the interruption by a commercial, or more than slight emotion at tear-jerking or calamitous events. In this respect Warhol is far more true than Saul to the attitudes of our technological society. Not everyone is so apathetic that he will watch a rape or murder without acting to prevent it, but many are.

97

Most of us are unmoved by the public and private disasters that touched and enraged artists and thinkers in the 1930's. After World War II the tear glands of the world dried up from over-use. It is this world for which Warhol is spokesman; few can throw the first stone. Perhaps the reason the visual humanisms of the last decade have by and large failed so miserably with their horrified withdrawal, tormented expressionism, or mutilated-victim protest, is because their supposedly universal bases are not in fact shared by their audience. Since *everyone* understands the process of dehumanization blatantly and impersonally described by Warhol, his work is more likely to produce a positive attitude than the righteous indignation of those who are *against* anything in the present, and *for* nothing but a vague, outmoded nostalgia. As Warhol has pointed out, 'Those who talk about individuality most are the ones who most object to deviation, and in a few years it may be the other way around. Some day everybody will probably be thinking alike; that is what seems to be happening.' These ideas find parallels in those of the French painter Jean Dubuffet, who has said: 'My system rests on the identical character of all men.... If all painters signed their works with this one name: picture painted by Man, this question of differentiating, classifying, measuring men by various standards, would be meaningless.... What interests me is not cake, but bread,' and asserts his anti-cultural position by saying that his aim is to bring 'disparaged values into the limelight'.[20] Statements such as these provoked as much antagonism in the early 1950's as Warhol's do today, although the artistic results are poles apart.

While Warhol may be the most impersonal of the Pop artists, he too draws his subjects from his own experience – that second-hand experience which we all share. He has run the gamut of Pop subjects, with love and its commercialization and vulgarization a constant favourite. Warhol likes the idea that his life has dominated him. The Death and Disaster paintings, despite, or rather because of, their 'mechanical' execution, become one of the few forceful statements on this aspect of American life to be found in recent American painting. Just as we are fascinated by the newspaper or magazine photographs that are their sources, so we are doubly titillated by confronting these photographs in a less casual context – that of art – even if, as Warhol points out, 'when you see a gruesome picture over and over again, it doesn't really have any effect'. Rhetoric is no longer either neces-

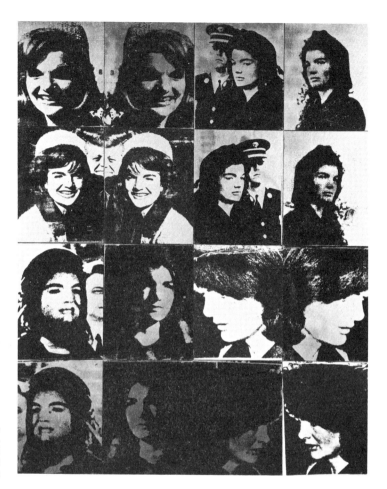

76 ANDY WARHOL
Jackie 1964.
Liquitex and
silk-screen on
canvas, 80 × 64

sary or significant; our senses are so overloaded with artificial emotion from politicians' speeches, bad movies, bad art, ladies' magazines, and TV soap operas that a *stark* repetition like Warhol's means more than an ultra-expressionist portrayal of accident victims ever could. Gesture is of prime importance in the new art. It is neither the physical gesture of the Expressionist nor the ironic gesture of Duchamp, but an unequivocal act that is both simple-minded and intellectually complex. Warhol's films and his art mean either nothing or a great deal. The choice is the viewer's, as it is with the plays of Becket and Albee, the films of Antonioni, and the novels of Butor, Sarraute, or Robbe-Grillet. The more that is left out, the more can

be seen of what is left. In Warhol's 'box show' at the Stable Gallery in 1964, which consisted of piles of wooden boxes simulating supermarket cartons with the brand insignias silk-screened on the sides (Brillo, Heinz, Del Monte, Campbell's), the idea was paramount, but the idea became concrete only in visible form. Oldenburg, whose art is quite different from Warhol's, admired this show because it was 'a very clear statement, and I admire clear statements.... There's a degree of removal from actual boxes, and they become an object that is not really a box, so in a sense they are an illusion of a box and that places them in the realm of art'.

Whether or not Warhol is indifferent to his subjects does not affect our own responses. He wants an art that will appeal to everybody, and his 'products' range from soup (*Ill. 71*) to cheesecake, Brillo to Marilyn Monroe (*Ills. 77* and *60*), nose surgery to Jacqueline Kennedy (*Ill. 76*). He is the most popular of the Pop artists; he did the cover for the 'teen-age' edition of *Time*, yet his *Most Wanted Men* were erased from the side of a New York World's Fair building as too controversial. Warhol is not by a long shot the best artist in conventional terms, but he is one of the most important artists working today, by virtue of his leadership of the uncompromisingly conceptual branch of abstract art. Warhol is greatly admired by many younger artists, even though he is also the centre of a fashionable cult whose extravagant homages inevitably arouse suspicion.

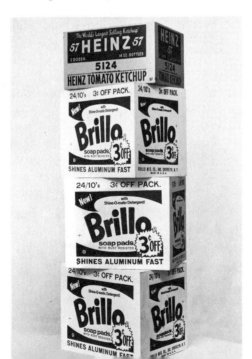

77 ANDY WARHOL
Brillo Boxes 1964.
Silk-screen on wood,
13 × 16 × 11 ¹/₂

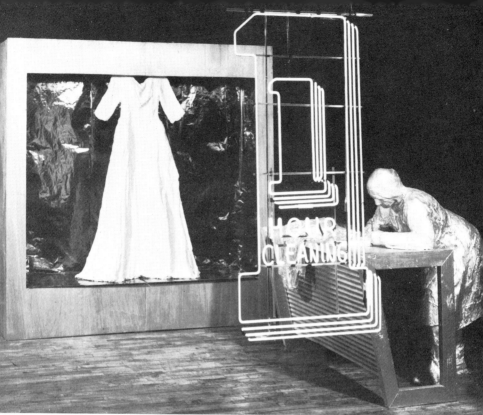

78 GEORGE SEGAL *The Dry Cleaning Store* 1964. Paint, plaster, neon, wood, etc., life size

Two other artists initially associated with Pop Art, but devoted to satirical and 'human interest' values outside of it, are Marisol (Escobar) and George Segal. Marisol owes her techniques of painted wood sculpture to her original mentor – William King – although she has carried them into the area of Assemblage by adding extraneous objects and plaster casts, by working skil-fully in and out of three dimensions, drawing, sculpting, and painting on her wood figures. Hers is a sophisticated and theatrical folk art justifiably reflec-ting her own beautiful face. But it has little to do with Pop Art, aside from its deadpan approach and touches of humour. Marisol rarely, if ever, uses commercial motifs, although her *John Wayne* (*Ill. 79*) and *The Kennedy Family* would fall within Pop iconography, and her wit is chic and topical.

Segal forgoes the toughness of Pop Art, and its humour too. His plaster moulds are made from the live model so that the true likeness is on the inside, and invisible. He has more in common with Allan Kaprow than with

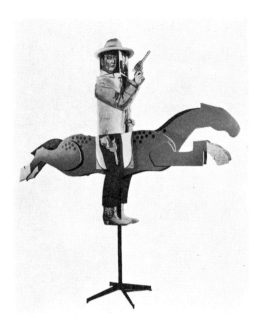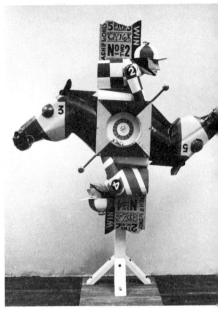

Pop; his *tableaux* of white figures in real-object environments (next to a Coke machine, in a bus driver's seat, against a cinema marquee) are like quick-frozen Happenings. His aesthetic is that of the creative candid photographer. 'The human being is capable of an infinity of gestures and attitudes,' Segal has said. 'My biggest job is to select and freeze the gestures that are most telling so that if I'm successful... I hope for a revelation, a perception.... I try to capture a subject's gravity and dignity.... I'm dependent on the sitter's human spirit to achieve total effectiveness.'[21] While Segal's single or grouped figures can be extraordinarily evocative, their muteness stems less from detachment than from the distance imposed upon them by their ghostly hue (*Ill. 78*). Otherwise they would be far more conventionally figurative. He is really a twentieth-century genre artist concerned with simple everyday activities that bring out a generalized humanity.

A second non-Pop vein, which specializes in social protest, should be mentioned, if only to dispel confusion by placing it properly outside Pop Art. That is the old March Gallery group, which got together around 1959 on Tenth Street and later moved uptown to the Gallery Gertrude Stein. Led by Boris Lurie, Sam Goodman (*Ill. 82*), and Stanley Fisher, these Assemblage, or 'Doom', artists are the political satirists that the Pop artists are not. They are all that Pop is not, and proclaimed themselves 'anti-Pop' in Febru-

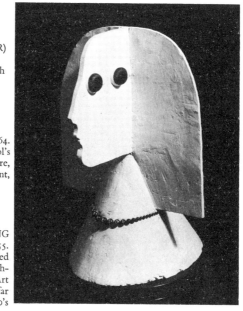

79 (*far left*) MARISOL (ESCOBAR)
John Wayne 1963.
Wood and mixed media, 104 in. high

80 (*left*) LEO JENSEN
Lure of the Turf 1964.
Painted metal and wood, 84×64.
Jensen, in turn, borrowed Marisol's
approach and vulgarized it still more,
to the point of total, if not important,
Pop Art

81 (*right*) WILLIAM KING
Marisol 1955.
Plaster, 15 ¹/₂ in. high. Marisol studied
with King and owes certain of her tech-
niques to him, but the fame of Pop Art
in general brought her a reputation far
broader than his in the early 1960's

ary 1964.[22] They are anguished, angry, and hot where Pop is cool, detached, and assured. They omit nothing from their conglomerations of trash, paint, collage, and objects, whereas the Pop artists omit almost everything from their direct presentation, and they are essentially pessimistic where Pop is optimistic. The March Gallery artists oppose the goals of the political cartoon to the goals of the advertisement. Their objects, designed to shock, are heavily dependent on ban-the-bomb horrenda – 'bloody' and dismembered dolls, crushed toys, primitive sexual fetishes, sado-masochistic *National Enquirer* photographs, girlie magazines. All the Doom artists tend to work alike, and each exhibition was actually a chaotic and occasionally effective environment. In this context, their work has much in common with Parisian-based artists like Jean-Jacques Lebel and Ferrò. (They have also been compared with Kurt Schwitters, although he was a rigorous organizer of his motley materials.) Belligerently romantic, as a group they come as close to Neo-Dada as is possible today. Their actual source is post-Abstract Expressionism – particularly Kaprow and Rauschenberg. They too are 'impatient with an art separated from life'.[23] Yet there is a febrile dispersiveness about Doom productions (irate manifestoes, exhibitions titled 'The Vulgar Show', 'The Doom Show', 'The Involvement Show', 'The No Show'), which fatally weakens them despite their devotion to admirable causes.

A third non-Pop parodistic current is represented by a single artist: Jim Dine. And although he is frequently included in the Pop rosters, his every work and statement show him to be worlds apart from that tough icono-clasm and formal emphasis. The complexities of Dine's highly personal and ultimately destructive art are controversial, and a lengthy treatment does not belong here. Dine is far closer to Johns, Rauschenberg, R.B. Kitaj, and the European Neo-Surrealists than to the Pop artists. The confusion with Pop probably began when he was one of the first to exhibit paintings of 'common objects' at the Martha Jackson Gallery early in 1962. His enormous ties, coats, hair or beads – labelled in an unambiguous non-Magrittean manner – were rendered in a technique and style unhealthily similar to that of Jasper Johns, although it has been noted that Johns in turn derived certain devices from Dine. By their 'giantism of popular imagery' and the fact that the objects were 'not scatalogical, but bought fresh', in Lawrence Alloway's words[24], they were related to the work of Oldenburg, with whom Dine had been associated at the Judson and Reuben galleries, and, less so, to that of Rosen-quist, Lichtenstein, and Warhol.

83 JIM DINE
Shovel 1962.
Shovel against
painted panel,
96 × 38

MARCEL DUCHAMP
*In Advance of
the Broken Arm* 1915.
ready-made snow shovel,
39 3/8 in. high

In his 1963 and 1964 exhibitions at the Sidney Janis Gallery, Dine's pre-occupation was clearly with paradox and parody, within the framework of older art. 'There's too much emphasis on the new,' he says. 'I don't under-stand why everything has to be new – that's the most destructive kind of attitude. It's all new.... You can't have a successful picture without the old standards of beauty.' [25] References abound in his paintings to Dada and Sur-realism in particular (real faucets with painted drops of water, polka-dots coming off a real dress on to the canvas, objects played against their shadows to imply action, in the tradition of Duchamp's *Tu m'*, and of Man Ray). *Two Palettes (International Congress of Constructivists and Dadaists, 1922) No. 1* refers to the figures in a famous photograph of that event, and recalls the paradox of those two groups getting together at all, perhaps a comment on history repeating itself in present trends. Direct reference is made to another Dada event (Max Ernst's contribution to the notorious 1920 Dada Vorfrüh-ling exhibition in Cologne) by Dine's *Hatchet with Two Palettes*, in which the hatchet – attached by a chain to a piece of wood – invited the spectator to destroy the object; his *Shovel (Ill. 83)* obliquely recalls Duchamp's *In Advance of the Broken Arm (Ill. 84)*.

Dine's parody does not hinge on the 'meaning' of the objects he uses, but on the way he uses them in a painting. He is not involved with subject or with new formal and pictorial devices, but with a complex and often re-dundant exposé of ways to paint. The Surrealists parodied the old masters by displacing and dismembering elements from famous works; Dine does the same thing to Abstract Expressionism by displacing and dismembering its treatment and paint quality, parodying the self-expression of its tech-niques by using the same mannerisms in a superficial and muted way. Max Kozloff has written that Dine 'outwits our cherished illusion of the non-representational and is an inspired middleman between the simulated and the recreated, reselling them at his pleasure; he is, if you will, the mad jobber of art'. [26]

If Dine is not a Pop artist at all, why then, it might well be asked, is Claes Oldenburg considered one of the hard-core? Oldenburg was among the earliest to propound a Pop attitude, and to use 'pure' Pop motifs. As he wrote in 1961: 'I am for the art of red and white gasoline pumps and blink-ing biscuit signs... I am for Kool-Art, 7-Up Art, Pepsi Art, Sunkist Art,

85 Claes Oldenburg at his one-man show at the Green Gallery, New York, 1962

Dro-Bomb Art, Pamryl Art, San-O-Med Art, 39 cents Art and 9.99 Art.'[27]
He has consistently used 'commercial' subject matter and his objects, unlike
Dine's, are always For Sale. Oldenburg has made no attempt to disguise the
Expressionist-Surrealist sources of his art because his powers of invention
are strong enough to absorb them. In 1958 he was painting rather conser-
vative nudes and portraits, but a year or so later his passionate involvement
with the city provoked a more original art. His Judson Gallery exhibition
in 1959, 'The Street', reflected the influences of Jean Dubuffet and the nov-
elist Céline. But where Dubuffet's primitivism is a timeless one, Oldenburg's
referred specifically to the modernity and vulgarity of America: New York,
Manhattan, the Lower East Side. Beginning with the grey, black, and brown
cardboard or *papiermâché* urban-refuse objects (*Ill. 57*) and the newspaper
reliefs (such as *Céline Backwards*, 1960), the grotesque figures (such as *Bride*,
1961), 'The Store' and its 'saleable' objects that blossomed out in bright
primary coloured plaster in 1961 and grew to monstrous sizes in 1962 (*Ills. 9,
85*), Oldenburg's attachment to materials was evident. He shares with Du-
buffet the gift of discerning art in the lowest form of matter – dust, dirt, and

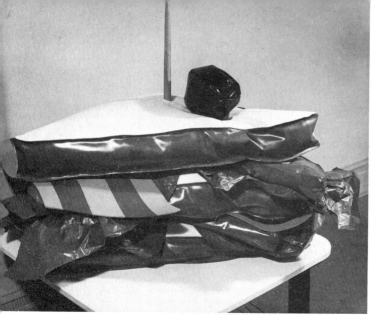

86 CLAES OLDENBU[
*Bacon, Lettuce
and Tomato* 1963.
Vinyl, wood, kapok,
and cloth,
32 × 39 × 29

garbage; his early objects bear comparison to Dubuffet's sculptural figures of glue, newspaper, steel wool, roots (*Ill. 58*). Oldenburg also shares with Max Ernst the gift of endowing found or accidental shapes, materials, or textures with fantasy and form; he is 'fond of materials which take the quick, direct impress of life... also those materials which, like wire, seem to have a life of their own – socking you back when you sock them. I like to let the material play a large part in determining the form'.[28] This attitude makes him a kind of 'Pop automatist', and he is heir to other aspects of Surrealism as well.

Unlike most of the Surrealists, however, and unlike their successors in the 'messy' vein, for instance, Oldenburg is not dependent upon juxtaposition for effect. Like all the Pop artists he takes his objects whole and unadorned. But unlike most of them, he has never made the complete transition from rough to pristine handling. His surfaces until recently were expressionistically pitted, striped by drips, or gawky and awkward (*Ill. 13*). Like Dubuffet he sees art as a 'celebration', and his plaster objects were inspired by a desire to enhance life itself, in action: 'Painting, which has slept so long in its gold crypts, in its glass graves, is asked out to go for a swim, is given a cigarette, a bottle of beer, its hair rumpled, is given a shove and tripped, is taught to laugh, is given clothes of all kinds, goes for a ride on a bike, finds a girl in a cab and feels her up....'[29]

108

87 CLAES OLDENBURG
Bedroom (detail) 1963.
As shown in the 'Four Environments by New Realists' exhibition at the Sidney Janis Gallery, New York, January 7 – February 1, 1964. The furniture is all rhomboidal; not seen here are a bureau with a huge metal 'mirror' and a fake zebra couch with a fake leopard-skin coat thrown across it. The sheets are shiny white vinyl, the bedspread quilted black plastic, the marbled accessories a strong, bilious turquoise; the 'paintings' on the walls are ordinary textile with a black embossed pattern like an imitation Jackson Pollock. The total effect is nightmarish

88 CLAES OLDENBURG
Ping-pong Table 1964.
Plywood, plaster, and metal, $39 \times 54 \times 84$. The table is rhomboidal, or 'in perspective', as though jagged from reaching, and the paths of the balls – solidified in plaster – provide a second kinetic implication

Finding paint too limiting for such freedom, Oldenburg went on to work with 'total space' in Happenings, then added plaster to his paint to make reliefs, and finally, free-standing objects. 'I'm not terribly interested in whether a thing is an ice-cream cone or a pie and so on.... The fact that I wanted to see something flying in the wind made me make a piece of cloth, the fact that I wanted to see something flow made me make an ice-cream cone.' He makes these things in order to 'give a concrete statement to my fantasy. Instead of painting it, to make it touchable, to translate the eyes into the fingers'. When Oldenburg uses actual ready-made objects, they are entirely integrated into the final 'scene' or environment – unlike those of Rauschenberg, Johns, Dine, or even Wesselmann. His 1961 *Stove*, for instance, is not 'transformed' as in Assemblage nor left to speak for itself as are ready-mades or found objects; it is recreated. Art and reality are unified, but each retains its own characteristics. This kind of interplay is at the heart of Oldenburg's creations. His cones and hamburgers, his bright pastries, vegetables, sandwiches, and meat are even appetizing at times (*Ills. 85, 86, 89*); they are appealing because they combine gaiety with elephantine sadness. They are, as Apollinaire said of Picasso's objects, 'impregnated with humanity'. In this sense Oldenburg is a humanist, although it is a humanism devoid of sentimentality. Until 1965, his Pop Art was that of a sub-culture rather than a super-culture. It belonged to the shabby little stores and delicatessens on Second Avenue, the hopeful outdoor clothing racks of Orchard Street, the tawdry finery of Fourteenth Street, rather than the brand-new shiny department stores and ranch-style burger joints with ersatz-wood panelling and checkered tablecloths. His food comes from small diners rather than from decorated restaurants, Nedick's rather than Stark's. His clothes have been pawed over on Klein's bargain counters, and his rhomboidal furniture is displayed on Avenue A.

With the furniture Oldenburg moved into the 'Home' period – a much more streamlined style that reflects Los Angeles, where it was executed and became fused with another sort of urbanity. In the luridly artificial grandeur of the *Bedroom* (*Ill. 87*), shown in 1964 at Sidney Janis (a suite of furniture made 'in perspective' and nightmarishly glamourized with white vinyl sheets, textiles, mass-produced abstract paintings, and fake leopard-skin trimmings), or in the kinetic implications of *Ping-pong Table* (*Ill. 88*), he began to extend 'cool' Pop imagery into new areas. His shiny vinyl 'soft objects'

(*Ill. 6*) and their rough 'ghost' maquettes are among the most memorable Pop creations. Their shapes can be changed at touch, like Oyvind Fahlström's variable paintings (*Ill. 168*), and they were conceived as 'new ways of pushing space around. 'If I didn't think what I was doing had something to do with enlarging the boundaries of art,' says Oldenburg, 'I wouldn't go on doing it'.

Tom Wesselmann's integration of objects into his paintings differs considerably from Oldenburg's, and from Dine's, Rauschenberg's, and the Assemblagists'. His one-wall interiors (*Ill. 92*) are not environments ('my rugs are not to be walked on'), nor are they paintings with decorative three-dimensional additions. They are, perhaps, a 'slice of life'. Wesselmann did not have to make a radical break with his previous style to become Pop. His small 'portrait collages' quite logically grew into the *Great American Nudes* for which he is best known (*Ills. 64* and *90*). Fusing the arabesque and brilliant colour of Matisse with the sinuous line of Modigliani and a more rigorous framework traceable to Mondrian, the *Nudes* were first shown at the Tanager Gallery on Tenth Street in 1960. Unlike the rest of the artists discussed here, Wesselmann did not paint *from* magazine advertisements, billboards, and objects, but used them directly on the canvas, thus following conventional collage-assemblage methods. Only in 1964–65 did he finally abandon the real materials – and from necessity, for his work had become bigger and bigger, finally outgrowing its components. He first used ads from magazines, then from billboards; the objects grew apace, beginning with radios, fans, then windows, refrigerator doors, radiators. As his paintings enlarged, they tightened up: 'Colors became flatter, cleaner, brighter; edges became harder, clearer.... The sound of the paintings became sharper. I felt the need to lock up my paintings so tightly that nothing could move. This way, by becoming static and somewhat anonymous, they also became more charged with energy.' [30] This statement describes the experience of numerous young artists in the last five years – abstract as well as figurative.

During 1962–64 the *Great American Nudes* became bolder and more effective, incorporating ringing telephones, radios, and working TV sets. Changing constantly, the pictures were sentimental, satirical, nostalgic, or just plain silly depending on whether *Lassie*, a political convention, an old movie, or an ad was on. In contrast with the shiny new furnishings or implements, the

illusionistic collage pictures on the wall (George Washington, the *Mona Lisa*, Kennedy, Mickey Mouse), and views from the window, the nudes and painted backdrops were incongruously flat and stylized, often faceless or boldly patterned with stars and stripes. Wesselmann likes the 'reverberations' between painted and collage images, art history and advertising, *trompe-l'œil* and reality. When he was forced to return to actual painting as the pieces got larger and collage materials scarcer, he discovered 'how audacious the act of painting is. One of the reasons I got started making collages was that I didn't have enough interest in a rose to paint it; I don't love roses or bottles or anything like that enough to sit down and paint them lovingly and patiently.... Now I had to invent a bowl and I couldn't believe how audacious it was'.

Paralleling the *Great American Nudes* was a series of less abstract still-lifes using similar elements, but more brand-name collage (*Ill. 21*). Jill Johnston praised them in 1962 by saying, 'If a commercial advertising firm had a mind really to knock the public out for a hard sell, they might use one of Wesselmann's paintings'.[31] Some of them were as 'untransformed' as any Pop painting, although the masterful design and colour of the *Nudes* were perceptible behind the uncompromisingly unattractive array of products. Wesselmann's colour – brilliant and primary – had always been one of the most interesting aspects of his work, and it took courage to abandon it and do a series of grisaille still-lifes in 1964–65. At first these incorporated real objects, or models of grey 'oranges' and labels recalling the paradoxical monotones of Johns, Watts, and Morris. Finally the constructions outgrew actual objects altogether. Only the landscapes – with almost life-size Volkswagen cut-outs (*Ill. 91*) – employed billboard materials. With them Wesselmann's work became belligerently simple, resembling that of Warhol and Lichtenstein more than his own previous production. Its 'modernization' parallels these artists' developments and Oldenburg's slick furniture. Wesselmann's immense blank beer cans, radios, bottles, fake façades of form resting on a shallow shelf are hollow, concave, or convex against stern rectilinear grounds (*Ill. 93*). They have the clarity and strong design of the *Nudes* but lack the latter's *joie de vivre* and lively charm. At a moment when several of the other Pop artists are approaching a more aesthetic or abstract style, Wesselmann is moving away from one towards a pure commercial idiom.

89 CLAES OLDENBURG *Hamburger, Popsicle, Price* 1962. ▶
Enamel paint on canvas stuffed with kapok, *c.* 36 in. high

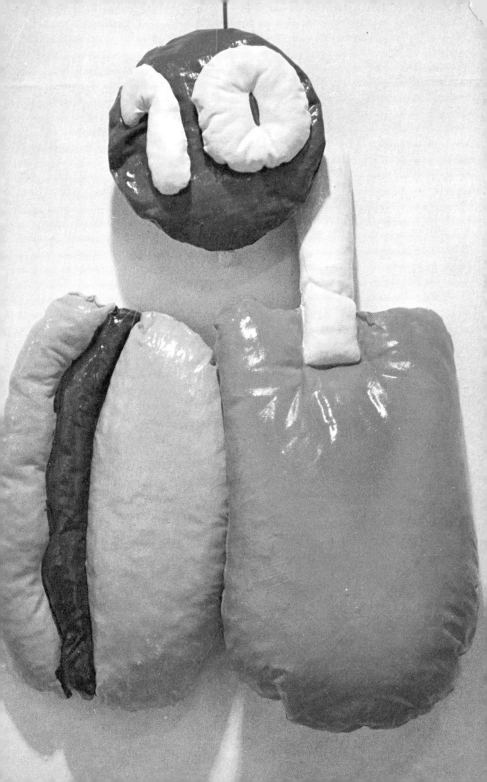

Wesselmann's new austerity can be seen as part of the general purification of Pop Art. James Rosenquist, for example, says his images are 'expendable'. Yet once the choice is made, a stream-of-consciousness dialogue between images and artist ensues. 'Current methods in advertising, sublimation, and the hard sell, invade our privacy,' he has said. 'It's like getting hit with a hammer; you become numb. But the effect can be to move you into another reality. These techniques are annoying in the form in which they exist, but when they're used as tools by the painter, they can be more fantastic.' [32] Based on a painted collage concept of image juxtaposition, his painting bears a superficial resemblance to Surrealism; in intention it could not be more different. Rosenquist is not concerned with symbolism of any kind; his juxtaposed fragments do not act upon each other, but directly upon the

90 TOM WESSELMANN *Great American Nude No. 54* 1964. Mixed media, 84 × 102 × 40. Tape-recorded street sounds are barely audible from behind the window; in other, similar canvases, the phone on the wall rings at intervals

91 TOM WESSELMANN *Landscape No. 5* 1964. Paint and billboard construction, 84 × 150 × 18

spectator. The idea occurred to him while he was painting billboards for a living in New York in the late 1950's. His style was a sombre Abstract Expressionism at that time, but as he worked on the billboards, he began to realize that there was more potential innovation in his trade than in his art. He had become accustomed to seeing gigantic figures, objects, or seas of colour right up next to his face. As an abstract painter he was vitally attracted by the fact that such images close up lost all meaning or recognizability. Having gained through his billboard experience an insight into the spectacular possibilities of size (available to most of us only through the film), Rosenquist also sensed parallels with everyone's daily experience – especially in cities. He calls his work 'visual inflation. I'm living in it. Painting is probably more exciting than advertising – so why shouldn't it be done with that power and gusto, that impact?' In the winter of 1959–60 he made the breakthrough and discovered that he had escaped 'that old, pictorial space'.

★ ★ ★

92 TOM WESSELMANN *Bathtub Collage No. 3* 1963. Mixed media, 84 × 106 × 18

93 *(left)* TOM
WESSELMAN
Still Life No. 4
1964.
Plastic with int
illumination,
48 × 60 × 4.
Edition of 5

94 *(right)* JAM
ROSENQU
1, 2, 3 and Out 1
Oil on can
wood and v
96

95 JAMES ROSENQUIST *F-111* 1965. Oil on canvas, 10 ft. × 86 ft. This mural filled the entire Leo Castelli Gallery in April 1965. The fragmented image of a jet plane roars across a series of pictorial reminders of the contemporary world: a cake with its nutrients tagged, a tyre,

Scale is the key to his work. The immense, sometimes unrecognizable images proceed from an inverse illusionism (*Ills. 65, 94*); they burst off the wall at the spectator in the initial encounter, but when the original impact has worn off, the skilful interlocking and subtle spatial devices holding them to the surface plane offer a rich visual experience to the viewer (*Ill. 98*). The complex maelstrom of variously scaled images are knit into an intricate formal unity, every element firmly but unobtrusively related and held in the vice of the whole (*Ill. 66*). Transparency, grisaille, relief panels, chromatic dislocation, subliminal suggestions, and above all an essentially abstract sensibility, are among the devices he uses. Once an ambiguous area in a Rosenquist painting is recognized as, say, a part of an umbrella, the linear pattern across it becomes rain. Each compartment does not contain an image, but the geometrical divisions conduct the orchestra of changes. A seven-foot leg, like that in *Over the Square* (*Ill. 99*) throws the 'reality' of the entire canvas into question.

The climax of the compartmented style was the mural *F-111*, shown at the Castelli Gallery in April 1965 (*Ill. 95*). Eighty-six feet long and ten feet high, its theme is the position of the artist in an era of immensity, jet war machines, and *nouveaux collectionneurs*. It has been billed as 'the world's largest Pop painting', which hardly does it justice. The eye is rushed along the wall by the image of a jet bomber, stopping only for four weighty verticals that punctuate the horizontal movement of dazzling colour and aluminium.[33] The stamp of the man-made is ubiquitous in this as in all of Rosenquist's work. He wants to get 'as far away from nature as possible', and he is

spaghetti (canned), a child under an elaborate hairdrier, a mushroom cloud covered by a gay umbrella, a deep-sea diver, whose helmet repeats the shape of the nose cone of the plane and the hairdrier, and whose air bubbles echo the atomic explosions

troubled by what he feels is a 'heavy hand of nature on the artist'. Figure or landscape references are often read into Abstract Expressionism, and the Pop artists, by leaving no question as to the origins of their images, seek to avoid these associations. By leaving the question of identity clear, they are free to make their own paintings, on their own terms, and these paintings often, conversely, appear to be abstract. In a painting and a construction entitled *Capillary Action I* and *II* (*Ills. 96, 97*), he depicted landscape elements with neon, plastic, and other unlikely elements, but included a real sapling tree, disrupting the common conceptions of nature and art, artifice and reality.

It is difficult to summarize the work of any of these artists in so little space, but with Rosenquist the difficulty is compounded. His is a complex, multiple art. Each painting demands detailed analysis of both its formal and emotional effects, and over the last five years he has encompassed a greater variety of techniques and materials than any of the other Pop artists. While the immense compartmented images (there may be two or twenty such fragments in a painting) remain the scaffolding of his experiments, he has set himself no other limitations. Since 1962 Rosenquist has employed extraneous materials such as diaphanous plastic sheets, mirror, plexiglass, neon and electric light, paint-smeared or rainbow-spattered bits of wood or twine; he has recently embarked on an immensely ambitious project dealing with the effects of peripheral vision. Free-standing constructions (*Ill.* 100), shaped canvases, hinged or pierced surfaces, new industrial and commercial materials – all have been part of his vocabulary for years. Rosenquist's free-wheeling inventiveness makes other Pop artists (except perhaps Oldenburg) look

96 JAMES ROSENQUIST *Capillary Action I* 1962. Oil on canvas with collage of newspaper and plastic, *c.* 72 × 12

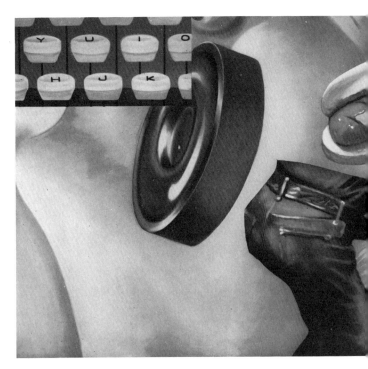

97 JAMES ROSENQUIST
Capillary Action II 1963.
Metal, neon, plastic, wood, and paint,
102 × 66 × 55

98 JAMES ROSENQUIST
*The Lines Were Etched
Deeply on her Face*
1962. Oil on canvas,
66 1/4 × 78 1/4

99 JAMES ROSENQUIST
Over the Square 1963.
Oil on canvas, 84 × 84.
The title refers
to the painter's
experience painting
billboards over
Times Square

conservative, yet he has been called the academic of the group because of his quasi-photographic style of rendering images and his inverse illusionism. What he does with these techniques, however, is more important. By refusing to accept any limitations, often by abandoning fresh ideas before barely scratching their surfaces, Rosenquist continually demands more of himself and his art. He belongs to the romantic tradition.

100 JAMES ROSENQUIST *Untitled* 1963. Oil on plexiglass with paint, wood, and electric lights, 14 × 104 × 72. This was another of the 'Four Environments by New Realists' shown at the Sidney Janis Gallery in 1964 (see also *Ill. 87*). The spectator walked across a multi-coloured ramp while below him flashed lights that acquired colour from being seen through the painted surface (part of a 'Fab' soap label): the effect was of great height, slightly dizzying, like seeing a carnival from the top of a ferris wheel

Robert Indiana (*né* Robert Clark, in Indiana) has from the beginning straddled the gap between Pop iconography and abstraction. I have not included him in the hard-core because his work has always been fundamentally non-objective. On the other hand, he is perhaps the most 'literary' of all, and his attitudes have been as much in key with the Pop programme as anyone's. He was one of the first to exploit the new subject matter in his geometric abstractions derived from pinball machines and traffic signs; his colour and heraldic style can be traced to Ellsworth Kelly. Now that the trend of Pop Art is to the abstract, Indiana could be reinstated, although formally he is less of an innovator than the five men discussed here. His contribution has been the marriage of poetry and geometric clarity via the inclusion of American literature and history in a non-objective art. Despite his superficially 'purist' style, Indiana is an out-and-out romantic. His poetic invocations of

ROBERT INDIANA *God is a Lily of the Valley*
1. Oil on canvas, 60 × 48. The inscription, 'God
Lily of the Valley, He is a Tiger, He is a Star, He
Ruby, He is a King, He can do Everything but
", is drawn from a Negro spiritual

102 ROBERT INDIANA *USA 666* 1964.
Oil on canvas, 102 × 102. Indiana's *leitmotif*
is the two sides of the American dream: one,
the literature and history of America, the
other, its way of life

Melville and Whitman and his references to Americana (*Ill. 101*) and speci-
fically to the history of the lower Manhattan shipbuilding district are subor-
dinated to the concentric rings of colour in which they are stencilled; once
they are read, the canvas is transformed, the rings become wheels instead of
pure form, and the literary content surges to the surface. If the stencilled
legends are not read, the paintings remain non-objective. In Indiana's *EAT*
and *DIE* pieces or the highway route signs (*Ill. 102*), the message is mistak-
able, though the format is still more cool and generalized, and the American
Dream of easy life and death is pointedly the subject. In this manner he is
also able to inject more than the usual amount of outright social comment
into his work, though he does so only occasionally, as in the Selma, Alabama
painting ('Just as in the anatomy of man, every nation must have its hind
part') (*Ill. 103*), or by single-word references of a topical nature (*Ill. 55*).

103 ROBERT INDIANA *Alabama* 1965. Oil on canvas, 60×50.
After commemorating the shame of Selma, Alabama, in this mordant manner, the artist did the same
a year later for Bogalusa, Louisiana

104 ROY LICHTENSTEIN
Golf Ball 1962.
Oil on canvas, 32 × 32

Roy Lichtenstein has been most closely associated with the 'new' or 'cool' abstraction – surprising, perhaps, since his work was for years the most conspicuously narrative and representational. In a sense, his paintings have the opposite effect from Indiana's; they become *less* rather than more literary with perusal. The insistent dramas of love and war interest Lichtenstein less than 'the formal problem.... Once I've established what the subject matter is going to be, I'm not interested in that.... I think of it as abstract painting when I do it. Half the time they're upside-down anyway when I work'. Most Pop Art is essentially emblematic in its conjunction of word and image. Lichtenstein shares with 'post-painterly abstraction' his enlarged scale, broad flat forms on colour fields, carefully depersonalized line, reductive composition, and expanded forms that seem to exist beyond the framing edge (*Ill. 106*). Like the recent *Big Painting* (*Ill. 67*), some earlier paintings had been virtually non-objective, even when specific objects were depicted; the *Explosions* are dynamic, spiky forms that have been lifted from their grounds and made into star-like reliefs of uncompromising vulgarity. *Golf Ball*, 1962 (*Ill. 104*), is a single sphere with patterned, variously directional semi-circular grooves; *Magnifying Glass* has a dazzling field of Ben Day dots, enlarged in the centre; and *Before and After* – two holes in rectangular patches of fabric – utilizes abstract and optical conventions. These were also much in evidence in the double-surfaced landscapes, where a slightly off-register optical vibration occurs when a dotted sheet of clear plexiglass is laid over another surface, or Ben Day screens (previously employed to reproduce dots) are superimposed on each other.

105 ROY LICHTENSTEIN
Ceramic Sculpture 12 1965.
Glazed ceramic, 9 in. high

106 (*opposite above*) ▶
ROY LICHTENSTEIN
Good Morning, Darling 1964.
Oil and magna on canvas,
30 × 50. One of the
later comic-book paintings.
The striking design
that has been created
from a banal image
is very clear here

107 (*opposite below*)
ROY LICHTENSTEIN
Seascape II 1964.
Oil and magna on canvas, 48 × 56 ▶

During 1964, Lichtenstein's work became increasingly abstract as the comic images moved closer and closer to the spectator (like Rosenquist's fragments, but hard and graphic); for subject matter he turned to Greek temples (*Ill. 150*), and to landscapes (*Ill. 107*) – sunsets, sunrises, seas, and cloudy skies – once removed from reality like the comic strips, since they refer to travel posters and dime-store art. After being reduced to striking three-colour rectangles divided by a horizon line or an Art Nouveau whip-lash, these became reliefs of plastic or enamel on metal. The logical outcome was the 'sculpture' begun in 1965: precariously stacked cups and saucers (*Ill. 105*), pitchers, heads of comic-strip characters made with the aid of a professional ceramist. Witty and fresh, these are the first sculptures about painting, for each object is treated as though it were two-dimensional, with all the flattening devices of Lichtenstein's paintings – half-tone screening, bright solid colour shadows, heavy outlines, and metallic highlights.

By the exhibition season of 1962–63 Pop Art was already attracting new adherents, only a few of whom had valid contributions to make before a third wave appeared. The second wave included artists who were working towards a Pop style by 1961 and others who were influenced but not overwhelmed by the hard core. Among the former was John Wesley, who had come from California to New York in 1960 and showed at the Robert Elkon Gallery in 1962. Wesley's whimsical emblems, enshrined in floral or decorative borders and painted in a deceptively sweet poster style, celebrate old-fashioned sports figures, ladies' lacrosse teams, Indians, nudes, squirrels (*Ill. 130*), and presidents, often in pale blue and white with pink-and-green touches and black outlines. In 1965 he made some furniture decorated with zany figures – pregnant women and bearded men on bicycles. The strength of Wesley's work derives from its apparent innocence, even coyness, fused with an underlying eroticism. His wit is a curious one – partially subtle and Surrealist (the juxtapositions of cows and dancing nudes (*Ill. 148*), baseball players and garlands), but also broadly humorous in the sight-gag tradition. Al-

108 (*opposite*) ANDY WARHOL *Flowers* 1964. Silk-screen on canvas, 24 × 24 each. Detail of one wall consisting of twenty-eight such panels at the exhibition at Leo Castelli Gallery, New York, 1965. The same image, differently coloured and slightly differently printed, made up the whole show; a few paintings were larger and depicted only two flowers

109 ALLAN D'ARCANGELO
Road Series 1965.
Acrylic on canvas
96 × 22

though reflecting commercial imagery less than a family-album folk art, the paintings are executed in a no-nonsense hard-edge style (*Ill. 11*).

Allan D'Arcangelo showed at the Fischbach Gallery in 1962 and there preempted an ultra-Pop subject matter for his own: the American highway speeding vertiginously into the future – a knife-edged path punctuated by billboards, route and speed-limit signs (*Ill. 151*), and an occasional languid female hitchhiker. The distance leaps toward the viewer and accentuates the velocity. By employing the conventions of non-objective hard-edge art, silhouetted forms and a restricted but brilliant palette, D'Arcangelo often achieves a striking simplicity that firmly allies him with the hard-core Pop artists. Around 1964 he added actual cyclone fencing (*Ill. 110*), Venetian blinds, or striped wooden 'road barriers' in scale with his increasingly abstract imagery. During 1965 he flattened the perspective, abandoning illusionism for a flat, clarified surface (*Ill. 109*), and now works both in this bold idiom and with a more delicate, draftsman's use of the same motifs.

Marjorie Strider's bathing beauties made their début at the Pace Gallery's First International Girlie Show in 1963. They stood out, literally, with protruding buttocks, lips, and breasts carved from wood and later from the lighter styrofoam, which enabled her to build larger, gravity-defying sec-

110 ALLAN D'ARCANGELO
Airfield 1963.
Liquitex on canvas
with cyclone fencing,
86 × 60

111 MARJORIE STRIDER *View from a Window* 1965. Epoxy, styrofoam and acrylic paint, *c.* 84 × 120

tions. Half painted, half sculpted, rendered in a crude commercial idiom like that of Lichtenstein, these figures are conceived in resolutely formal terms, more apparent when the pin-ups gave way to immense flowers and vegetables in 1964, and in 1965 to great free-standing or hanging sculptures of landscape elements (clouds, moon, beach) with the rectilinear outlines of a window frame painted on them (*Ill. 111*). These bulky forms are Strider's best and most original work to date.

Robert Watts, one of the more eccentric artists to be connected with Pop Art, predicted as well as participated in its inception. His postage-stamp machine, dispensing distinctly non-governmental issue, was a memorable creation. Like the Duchamp- and Johns-derived object artists, Watts deals in paradox, exposing the nature of perception and deception in his common objects. The 'heavy foodstuffs' (*Ill. 156*), made of gleaming chrome-plated lead, the rows of graded white, grey, and black loaves of bread, the transpar-

TELEPHONE

112 VERNE BLOSUM *Telephone* 1964. Oil on canvas, $46^3/_4 \times 35^3/_4$

113 ALEX HAY *Toaster* 1964. Oil on canvas, 92×73 (over-all)

114 ROBERT WATTS *Bacon, Lettuce and Tomato* 1965. Wax in plexiglass, $7^3/_4 \times 7^1/_4 \times 2$. The filling of this transparent sandwich is a coloured photograph. For Oldenburg's treatment of the same subject, see *Ill. 86*

ent sandwiches (*Ill. 114*) or fake-fur popsicles parallel Oldenburg's subject matter but relinquish the robust qualities in favour of attractiveness.

Alex Hay's cut-out utilities (*Ill. 113*), Leo Jensen's good-natured heroes (*Ill. 80*), Vern Blosum's telephones (*Ill. 112*), Don Nice's fruit ads, Milet Andrejevic's stylized US mailboxes on raw canvas, Steve Antonakos' stencilled Dream pillowcases, Aaron Kuriloff's unadorned utilities (*Ill. 158*), Robert Moscowitz's window shades, and certain of Robert Whitman's uncategorizable film-environment object creations are also legitimately related to Pop of the early period. Rosalyn Drexler's photograph-derived celebrities (*Ill. 117*), love scenes, and dramatic news shots have the immediacy and colour but not the technique associated with Pop. Like Idelle Weber's mute urban groups moving across chequerboard grounds (*Ill. 115*), and Harold Stevenson's monstrous enlargements of the male anatomy, they are motivated by different attitudes. There are several well-known artists who do not subscribe to the Pop impersonalism, but react to contemporary phenomena with a similar excitement. To this extra-Pop area can be assigned Richard Lindner's increasingly brutalized banners and recent paintings in which the Léger-Beckmann figures sport teen-age gang jackets, bat-winged sunglasses, and garish

115 IDELLE WEBER
Munchkins III 1964.
Acrylic on linen,
70 × 77.
Third section
of a triptych

116 RED GROOMS
Hollywood (Jean Harlow) 1965.
Acrylic on wood,
$31 \times 35 \times 12$

119 NICHOLAS KRUSHENICK
Battle of Vicksburg 1963.
Liquitex on canvas, 84×70. A later
series of paintings bore the Pop-like
titles of James Bond movies and
characters

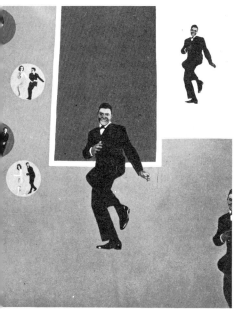

117 ROSALYN DREXLER *Chubby Checker* 1964.
Liquitex, oil, collage on canvas, 75 × 65

118 RICHARD LINDNER *Coney Island No. 2.*
Oil on canvas, 75 × 50

colour to augment the repressed violence of his personal style (*Ill. 118*), iso-
lated plasters by Peter Agostini (the clothes line, the carousel), Yayoi Kusa-
ma's phallus-studded furniture, Red Grooms' movie-star and movie-set cut-
outs (*Ill. 116*), Alex Katz's Revolutionary War soldiers (*Ill. 155*) (designed in
1961 as stage sets), Ernest Trova's Falling Man series. In addition, there is the
third string of Pop artists, largely repetitious and inept, of interest mainly
because they prove that Pop Art, like any other art, cannot be necessarily done
by anyone so inclined. Merely choosing a jazzy commercial image to con-
centrate on is not enough. Among them there is a drift toward simple, often
tasteless jokes or bold pornography as subject matter, and their styles often
depart from hard-edge Pop to return to a more generalized Assemblage
mode.

Since Pop Art first appeared on the scene there has been speculation as to
whether it could, or would, evolve, and if so, in what direction. Condemned
for some four years as a passing fad, its detractors have not yet had the satis-
faction of attending the obsequies. It is true that the third wave of Pop, like
the third wave of Abstract Expressionism, has been redundant; the super-
ficial conventions are easily converted into mannerisms. The force of the

135

120 RAY DONARSKI *Lions International* 1964. Oil on two canvases, 39 × 50 and 39 × 18. Donarski was living in Luxembourg when this was painted

original group becomes even more apparent when viewed in the light of its imitators.

In the meantime, Pop Art has been engaged in an articulate dialogue with current abstraction. Forcing a change of attitude toward 'art', 'art materials', and 'art-worthy subjects', the original Pop artists, like all innovators before them, have altered the way in which we see the world. Not only have some of the hard-core Pop artists been moving toward a more abstract style, but others have been affected who could not by the wildest stretch of the imagination be called Pop. Andy Warhol's new conceptions of mass production, the anti-sculptural structures of Donald Judd and Robert Morris, the paintings of Frank Stella and Larry Poons – whose work, like Pop, has seemed to many people too sparse to be art – have spawned what Max Kozloff has called 'dissimulated Pop'[35]: the handsome boxy furniture of Richard Artschwager (*Ill. 122*), Irwin Fleminger's 1964 *Subway Unit* (in which formica

121 WILLIAM KENT *Nation is in Good Shape* 1964. Kent has dealt with popular images for years now, but unlike the Pop artists', his motifs are strongly satirical, especially in this slate print series

122 RICHARD ARTSCHWAGER *Executive Table and Chair*. Formica on wood, 44 × 44 × 25 (table), 54 in. high (chair). Artschwager had already developed his own stylized construction as a Pop device when he helped Oldenburg build the *Bedroom (Ill. 87)* and should be considered a forerunner of the quasi-formalist tendency.

I-beams, a white 'scale', an orange-and-blue 'trash can' and plastic 'gum machines' referred to these common objects in a general rather than a descriptive manner), or Robert Smithson's 1965 panels of metal-flecked plastic, as vulgar as Hollywood Modern bar sculpture. John Chamberlain's gleaming chrome and flecked enamel relief plaques are the result of time spent in Los Angeles, where the modern craft aesthetic has hit a peak of expertise, freed by Pop and particularly by Billy Al Bengston (*Ill. 125*); Nicholas Krushenick's abstract 'science fiction' canvases (*Ill. 119*) were probably the first non-objective Pop Art, although he was directly affected less by Pop than by Matisse. Robert Mangold's non-objective paintings were initially suggested by the lettering on truck sides, and his *Walls* by prefabricated buildings.

Industrial materials like formica, chrome, Day-Glo and aluminium paints, false wood-grain or wallpaper textures, cheap textiles, plastics, automobile enamels, lacquers, and neon light have added to the formal possibilities of

137

the new art. Rosenquist's shaped canvases, commercial paints, and 'invented materials' (like chrome-plated barbed wire), Lichtenstein's enamel editions of his paintings, Warhol's box show and helium-filled silver pillows all have had repercussions. Oldenburg's work has been particularly influential, above all his *Bedroom (Ill. 87)*. His vinyl and kapok objects, or 'soft sculpture' (*Ills. 6, 86, 123*), have signalled a fertile direction; several highly individual artists (who may or may not consider Oldenburg a direct source) work with cloth or similar materials as an abstract sculptural medium, fusing aspects of Pop, Surrealism, and non-objective art: Frank Lincoln Viner, Eva Hesse, Alice Adams, Jean Linder, Anne Wilson, and Marc Morrell. Chryssa, Dan Flavin, and Steve Antonakos use neon or fluorescent light and others are using a non-art palette of insipid ice-cream shades or 'kandy kolors', glow-in-the-dark tones, Howard Johnson's or institutional decorators' hues like turquoise, pistachio, mauve, lavender, and peach – hitherto considered too bland for fine art, unless employed sparingly in delicate touches.[36]

The popularity of eye-catching target and stripe motifs, bold patterning, zigzag shapes and hard outlines, a certain flashy crudity of presentation, a disregard for 'composition' and strictly aesthetic enjoyment – all the main characteristics of a 'difficult art' that refuses decorative security – are part of the same phenomenon that produced Pop. In a year's time these instances of cross-fertilization with non-objective art will have multiplied.

123, 124 CLAES OLDENBURG (*left*) *Switches Sketch* 1964. Vinyl, cloth, and kapok, 42 × 42 and (*right*) *Switches* 1964. Wood, 48 × 48. The slouched sketch and the precise result represent the two poles of Oldenburg's art, both of which have been influential

Pop Art in California

Nancy Marmer

There is a ritual piety in the way American art and literature periodically return for sustenance to the American experience. Once caught up with the myth of the frontier and the cliché of 'a new life', the native mood also takes identity from a hubristic opposition to the past, a parochial rejection of Europe, and, in the arts, a renunciation of the seductions of super-aestheticism. In his star-spangled phases, the American artist has tended to suggest that by immersing himself in native or regional subjects, he has returned to 'reality' (albeit a 'new reality') from the trap of a stale *cul-de-sac*, variously considered as 'European', 'academic', or 'lifeless'. Pop Art, the latest instance of the all-American pattern, has, especially on the West Coast, had exactly such indigenous overtones. In its ironic temperament the movement exhibits upstart antagonism to the aesthetic formulas of the immediate past; in its serious notion of content, however, it everywhere displays innocence, a eulogistic vision of a new American subject, if not necessarily of America itself.

It is a moot point whether the current disparate body of Pop Art on the West Coast grew logically out of its own local antecedents, out of the same nation-wide *Zeitgeist* or (if one takes the formal view) 'crisis' in art which produced the entire spectrum of post-Abstract Expressionist styles, or whether it developed rapidly after and only as a result of influences from New York. Except for the truly indigenous Bay Area figurative group and the vital California Assemblage movement, most postwar, pre-Pop, West Coast art had indeed been either provincially retrogressive or imitatively Eastern; so it is not surprising that the instantaneous concurrent eruption of an *avant-garde* manner (or at least matter – Pop manner is a more complicated issue) in California in the early 1960's should provoke in some quarters all of the now familiar sociological and mercantile speculations about the dissemination of 'in' styles and some raised eyebrows about the 'separate but equal' positions taken by West Coast practitioners of the style. Whatever and whenever the ultimate sources, it is beyond question that in the work of

such artists as Billy Al Bengston, Edward Ruscha, Joe Goode, Wayne Thiebaud, and Mel Ramos Pop Art did take root easily, early, and that it has flourished smartly, if diversely, in a milieu in which it could well have been invented.

Aside from the backdrop influence of Hollywood and the hypertrophied 'neon-fruit supermarket', there has also existed in California an idiosyncratic welding of sub-cultures and a body of small but curiously prophetic art, whose influence, if not always direct, is at least in an askew relation to contemporary Pop Art. For example, the Los Angeles hot-rod world, with its teenage rites, baroque car designs, kandy-kolors, its notion of a high-polish craftsmanship, and, perhaps most influential, its established conventions of decorative paint techniques, has flourished in the southern part of the state since the 1940's. If the imagery ('Mad Magazine Bosch', one writer has called it) has fortunately not been especially important, the custom-coach techniques of air-brush manipulation, 'candy apple-ing', and 'striping' have been variously suggestive. Northern California, on the other hand, was the coddling ground for Beat poetics in the 1950's; the ambivalent nostalgic-damning vistas of 1940-ish Americana typical of the Beat poets is also at the heart of the Assemblage *tableaux* constructed by a major Los Angeles proto-Pop artist, Edward Kienholz, who, since the mid-1950's, has transformed motifs and bits from American urban folk lore (e.g., the automobile as passion

125 BILLY AL BENGSTON
Birmingham Small Arms I 1961.
Oil on canvas, 36 × 34

126 BILLY AL BENGSTON *Skinny's 21* 1961. Oil on canvas, 42 × 40

pit [*Ill. 127*], or the John Doe family, the abortion underground, patriotic sentiments as household décor) into bizarrely gothic allegories on the decay, human contamination, and psychic disorders underlying banality. He has a moralist's eye for shocking juxtaposition; found objects, scarred by abuse and squalid in their detail, are combined to tell pointed anecdotes (*Ill. 7*). A typical piece of mythicizing was his seamy replica of an infamous 1943 bordello, 'Roxy's', oppressive in its period furnishings, skull-headed madam, decayed working girls, MacArthur-portrait decoration, and its proliferation of horrific minutiae (*Ill. 128*).

127 (above) EDWARD KIENHOLZ
Back Seat Dodge-38 1964.
Tableau, 240 × 144 × 66. Kienholz started making these 'tableaux' in the late 1950's; they range from intricate replicas of entire rooms to graphic satirical swipes at the American way of life, as in this Lovers' Lane scene complete with beer bottle tossed out on the grass

128 EDWARD KIENHOLZ
Five Dollar Billy 1963.
From Roxy's Tableau.
Mixed media, life size

Three artists connected with both the San Francisco and the Los Angeles milieu should also be mentioned as antecedents of West Coast Pop. Wallace Berman, personally a direct link between the Beat poets and the Assemblage movement, was a formative influence in the 1950's, though his own work in the mode, like that of most of the other Assemblagists, had less relevance to Pop than Kienholz's and belongs, rather, to the Surrealist-poetic-mystical side of the movement. He was also, however, doing (in the 1940's) detailed pencil drawings of such Pop figures as Harry the Hipster and Nat King Cole, and now, no longer making assemblages, he works in a new photomontage-verifax-produced technique which relates both to Pop and to his earlier concerns. One of the very few Californians to use mechanical reproduction (the verifax machine) and to experiment with a repeated image, Berman's effects nevertheless remain subtly personal; he exploits the possibilities of verifax shading for a wide range of sepia, mood-ridden variations. His tenebrous montages include Cocteau, anonymous bodies, schemata, news-like photos of vaguely sinister events, Hebrew letters (*Ill. 129*). The tough-minded strain of visual Surrealist poetics with which he may be associated is a potent force in California and relevant to the current Pop movement.

129 WALLACE BERMAN *You've Lost That Lovin' Feeling* 1965. Verifax, $6^{3}/_{4} \times 9^{1}/_{4}$. Berman invented this 'collage' technique after finding an old verifax machine in a friend's studio. Contradicting the machine's *raison d'être*, he makes unique examples with it

130 JOHN WESLEY *Squirrels* 1965. Oil and liquitex on canvas, 30 × 48

Jess Collins is another precursor of Pop Art who has had connections with the San Francisco poets and whose work shows a distinctly Surrealist tinge. Currently he paints thicky impastoed Picabia-esque images which have no direct relation to Pop, but from 1953 to 1959 he did a series of seven comic-strip collages called *Tricky Cad* (*Ill. 131*), in which, working within the given newspaper format of the Dick Tracy panels, he condensed a number of the original sequences by skilful cutting and pasting; the resulting 'Cases' were surrealistically distorted, punning, and wittily altered sets of comics. He has also done transformations of Big Ben Bolt and Lance Comics which (in his own words) 'single out the homo-erotics of the original material'.

One further aspect of the West Coast Pop movement can be traced back to, among other sources, the ironic, Dadaistic anti-aestheticism that emerged in San Francisco in the mid-1950's, in part a reaction to the Rothko-Still influence and in part an embodiment of anti-East Coast, anti-Abstract Expressionist feeling.[1] Wally Hedrick's work at that time embraces some of these atavistic attitudes and is prototypic as well in its Pop subject matter, e.g., ironic junk sculpture made of beer cans, decorated television cabinets

131 JESS COLLINS
Tricky Cad (Case VII) 1959.
Newspaper collage, 19×7.
An ambiguous Surrealist comic-strip
made by clever fragmentation of
Dick Tracy

132 RICHARD
PETTIBONE
Flash 1962-63.
Assemblage in bo
9 × 11 ¹/₂

and radio parts, paintings of images such as an American flag containing the ironic inscription 'Peace' (*Ill.14*), or a crudely delineated train with the cartoon phrase 'Chug!' above it. Dadaism has in recent years had as large an appeal on the West Coast as in New York and must be attributed its share of influence in the Pop movement; an already lively interest was stimulated even further by the large Duchamp retrospective at the Pasadena Art Museum in 1963. Among non-local influences, the work of Jasper Johns has been particularly apposite, and should be mentioned in this context.

No doubt because of such antecedents, Pop Art has developed some of its own peculiar West Coast variants. Except for the paintings of Mel Ramos and Edward Ruscha, California painting seems utterly lacking in the bright brassiness of much East Coast Pop. There is a notably Surrealist cast deriving not from the irrationality of juxtaposition, but from the common object isolated, uprooted, placed in an undefined or vacant space, a hostage to commercial fortune. There is also a perceptible lack of interest on the West Coast in the straightforward mechanical reproductions typical of Warhol, or in the exclusive use of a 'found image', as in Lichtenstein. Furthermore, one should note that Pop Art has probably played a much more aggressive role

146

among local styles in California than its counterpart in New York, where the mode insinuated itself into an already active, various, and partially hostile *avant-garde*. On the West Coast, and this is especially true for the fluid Southern California scene, Pop Art has rightly been considered the active ingredient in a general housecleaning that during the past three or four years has all but exterminated the last traces of prestige for local and imitative versions of Abstract Expressionism, for second-generation Bay Area figurative, and for stillborn Lebrun–Mexican–Expressionism; in other words, it has functioned most significantly as a transitional art, an opening wedge.

Yet the distinction between Pop Art as a newly figurative American subject matter ('capitalist realism') and Pop Art as a usable set of novel artistic formal conventions (an aesthetic strategy) still tends to be muddled; not that such confusion of matter and manner is necessarily restricted either to this geographic locale or to the Pop movement in general. An extraordinary number of makers of movements in both the literary and visual arts have, with a certain ardent *naïveté*, claimed that their new, seemingly unkempt vitality was simply a 'return to life' after the jettisoning of stale aesthetic conventions from an immediately preceding style. After the brouhaha, however, these returns are seen to be a new set of conventions; nor is it unusual, as is the case with Pop Art, that the fresh conventions are drawn from some previously infra-aesthetic mode. Northrop Frye writes, 'It is difficult to

133 MEL RAMOS
Photo Ring 1962.
Oil on canvas,
10 × 12

think of any new and startling development in literature that has not bestowed glass slippers and pumpkin coaches on some sub-literary Cinderella.... In itself it [the sub-literary world] is made up of the most rigidly stylized conventions: the primitive, like the decadent, is inorganically conventional, and what it suggests to the artist is not new content, but new possibilities in the treatment of convention. In short, it is not the world of ordinary life or raw experience, but a suburban literary world.'[2]

Similarly, the central novelty and perhaps most fruitful aspect of Pop Art obviously consists not in its concentration on common objects (which, after all, have appeared sporadically throughout art history since seventeenth-century Dutch genre painting), not in its popular culture subjects (which provided material for earlier generations), nor in its 'questioning' of the nature of the relationship between depiction and reality (all art since 1890 does that), but in its sanction of advertising, illustration, and commercial art conventions as well as techniques for the presentation of these, or any other figurative subjects, in a context of 'high art'. But the movement itself, and particularly in California, cannot be characterized solely on the puristic basis of these novelties of style, since the typical common object or mass-media subject has also been widely prevalent on the West Coast, if with less original results, for certain artists whose styles have not been simultaneously affected by any of the newly elevated commercial conventions. The converse of this statement is also interestingly true – i.e., that there are a number of artists on the West Coast (and this may include some of the most advanced work now being done in California) whose style, rather than subject, has been influenced by what might be called a Pop stance. Though these artists fall outside the scope of this present survey, it seems correct to mention here that one of the major significances of the Pop temper on the West Coast is in the way it has permitted the evolution of an ascetic, mechanistic, and highly polished formalism – a style which may have learned its ironic distance and commercial sheen from Pop, but not its abstract iconography.[3]

The paintings of Billy Al Bengston bridge the gap between this new California formalism and Pop Art. Born in 1934 in Dodge City, Kansas, Bengston lives in Los Angeles, where he has been influential in asserting the value of a pristinely perfectionist technique, as well as in suggesting through his work the aesthetic potential of industrial materials. He is best known for his emblematic series of chevron paintings, on which he has worked since

1960 (*Ill. 125*); but these were preceded and accompanied by a group of similarly heraldic images in which the central motifs are hearts, irises, and, in 1961, an especially Pop sequence including one atypical painting of a total motorcycle (*Ill. 126*), but otherwise based on the theme of isolated motorcycle parts. Early chevron images were located on square chequerboard backgrounds or in modulating atmosphere; other motifs are sometimes surrounded by Noland-like targets. Most recently his chevron paintings have been done with oil lacquer on masonite, exploiting a spraying technique related to hot-rod striping and achieving a finesse that would have satisfied Léger's criteria that 'nowadays a work of art must bear comparison with any manufactured object'. They are simply organized, but complexly elaborated formal compositions in which a central, factually stated ('real') chevron is caged by a circle and slyly played against symmetric rotations of flickering colours; the luminous forms suggest both fluorescent and astral lights, both hard-sell and subtle galaxial order. Surface gloss confutes illusory depths. The chevron, which, on the one hand, is treated this side of idolatry in the entire sequence, also, ironically, evades its literal militaristic meaning; it functions primarily as a 'bringing down' device, a method for undercutting formalist pretensions, an anti-aesthetic handle.

Edward Ruscha, especially in his most recently exhibited sign and gasoline-station paintings, also concerns himself with a hermetic and icy perfection of style. His combination of an original imagery based on the signs and products of commerce with an impeccable lettering and design technique taken from advertising conventions, brings him closer to 'pure' Pop than any of the other artists working in the style on the West Coast; but he, too, like the other Californians, shows little or no interest in deadpan reproduction of a ready-made image, preferring instead to invent his own ironic commercial iconography. Born in 1937 in Omaha, Nebraska, Ruscha came to Los Angeles in the late 1950's and studied at the Chouinard Art Institute. Early sign paintings in 1961 and 1962 are bold but less austere than his more recent work, sometimes incorporating painterly variations of texture in letters, sometimes employing an indulgently thick impasto, and sometimes including an image of the product referred to in the sign (e.g., the falling Spam can in a shower of drips and spatters from *Actual Size* [*Ill. 134*] or the Fisk tire of *Falling But Frozen*). Surgically stark, his subsequent paintings eschew all painterly gesture and move in a direction that heightens the Sur-

134 EDWARD RUSCHA *Actual Size* 1962.
Oil on canvas, 71 × 67

135 WAYNE THIEBAUD *Candy Cane* 1965. Oil on cardboard, 9 × 5 ¹/₂

136 EDWARD RUSCHA *Standard Station, Amarillo, Texas* 1963. Oil on canvas, 121 $^1/_2$ ×65. Ruscha also made a small, totally deadpan book from ordinary photographs of twenty-six gas stations across the United States

realist flavour already implicit in the ambiguously dislocated words of the early signs; now individual letters of such words as 'Boss' or 'Radio' fall victim to distorting minatory clamps, which add an ominous irrationality not usually associated with Pop Art. A huge painting of an isolated gas station with sharply delineated perspectives into airless lunar space and engineer simplifications (*Ill. 136*) reminds one of Charles Sheeler and, by extension, of the Immaculates, painters whose semi-abstract distillations of the industrial American landscape are not unrelated to aspects of the current Pop mythicizing of mass-media America.

Joe Goode, on the other hand, makes no such attempt at mechanistic finish; the Pop element enters not through style, which is painterly and animated in brushstroke, but through his Johnsian inclusion of the deracinated actual or represented common object. Born in Oklahoma City in 1937 and a fellow student with Ruscha at Chouinard, Goode began drawing and painting isolated household objects such as telephones or baby rattles in 1960. Subsequent paintings (Goode conceives of his work in terms of related series) included real milk bottles painted and perched on narrow platforms built out from the bottom of a single-colour-field canvas (*Ill. 137*); a second series contained anonymous house images freely sketched on bare, quasi-geometrically shaped areas in the centre of the colour field; and currently

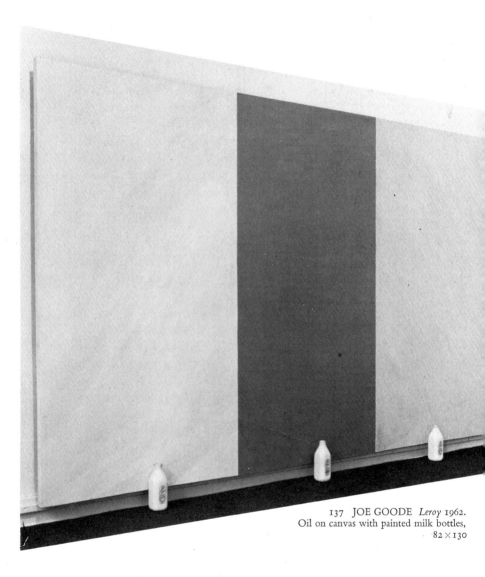

137 JOE GOODE *Leroy* 1962.
Oil on canvas with painted milk bottles,
82 × 130

he is at work on a group of window paintings and staircase sculptures. His
exploitation of such common objects contains only the merest murmur of
irony and no impudence, the precedent of Johns being enough to nullify the
possibility of such a self-conscious stance. Instead, as Goode has remarked in
conversation, he intends the familiar anonymity of the objects or images he
chooses to function idiosyncratically for each view – permitting a wide

range of individual emotional responses. As a trope for an undefined, yet particular, experience, the common object acquires here a patina of nostalgia; scale, i.e., the smallness of modest object in relationship to the largeness of field, further adds a suggestion of Surrealist dislocation to Goode's work.

Two Sacramento artists, Wayne Thiebaud and Mel Ramos, work in Pop styles which derive in paint quality from the Bay Area figurative school. Born in 1920, Thiebaud comes from Mesa, Arizona, and is Associate Professor of Art at the University of California's Davis campus. Of all the West Coast Pop artists, he has probably received the most extensive national attention for his still-life paintings of assembly line cafeteria goodies and his neon-lit bakeshop specials (*Ill. 138*). He deals in characterless repetition (a row of identical pastries, a shelf of lipstick tubes, a wall of pinball machines) and hygienically vacant settings. His subjects, though isolated, are solidly three-dimensional and cast shadows (*Ill. 135*). His fusion of the California school luscious and brilliant hued paint with a drawing technique based on the conventional simplifications of illustration has produced, in his pastries and other foodstuffs, an accessible, bright, and synaesthetic style. He has written that he is interested in 'what happens when the relationship between paint and subject matter comes as close as I can get it – white, gooey, shiny, sticky oil paint spread out on top of a painted cake to "become" frosting.

138 WAYNE THIEBAUD *Window Cakes* 1963. Oil on canvas, 60 × 72

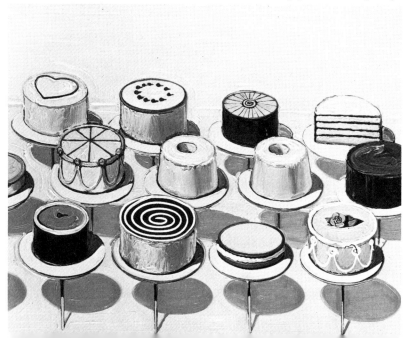

139 VON DUTCH HOLLAND *Helmet* 1962. Oil paint on motorcycle helmet, 10 in. diameter. Holland is a professional painter of custom cars, not an 'artist'

140 JIM ELLER *Scrabble Board* 1962. Mixed m 14 × 14. An actual 'Scrabble' board, with the word spelled out for a low score of three, could refer to land's *Helmet* (*Ill. 139*), owned by Eller

It is playing with reality – making an illusion which grows out of an exploration of the propensities of materials'.[4] This relationship has less relevance to his more recent figures, which are clearly representational, but share with the common objects the anonymous tone of mass production. In human form this anonymity becomes bovine, thoughtless inanity – the personality-free *lumpenbourgeoisie*, but wrapped in a slick package. Moral comment is implicit. If Thiebaud liked his subjects better, these paintings would be straight illustration.

Like Thiebaud, with whom he shares an oleaginous paint technique, Mel Ramos, born in 1935, studied at Sacramento State College. In 1962 and 1963, Ramos painted the over-developed heroes and heroines of comic books – Batman, Crime Buster, and Glory Forbes-Vigilante; his stated intention was to celebrate them in a straightforward manner (*Ill. 133*). Since then he has gone on to other fantasies, the nameless, clothesless heroines of the girlie circuit and garage calendars. Compared to most West Coast Pop Art, Ramos has a brassy vigour and a flagrant appetite for the vulgar. His technique is to juxtapose a three-dimensional, commercially 'real' figure against an emblematic, flat scheme. Initially he included the name of the character heroized; recently his American Women emerge from brand-name products and smile against background trademarks or, without all the commercial hoopla, just peep provocatively from heraldic keyholes.

A painterly quality, but considerably relaxed and non-edible, is also apparent in the work of two Los Angeles painters, Phillip Hefferton and Robert O'Dowd, both of whom have painted huge blow-ups of gag-store money. Hefferton's loose, ragged brushstroke and distortions of scale describe such slapstick visual jokes as eye-winking presidential images, dripped paint on bills (*Ill. 143*), the artist as treasurer, and George Washington sinking below the financial horizon. O'Dowd's style of bill-making has been even more wanton, wiping out governmental heroes left and right with a free-wash technique (*Ill. 144*); now he makes silver-coloured gift boxes. Anthony Berlant also constructs Pop boxes, but in the shape of toy houses and papered outside with colourfully printed metal, patterned cleanly with decorative motifs – Coca-Cola, Chiclets, flowers, maps, books, apple cider. His construction paintings relate to work by Dine and Oldenburg and are on the subject of clothes, often presenting the variously dressed female torso in the arm's-length position, extremities neatly amputated by canvas edge

ANTHONY BERLANT
Les Six 1964.
Glued cloth and paint,
36 × 36

142 VICTOR DUBREUIL *Money to Burn* 1893. Oil on canvas, 24 × 32. An early prototype of the Pop mania for money as a subject, also explored by Larry Rivers before Warhol, Hefferton, and others made their contributions

(Ill. 141). Others are male figures or bodiless shirts; all exploit fabric-counter stock (cotton prints, nylon netting, corduroy, oilskin, stuffing, padding and lace) in combination with paint to make tidy collage compositions. Richard Pettibone is currently making exact miniature copies with subtitle labels of the paintings in various local collections, many of which are Pop; prior to this *reductio ad absurdum* he made small box constructions *(Ill. 132)* and paintings on glass which incorporated comic-strip characters, simplified cartoon drawings, and racing cars. Roger Kuntz takes the California freeway system for his subject, and does painterly landscape vistas of signs, ramps, tunnels, and the road itself; some are close-ups in which the sign is the painting *(Ill. 147)*, but others retain an American regional landscape mood *circa* 1930. He has also made metal sculpture out of traffic signals in argus-eyed clusters. James Gill uses a grease-crayon-and-paint combination to reveal people 'in the process of'. Often he mimics the effects of excerpted frames

143 PHILLIP HEFFERTON *The Line* 1962.
Oil on canvas, 71 × 47 ½.
Lincoln rises again over the confederate landscape

144 ROBERT O'DOWD *$5.00* 1962.
Oil on canvas, 72 × 48

145 ROY LICHTENSTEIN *Ten Dollar Bill* 1956. Lithograph, 10 × 18 ¾

from a film strip, or fixes a transient television image; he has presented such Pop subjects as Marilyn Monroe, John Wayne (*Ill. 146*), and President Kennedy, investing these with the anxiety behind the news. Vija Celmins does realistically described portraits of isolated smoking objects, a just-fired pistol, steaming matzoh balls in chicken soup, cooking eggs, and a selection of turned-on electrical appliances. The isolation of object against empty background makes for comedy, in this instance, rather than Surrealist effects; most are warmly domestic pictures, and even the pistol has a fireside cosiness about it. John Altoon's painting is not in the Pop genre, but in 1964 he did a series of large drawings, parodies of familiar advertisements such as the Tabu (perfume) violin lesson or the Bell Telephone 'Here is one repairman who *doesn't* send a bill'; others in the series mock usual fashion poses. The central joke is the unexpected publication of the principals' privates.

Though many of the California artists discussed above had obviously begun painting and showing work in relevant modes from about 1960 on, Pop Art as a national phenomenon with a name and collective characteristics did not make its dramatic public début on the West Coast until mid-1962. In July of that year, Irving Blum of the Ferus Gallery arranged to show a series of Andy Warhol's Campbell Soup can paintings together for the first time in an exhibit that proved extremely provocative and virtually announced the advent of Pop in Los Angeles. In September, 1962, at the Pasadena Art Museum, Walter Hopps arranged what was probably the first museum show in the country for the new movement, entitled 'The New Painting of Common Objects' and containing work by Lichtenstein, Dine, Warhol, Hefferton, O'Dowd, Ruscha, Goode and Thiebaud, some of whom had not yet had gallery shows. In November, 1962, the Dwan Gallery, directed by John Weber, mounted a large Pop-oriented show labelled 'My Country 'Tis of Thee', in which the subject of Americana was presented in works by Lichtenstein, Wesselmann, Indiana, Johns, Marisol, Oldenburg, Warhol, Raysse, Frazier, Chamberlain, Kienholz, Rauschenberg, Rivers, and Rosenquist. Another major event, in July of 1963, was the arrival of the travelling version of Lawrence Alloway's Guggenheim show, 'Six Painters and the Object', at the Los Angeles County Museum; to accompany the Los Angeles showing, Alloway selected a group of West Coast artists for a concurrent exhibition entitled, succinctly, 'Six More', and prepared an accompanying catalogue; California painters included were Thiebaud, Ra-

146 JAMES GILL
John Wayne Triptych,
left-hand panel 1964.
Grease crayon on masonite,
48 × 93

147 ROGER KUNTZ
101 1961.
Oil on canvas,
40 × 50

mos, Bengston, Goode, Ruscha and Hefferton. The next significant Pop show on the West Coast was the September 1963 Oakland Museum exhibit, 'Pop Art, USA', organized by John Coplans, who also wrote the catalogue essay; this show was billed as 'the first to attempt a collective look in considerable depth' at the Pop movement, and endeavoured to reveal the nationwide character of Pop Art by including many West Coast figures as well as the major East Coast artists working in the style.

The galleries most intimately and enthusiastically involved with Pop in Los Angeles have been the Ferus and the Dwan. Both have exhibited key precursors of the movement (Johns at the Ferus, Rauschenberg at the Dwan, Kienholz at both galleries) and have made much of East Coast Pop easily available to Californians (the Ferus has given several shows to Lichtenstein and Warhol; the Dwan has exhibited Oldenburg and Rosenquist in one-man shows, plus most of the other East Coast Pop artists in group shows). In addition, both galleries have been showcases for West Coast Pop Art. The Ferus Gallery, in particular, has concentrated intensely on supporting the most advanced local painting. The Dwan, on the other hand, primarily exhibits relevant New York artists as well as representatives of the French Nouveau Réalisme, but in several interesting large theme shows, such as 'Boxes', 1964, and 'The Arena of Love', 1965, has also shown local Pop Art along with East Coast work. The Rolf Nelson and the David Stuart galleries, too, have been notably hospitable to California Pop Art and both have given group and one-man shows to new young talent in the mode; the Rolf Nelson Gallery has also presented such Pop events as the 'Blink' show in 1963. A number of local collectors, Dr and Mrs Leonard Asher, for example, have acquired West Coast paintings in the Pop genre, and the Los Angeles County Museum now owns work by at least several of the leading California Pop artists. But perhaps the major West Coast stimulus has been the vocal and partisan presence of the magazine *Artforum*, which in the past three years has given careful attention to both local and national Pop Art as a movement.

There has been, then, a demonstrative enthusiasm for Pop Art in California. A desire to celebrate and assimilate the new is obviously not unique to the West Coast today. In the context, however, of an artistic community just perceptibly though noisily inching away from a provincial past, it is significant that the new interest and vitality should, at least in its inception,

have been linked with the emergence of Pop Art, rather than, say, 'post-painterly abstraction'. When New York School painting, based on a broadly European and modernist heritage, removed the sting of provincialism from American art in general, it had no such profoundly invigorating effect on California. The paradox, of course, is that Pop Art, a movement in its own way as native in matter as the nineteenth-century landscape school, the urban 'Eight', or even (and the comparison is not too extreme) the 1930's region-alists, should play the cosmopolitan sophisticate.

148 JOHN WESLEY *Holstein* 1964. Oil on canvas, 50×60. Wesley leaves the spectator to draw his own conclusions about this combination imagery, presenting it impassively, rather than exotically as the Surrealists might have done

149 ROBERT RAUSCHENBERG *Overdrive* 1963. Oil and silk-screen on canvas, 84×60

Pop Icons

Nicolas Calas

Since modern art became the art of the Establishment, its opponent has been anti-art. The dispute between the champions of art and the sponsors of anti-art brings to mind the famed eighteenth-century quarrel between the proponents of the art of the ancients, in the name of perfection, and those of the moderns, in the name of progress. Today modern art is viewed in terms of art history, and anti-art in terms of 'life'.

During the 1920's, Surrealism was Cubism's anti-art, as Pop Art is the anti-art of Expressionism. In the 1937 *Portrait of a Lady,* Picasso reinterpreted Cubist multiple planes in psychological terms, suggesting split personality by fusing the side and front view of a face into one; the second eye is between two noses, or the two eyes are shown frontally and the single nose in profile. [1] The distance between his Cubist *Fernande* and his Surrealist Dora Maars might be measured in terms of the distance between Apollinaire and André Breton.

During this, the seventh decade of our century, doctors of philosophy would prefer to 'pre-empty' Pop Art of anti-art. Study of paintings in terms of basic patterns zeroes the difference between Roy Lichtenstein and Nicholas Krushenick; concentrically zeroes that between Jasper Johns and Kenneth Noland; squares that between Andy Warhol's bouquets and Josef Albers' rectangles. If form is the basic criterion for judging art, then why not also compare a basic pattern of two different paintings to analogous patterns found in nature? Why not compare the dots of a Lichtenstein to the spots of a ladybird, and Poons' dots to the dots of that other insect, known to the uninitiated in entomological classifications as a false ladybird? Don't let us *pointilliste* our eyes! The integration of anti-art into art is undoubtedly a valid preoccupation, allowing the erection of partitions. What would museums do without walls? If the critic's role is to establish that anti-art is art, perhaps a sibyl will prophesy the coming of anti-critics.

Let us enjoy images as images, as we enjoy games for the sake of playing. Addiction to images is a dream derivative. To be communicated in visual

terms, sights seen, whether in sleep or in the world around us, must be given form in a selected medium. Since a reproduction is not intended to be confused with its original, the artist in his painting will include only those aspects of the beheld which he either wishes to or is able to reproduce. Pictures of reality or of dreams that have crucial cultural impact are icons. In our century the first great icons are Cubist. Thus, in his post-Euclidian vision, Picasso projected on a single plane a synthetic view of the multiple planes of a man playing the violin.

From the Book of Daniel and from our dreams, we have learned that the key images are those of people and places. Portraits and landscapes are the bread and wine of painting. Let them be nourishing and appetizing, fermented and stimulating! The early Cubist paintings are exquisite. The guitar, the bottle of wine, the *journal*, the stilled cinematic descent provide glimpses of those non-Dutch interiors where the sophisticated *bourgeois* speculated on Bergson, Apollinaire, and Jaurès. The Cubist's dissection of form corresponds to the socialist's critique of institutions and to the psychologist's analysis of man. Cubism endowed us with a post-Ptolemaic 'Fayum' image

151 ALLAN D ARCANGELO
Flint Next 1963.
Liquitex on canvas,
70 × 60

(*opposite*)
Y LICHTENSTEIN
ple of Apollo 1964.
and magna on canvas,
× 128

152 GIORGIO DE CHIRICO
*The Amusements of a
Young Girl* 1916.
Oil on canvas,
$18\,^1/_2 \times 15\,^3/_4$

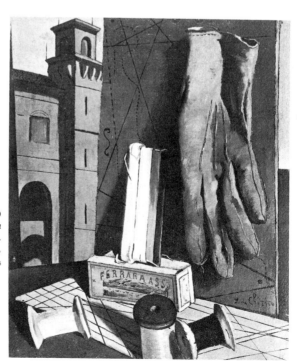

of man (a preview of Byzantine icons), but not with a post-Copernican view of the world. The Industrial Revolution outspeeded clocks, but the Futurist's view of the phenomenon remained trivial, and was exploded by de Chirico in the name of anxiety. Moreover, with de Chirico's biscuits, matchboxes, and fish mould, anti-art elements were introduced into modern art (*Ill. 152*). From his *Gare Montparnasse* back to Palladio, through a metaphysical reality, a world of false dreams is unravelled. Anxiety is indirectly derived from the Greek word *gonier* (corner). De Chirico, Ernst, Magritte, Tanguy are cornered. What relics are to worshippers of icons, Dada and Surrealist objects are to the devotees of modern icons, i.e., things that possess an element of magic, of having been made without hands, as Marcel Duchamp's term 'ready-made' implies; of having been assembled by a mysterious force – the Surrealist found object.

Difficulty of legibility is what Cubism and Surrealism have in common; Cubist statements are not clear; Surrealist meanings are obscure. Matisse and Léger are undoubtedly the twentieth century's great masters of clarity, and their influence today on both Pop and abstract artists is indisputable. Their ability to simplify is admirable, but I object to the casual manner in which they treat their subject matter. Are Matisse's odalisques pure imitations of Persian women, or are they *Vogue* imitations of French women? Are Léger's workers militant members of the proletariat or performers of a *ballet mécanique*? This weakness of Matisse becomes glaring when we look at Wesselmann's *Great American Nudes* – prototypes of America seen through the mass media (*Ills. 64, 90*). The weakness of Léger becomes obvious when the paintings are re-examined through the middle-class character of Léger's proletarianism. Pop artists, by forgetting even the immediate past, focus their attention on the 'positivism' of the present.

After the fermented light of the Impressionists, the aromatic pines and apples of Cézanne, the intoxicating colours of the Fauves, the alcohol of dreams of the Surrealists, defeated Paris was reduced to the imageless insomnia of Existentialism. The centre of art moved to New York. With the self-assurance of Periclean Athens, New York mixed its Doric and Ionic elements. American Abstract Expressionism detached automatism from the Surrealists' imagistic painting and, in so doing, liberated abstract art from its ob-

session with geometric form. Now we can make and appreciate the distinction between automatic abstraction and calculated abstraction. Historically, abstract art has its roots in Protestant and Judaic iconoclasm. It should be born in mind that France is the only great power in Europe which, due to the atheist spirit of the Revolution of 1789, passed from the medieval Catholic religion to the modern world without going through the iconoclastic phase of Protestantism. In France all the great movements of modern art, from Impressionism to Surrealism, experimented with images. Max Ernst, the most important German Surrealist painter, comes from a Catholic family. In England and in the United States, two countries with a Protestant culture, the current battle for the image is waged on behalf of a previously scorned image, the popular advertisement of consumer goods. The lowly ad is easily viewed as anti-art. An orthodox Surrealist sees no virtue in its use since the ad lacks reference to the esoteric. Surrealism opposes the dream to daydreaming and the myth to reality. Furthermore, emphasis on consumer goods is offensive to the Surrealist on ideological grounds, for he rates production over consumption. Iconoclasm explains why many abstract artists are more shocked by Pop artists' profanation of images than angered by their rejection of abstract art.

Lichtenstein, Wesselmann, and Warhol are no more Pop artists in the original British sense of the term than were Duchamp or Léger Futurists in the Italian sense. If the Italian Futurists had a Vulcan complex, the British Pop artists can be said to have a cornucopia complex, that is to say, a love-hate attitude toward America's wealth as they envisage it through the glossy American magazines.[2] In New York, ready-made vernacular images were first convincingly introduced into works of art by two former Abstract Expressionists, Larry Rivers and Robert Rauschenberg. Followed by Jasper Johns, Jim Dine, and Claes Oldenburg, these artists disfigure the ready-made image to adapt it to an over-all indeterminate pattern. Lichtenstein, Wesselmann, Warhol, and D'Arcangelo interpret the ready-made image in terms of calculated abstraction. With the former, the process of making is frequently interrupted by accidents, and with the latter, the formation of images conforms to a definite pattern.

In terms of significance these tendencies are complementary. We would be like the naïve Pre-Raphaelites looking at Botticelli without remembering Piero della Francesca if we included in our collection of icons Lichtenstein

153 LARRY RIVERS *Dutch Masters and Cigars* 1963. Oil on canvas, $96 \times 67^3/_4$. Rivers took his popular subject matter from America's past and its picturesque aspects, rather than from new commercial motifs

but not Rauschenberg, Rosenquist but not Rivers, Wesselmann but not Katz. But D'Arcangelo belongs and Fairfield Porter does not. By this I do not mean that the aesthetic contradictions of our time have to be resolved in terms of the humanist's concepts of beauty and truth. The contemporary imagists are searching for ways of assimilating a pictorial experience embracing the miniature comic-strips and the giant billboards. The illustrated weeklies demonstrate that the reproduction of *The Syndics* by Rembrandt can double as the trademark of Dutch Masters cigars. Why not also include a third version – Larry Rivers' painting of the Dutch Masters ad (*Ill. 153*)? Is a ruined Greek temple a historical monument or a TWA ad? What if it turned out to be a Lichtenstein (*Ill. 150*)?

Reproduction of the masterpiece refers to an object that is priceless because it is evaluated in historical terms, while the advertisement employing the historical piece refers to a commodity – a pack of cigars or an aeroplane ticket. Unlike the reproduction of the masterpiece that is meant to evoke the past, the ad encourages us to forget the past by inviting us to satisfy

transient urges, to smoke or to travel; the picture of a 1966 Chevvy makes us forget the 1965 Chevvy; the beauteous Miss Rheingold distracts us from the home where beer is drunk without her. Surrealism sought to overcome the contradiction between desire and reality on the plane of a super-reality. Pop Art deals with a reality that is apt to be the printed reproduction of an image. However, the identification of the reproduction with its model is blocked when we realize (with the help of a magnifying glass) that the image dissolves into the pattern of the grid formed by the Ben Day dots. The grid's network is the threshold on which the reproduction and the printing process meet on an anti-image level. When Lichtenstein focuses on this threshold he forcefully dissociates his blown-up view from the comic-book universe. Jasper Johns achieved similar effects in the mid-1950's when he fused the design of the Star-Spangled Banner with the brushstroke patterns of the encaustic surface (*Ill. 15*). Pop Art can be anti-Pop. Dissociations permit one to dismiss and, eventually, to forget the original. In their time, Surrealists such as Magritte, Tanguy and Ernst reawakened buried instances of a personal past and evoked that which is most difficult to remember: the dream, wherein the past is represented under a disguise or mask. But Lichtenstein and Johns chose to veil appearances more lightly by simple technique – grid or encaustic – which add an element of the unexpected without hiding identity. While the Surrealists' effects presented enigmas and masked faces, the effects of the younger men can be best likened to the recognition of a face despite unaccustomed sunglasses – as in Alex Katz's *Ada with*

154 JAMES ROSENQUIST
Untitled 1965.
Oil on canvas,
50 × 60

155 ALEX KATZ
British Soldiers 1961.
Painted wood, 65¹/₄ × 50¹/₄. These fig-
ures were made as stage properties for a
play by Kenneth Koch. In addition there
was a cut-out of Washington Crossing
the Delaware, a subject also treated by
Rivers

Glasses. With Rauschenberg, Rivers and their kin, the procedure varies in that they resort to disfiguring the image with brushstrokes and drippings. Either method aims ultimately at personalizing the image.

Lichtenstein has been criticized for his false madonnas. Similar objections could be raised against Wesselmann for degrading the nude, D'Arcangelo for counterfeiting the road to Bethlehem (*Ill. 151*), Rosenquist for crashing sacrifices on the road[3], and Warhol for his hot-selling sepulchral flowers (*Ill. 108*). Art is not a tranquillizer. 'Pop Art looks out into the world', says Lichtenstein. The Pop artists look out on the world through reproductions. They paint it the way the Surrealists painted the dream – photographically. Having rejected the role of spiritual sons to some great master, both the Surrealists and the Pop artists have been viewed as anti-artists. The major difference lies in their attitude. Whereas the Surrealist's is lyrical, that of the Pop artist is cool. Therefore the reaction to the Pop image should be cool. Whether that image is or is not a work of art is a secondary consider-ation. Does the worshipper of an icon of his patron saint care whether the representation is a masterpiece? The icon is for use, when warm for prayer, when cool for companionship. The same applies to the Pop artist's relics: the dead as lead flashlights of Jasper Johns (*Ill. 157*), and the hand-made metal chocolates or hot dogs (*Ill. 156*) of Robert Watts, subtracted from the superficial world of imitation, occupy a place in a reality from which identity has been excluded. Robert Morris' *Swift Night Ruler* stirs our sensibility through our inability to distinguish the correct measure from the false; Kuriloff's fuse boxes (*Ill. 158*) are set in the twilight zone between function and uselessness. Pop Art discovered the Surrealism of the understatement.

156 ROBERT WATTS
Hot Dogs 1964.
Chrome-plated lead

157 JASPER JOHNS
Flashlight 1960.
Bronze and glass,
$47^{7}/_{8} \times 8 \times 4^{1}/_{2}$

158 AARON KURILOFF
Fuse Box 1963.
Mounted on wood,
$15 \times 12 \times 4$

Europe and Canada

The further in spirit the cultural heritage of a country is from that of America, the more tenuous is the bond between Pop Art and related manifestations in that country. There is no hard-core Pop Art in Europe, although there are a few artists in Germany, Italy, and France who approach either its subject matter or its techniques. This is true for a number of reasons, one of the simplest being that a different tradition and living conditions produce a different art. For all the current talk of an international style of abstraction in the 1950's, *tachisme*, Abstract Expressionism, and *art autre* only superficially resembled each other. If there are no longer distinct national styles, there is still a healthy diversity of attitude.

Pop Art in particular seems to be the product of an affluent, even Anglo-Saxon, society. It is also produced by and consequently directed at the post-war generation – artists who were growing up during World War II. One need only compare the childhoods of a Frenchman, an Italian, a German, an Englishman, and an American who grew up between 1938 and 1945 to understand the fundamental differences in their art. This also explains why Germany, which with its ultra-modern industrial society would seem an ideal breeding ground, has produced little Pop Art. For everyone but the Americans, especially for the Latin countries, Americanization has an exotic appeal. It may be despised, romanticized, glamourized, idealized, but it is rarely taken for granted. By emphasizing the picturesque, the ominous, the satirical aspects of commercial subject matter, the Europeans are being true to themselves. Although there is little chauvinism in the ranks of Pop or New Realism, popular styles are superimposed upon indigenous traditions which alter them considerably. To create a genuine Pop Art, a European artist would have to disentangle the Pop motifs of Americanization from his own heritage; a clean break is usually impossible as well as undesirable.

159 TANO FESTA *Detail of the Sistine Chapel* 1963. Oil and collage on canvas, *c.* 76×51

160 NIKI DE SAINT-PHALLE *Ghea* 1964. Assemblage on wood, 66 1/4×41

161 JOYCE WIELAND *Young Woman's Blues* 1964. Painted construction, 20 1/2×12 1/4×8 1/2

162 H. P. ALVERMANN *Portrait of an Electric Pater* 1963. Object, *c.* 5 ft high

The European urban arts are called 'new realism', a term most Americans or English would forego because of its philosophical implications. Pierre Restany's group, christened the Nouveaux Réalistes on 16 April 1960 in his first manifesto (written on the occasion of an exhibition at the Galleria Apollinaire in Milan), is by far the most important and seminal of these. For most of the artists associated with Restany, the transposition of a single commercial image or object on to canvas without apparent alteration would be unthinkable; it would be too simple, too lacking in intellectual challenge. As Annette Michaelson has pointed out: 'If anything defines French sensibility as expressed in its art and intellectual life, it is the enormous range of an apprehension of reality which expresses itself in the respect for fact and in open acceptance of the sensual, on one hand, and in an enduring awareness of register of possible Transcendence on the other.... One must certainly feel that the limited, historical interest of the New Realism lies in its distinction from American Pop.'[1]

Restany's initial distaste for the work of Warhol and Lichtenstein was expressed in his article on the Sidney Janis Gallery's 'New Realists' exhibition in New York in 1962. He doubted that these two painters would still be talked about in two years, and found that the 'platitude of tones and dry rigour of commercial painting' left the spectator undernourished; he ended by congratulating Janis for bringing to New York this 'revivifying breath from Europe'. Actually, although the title of the show had been borrowed from Restany, the European contributions looked pale, overworked, and strongly Surrealizing compared with the new Pop Art. For the Nouveaux Réalistes are primarily Assemblagists, and there was already a plethora of Assemblage being shown in New York – some better, some worse. Since 1962, critics and museums all over the world have sought to confuse the various New Realisms and Pop Art, but it is clear by now that they should be viewed as two totally separate visual phenomena.

There are, however, significant similarities in the impetus behind both the European and the Anglo-American trends. The return to a New Realism of any kind was born of discontent with the further possibilities of an abstract, spontaneous art. Neither the New Realists nor the Pop artists were interested in the 'new figurations' that stemmed from Francis Bacon or Goya. Both were far more involved with the ordinary artifacts of an industrial and luxury-oriented civilization. Yet the Americans take their daily reality

174

straight, whereas the Europeans are likely to call their sources 'daily mythologies'.[2] Stylistically and formally, the European artist is not as aggressive as the American, but he is given to manifestoes and demonstrations that are ferocious, emotional, and *engagé* in contrast to the 'cool' Anglo-American viewpoint, which spurns group identification. The Parisian attitude toward the New Reality, the 'twin signs' of factory and city, is far more literary. Restany writes of taking a 'metaphysical look at technology', and notes that his artists are concerned with 'quantitative instead of qualitative expression, respect for the intrinsic logic of the materials'.[3] The New Realists, particularly Arman, have explored the aesthetics of 'accumulation', which corresponds to the 'inventory' devices of poets like E. E. Cummings, the exacting and unselective descriptions of objects in the new French novels, and 'the importance of objects, especially artifacts, in the recent films of Resnais and Antonioni'.[4] In addition, Restany promulgates a sociological point of view toward art that holds little interest for Pop artists, although it has provided their critics with food for thought. The American group that had most in common with the New Realists, and corresponded chronologically as well, is Allan Kaprow's circle (including, originally, Oldenburg and Dine), and other proto-Pop figures such as Edward Kienholz on the West Coast or Peter Blake in England. The writings of the New Realists include references to such New York School phrases as the act, the gesture, throwaway and expendable materials. Restany himself has found similarities between his protégés and Rauschenberg or Johns, once comparing César's crushed and compressed automobiles to John Chamberlain's sculpture; actually, their differences and those between most of their respective colleagues are only stressed by such a comparison. César's cars are acts of defiance; Chamberlain merely picked a colourful and available raw material with which to make abstract sculpture. A major factor in the divergence between European and American developments, which began so close but matured so differently, is that the non-relational trend gathering strength in America at the time had no counterpart in Europe.

The first Nouveau Réalisme exhibition, in Milan, included Yves Klein, Tinguely, Hains, Villeglé, Dufrêne, and Arman, but officially the group was formed some months later in Paris, on 27 October 1960, when Raysse and Spoerri were added. César and the Italian Mimmo Rotella also participated in the early group activities, and later Niki de Saint-Phalle, Des-

champs, and Christo joined the ranks. In May 1961, they held their first Paris exhibition – '40° au-dessus de Dada' (40 degrees above Dada) at Restany's Galerie J. The title of this show is significant, for the New Realists had made no attempt to break with the strong Dada and Surrealist tradition still existing in Paris. On the contrary, by pointing to Duchamp's ready-mades as their source, they proudly proclaimed their legitimacy, and it is impossible to overemphasize Duchamp's influence on their activities. While a certain blatant iconoclasm and wit allied them to Dada rather than to Surrealism, Surrealism is the obvious predecessor of many New Realist objects, and its trenchant eroticism is another major legacy. The New Realists rarely let the chosen object speak for itself, as Duchamp's ready-mades (*Ills. 5, 84, 175*), or Johns' ale cans (*Ill. 61*) did, but invest it with a soupçon of mystery and elegance by fragmentation, juxtaposition, or slight alteration. It is not the directness, the banality, the refreshing anonymity of urban reality that appeals to them, but the hitherto unrecognized strangeness latent in every common object, old or new.

Yves Klein, who died in 1962 at the age of thirty-four, was the most influential member of the New Realists. He had virtually nothing to do with Pop Art, but is so important to the entire French *avant-garde* that he must be mentioned here. 'Yves le monochrome', as he called himself, has become something of a legend. In the 1940's he began to work with solid-colour canvases, finally settling on royal blue for most of his work. In April 1958 he produced an exhibition at the Iris Clert gallery in Paris which consisted of an empty room. Because of his extraordinary flair for theorizing the spiritual *tabula rasa*, Klein corresponds in importance to John Cage in America. Otto Hahn has pointed out that Klein's 'colour was given not as the transcription of an emotion but as reality'.[5] The closest Klein came to figuration was his 'body prints', made by manipulating nude models covered in blue paint against white canvases. But he considered all of his efforts – monochrome, air, the fire and water pieces – as realism, saying: 'I am the painter of space. I am not an abstract painter, but representational and realistic.'[6] Klein's activities indicate the breadth of New Realism in comparison to Pop Art, and Klein at least, no matter how pretentiously, humorously, or profoundly, he went about it, did go at least forty degrees beyond Dada.

Most of the New Realists have not gone so far. By transforming the function, and often the appearance, of an object, they create a subjective rather

than an objective reality. Martial Raysse is the only member of the original group to share both image and techniques with the Anglo-American Pop artists, although his style is still lyrical, his approach more intellectual and satirical than theirs. Raysse's *Beach*, 1962, was a *tableau* rather like those of Edward Kienholz, but since then he has moved from dime-store assemblage to Pop painting with experimental touches such as movies projected on the canvas, neon detail, and images photographically reproduced on the canvas. Raysse's art is based on a peculiarly ultra-modern sense of beauty and ugliness; he has made a series of *tableaux affreux* (frightful pictures), and another of 'Made in Japan' pictures which 'improve upon' old-master paintings with lurid colours and patterns. His neon-accented landscapes go nature one better and 'compete with life'. Raysse is from Nice, and his favourite image is appropriately the bathing beauty, preferably sunglassed, and tanned a garish orange or pink tint (if not green) (*Ill. 163*). An exuberant jet-set eroticism and comic possibility pervades all of his work. Related to Raysse in the use of old masters as models for vulgar, photographic paintings in acrid colours is the relative newcomer to the New Realists – Alain Jacquet. The Poulet 20 NF group (Smerck, Sanéjouand, and Chabaud) work with similar photographic blow-ups, as does Nikos Kessanlis.

163 MARTIAL RAYSSE
Last Summer 1963.
Paint and collage,
39 $^1/_2 \times 86\,^1/_2$

Some of the New Realists have so little relation to Pop that they will not be treated here. Tinguely is a kinetic sculptor, César an abstract sculptor, Niki de Saint-Phalle a compelling religious fetishist and mythologian, though maybe her shooting at her plaster and toy assemblages with a rifle was a 'realist' gesture in Restany's sense. Her recent earth-mother, carnival sculptures (*Ill. 160*)are totally unrelated to Pop, as are Deschamps' abstract reliefs made of swathes of draped textiles. Raymond Hains, an early *affichiste* artist dealing with posters torn from walls and fences (also called *décollages* or *affiches lacérés*), now makes giant matches under the pseudonym of Saffa or Seita – the initials of the Italian and French match tax bureaux. Outside of the New Realist fold, but similarly inclined, are artists like Daniel Pommerville, who has made a variety of paintings and object paintings based on a clothes-hanger motif and simple objects like a neat coil of barbed wire, a chair with a plastic shopping bag hung from it. Erik Dietmann, a Swede, who has lived in Paris and Ireland, neatly covers common objects and furniture with strips of 'bandage' – an obsession paralleling that of Yayoi Kusama who, although she works in New York, is closer to the Surrealist approach of the Parisians. Roy Adzak makes pale relief moulds of objects; Tetsumi Kudo makes glass and plastic 'surgical' constructions; Philippe Hiquily has made a stylized iron figure that rides a real motorcycle; Jean-Pierre Raynaud does geometric sign paintings, Edmund Alleyn paints abstract machines, and Monory, Gilli, and Pavlos share a quasi-New Realist attitude.

Few of those listed above are wholly or even peripherally devoted to the New Realist programme. Armand Fernandez Arman, however, is a Nouveau Réaliste *par excellence*. His all-over accumulations, which have their roots in some rubber-stamp drawings made in 1954 under the influence of Jackson Pollock, exist in limbo between abstraction and figuration. His collections of ball-bearings have a direct precedent in a Surrealist object by Man Ray, and Arman is frank about the fact that he is not doing anything new, but only 'bringing a little facet of reality through the prism of all the arts of all times'.[7] By accumulating groups of identical or similar objects in a glass case (more recently freezing them in chunks of clear plastic), Arman seeks to 'suspend events, stop speed or explosion'. The same thing is accomplished by his *colères* (tantrums), which are 'action sculptures' – objects smashed, crushed, or otherwise destroyed and then mounted, often in decorative patterns; and his *coupes* (cross-sections) – objects sliced into silhouetted

164 ARMAN
Glug-glug 1961.
Accumulation of
bottle-caps, *c.* 9 × 13

reliefs. Arman's best works are those in which the accumulated items are various in colour (toys, bottle caps [*Ill. 164*]) or strictly identical and new (glistening machine parts or ball-bearings). The idea is a limited one, most expressive in his early *poubelles* – glass-boxed trash from wastepaper baskets, and most effective in a 1960 exhibition at Iris Clert where the whole gallery was filled with loose rubbish.

Christo (born Christo Javacheff in Bulgaria) has also carried an idea originated by Man Ray to new extremes. The latter's *Enigma of Isidore Ducasse* (*Ill. 165*) presented a mysteriously wrapped shape; from this Christo has developed an obsession with packaging, as a modern industrial technique rather than a theatrical guessing game. Over the last few years he has packaged everything from people to bicycles. Recognizable or unrecognizable, tightly, even sadistically bound, his lumpy parcels have a distinctive ambiguity as well as evoking a natural curiosity about their contents (*Ill. 166*). The Pop aspect of his work was emphasized in a recent exhibition announcement which quoted ads for a packaging firm: 'Packaging often ranks next to product in influence upon a buyer', 'Last year the average American used a record 210 pounds of paper packaging'. Since moving to New York, Christo has expanded into life-size store fronts with veiled windows draped by clear plastic. In June, 1962, he filled the Rue Visconti in Paris with an accumulation of oil cans (*Rideau de fer*), an act paralleled by Allan Kaprow's environment at Martha Jackson's in New York, 1961 – a backyard filled with automobile tires.

165 MAN RAY
*The Enigma of
Isidore Ducasse* 1920.
No longer exists.
Isidore Ducasse wrote under
the name of the Comte
de Lautréamont and was a
proto-Surrealist deity;
the exoticism of this silhouette
is in strong contrast to the
almost rectilinear Christo
opposite

Öyvind Fahlström, who was born in Brazil, has lived in Sweden, Rome, Paris, and is now in New York, spans the gap between Anglo-American and New Realist attitudes. While he uses Pop images taken from magazine illustrations and comics, and began with intricately detailed 'abstract comic-strips' in the early 1960's, his art is concerned with far more complex ends. In the 'variable paintings' the figures and images can be moved to form any number of different pictures (*Ills. 167–68*). They are manipulated on hinges or by magnets, as in *Planetarium*, which is fundamentally a paper-doll game – the figures can be dressed and their 'characters' changed. Fahlström explained his idea in an essay, 'A Game of Character': 'A game structure means neither the one-sidedness of realism, nor the formalism of abstract art, nor the symbolic relationship in surrealistic pictures, nor the balanced unrelationship in "neo-dadaist" works…. The arrangement grows out of a combination of the rules (the chance factor) and my intentions, and is shown in a "score" or "scenario" (in the form of a drawing, photographs, or small paintings). The isolated elements are thus not paintings, but machinery to make paintings. Picture-organ.'[8]

Paralleling Tinguely's meta-matic sculptures, which may draw pictures or destroy themselves, Fahlström's paintings progress in time rather than in space (although the actual space in which his pictures operate is also a particularly disturbing one – discontinuous and fluctuating). Rauschenberg has written of the variable works: 'The logical or illogical relationship between one thing and another is no longer a gratifying subject to the artist as the

awareness grows that even in his most devastating or heroic moment he is part of the density of an uncensored continuum that neither begins with nor ends with any decision or action of his.'[9]

Daniel Spoerri, a highly imaginative theorist, has carried Pop Art's implications much further than the Americans, though his work lags far behind his theories. He is best known for his 'snare pictures', in which objects arranged by chance (such as a table top complete with dirty glasses, ashes in the ashtray) are fixed and then hung on the wall (*Ills. 169–70*). This is an extension of the ready-made or found-object principle; only the plane is altered (as it was in Rauschenberg's *Bed*), but any alteration at all opens the objects to new interpretation. Departing from Duchamp, Spoerri has made a close study of the laws of chance, according to which all reality operates. His American counterparts would be Kaprow or Cage. In October 1961, Spoerri paralleled Oldenburg's contemporary *The Store* with a *Grocery Shop* in the Galerie Köpke, Copenhagen. Ordinary perishable items (not made by the artist as were Oldenburg's) were 'chosen' as works of art, and so labelled. 'Does a tomato cease to be a tomato merely because it is named a work of art?' demands Spoerri. 'To buy a tomato while realizing that it's a work of art that one is buying is participating in a great spectacle. In a spectacle what is false becomes true, provided one enters into the game.'[10] Where Oldenburg's *Store* was a tangible gesture intended as an act of creation, Spoerri's was an intellectual game; both far outreach the purely commercial motifs of the Bianchini Gallery's *Supermarket*, in New York, 1964.

166 CHRISTO (JAVACHEFF)
Packaged Magazine – Life 1962. Plastic and
string, *c.* 23 × 20

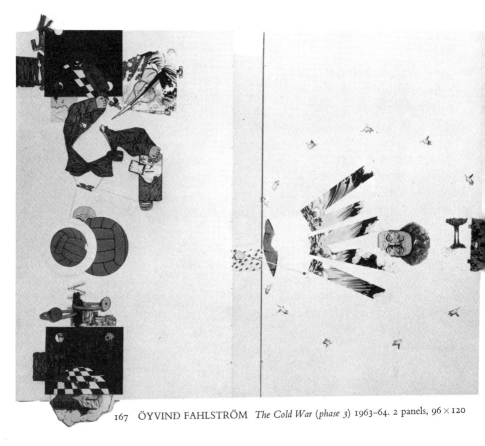

167　ÖYVIND FAHLSTRÖM　*The Cold War (phase 3)* 1963–64. 2 panels, 96 × 120

168　ÖYVIND FAHLSTRÖM　*Sitting ... Six Months Later (phase 4)* 1962. Tempera and canvas on plastic, 28 × 59. Both of the Fahlströms reproduced here are 'variable paintings', in which the image elements can be moved around on the surface to form new configurations

169, 170 DANIEL SPOERRI (*left*) *Here Lies Jean Onnertz* 1960. Assemblage, *c.* 16 × 41 and (*right*) *The Lovers* 1962. Assemblage, *c.* 41 × 18

Among Spoerri's other manifestations were the June 1961 *Trunk*, in Cologne (where the spectators packed and unpacked the contents as they had George Brecht's medicine chests at the Reuben Gallery around 1959), and his *Anecdotal Topographies* at the Galerie Lawrence, Paris, 1962 (where objects were spread at random on a table and indicated on a chart with appropriate anecdotes). In New York, in 1964, Spoerri gave a dinner party for critics and artists and fixed the leftovers of each place-setting with epoxy for a snare-picture exhibition at the Allan Stone Gallery; in 1965 he showed some 'collections' (groups of like objects reflected, repeated in different colours, photographed or real) in his crowded room at the Chelsea Hotel in New York under the auspices of the Green Gallery; Allan Kaprow wrote the catalogue preface.

Spoerri's events, like the early American Happenings, are more typical of the European *avant-garde* than of Pop Art. The Parisians, and the Germans, are greatly given to demonstrations of one sort or another. Some of them are conducted with an abandonment worthy of the Dada soirées. The artists involved do not have enough in common with Pop Art to be discussed here, although Jean-Jacques Lebel and the Icelander Ferrò use, respectively, magazine cut-outs (especially pin-ups) and painted comic-book and advertising motifs in their work. Both have been associated with Italian groups and galleries, and, with critic Alain Jouffroy, have produced such manifestoes and environments as *Anti-Procès* and *Mecanismo*. The Germans, led by Wolf Vostell, are mainly allied with the Décollage group, whose review, published from 1962–64, has printed contributions by Christo, Lebel, George Brecht, Al Hansen, Kaprow, and others. Dick Higgins, an American composer, and Nam June Paik, a Korean pianist then living in Cologne, shared the spotlight with Vostell, who did assemblages, *décollages* (lacerated posters), and television Happenings. The 'accidental' musical and theatrical orientation of the Décollage artists has also won them the approbation of John Cage. A splinter group – Fluxus – has performed its own brand of Happenings in New York and Europe. A prime example of the environmental trend was 'Dylaby', produced at the Stedelijk Museum in

Amsterdam in September 1962. Six artists (Raysse, Tinguely, Saint-Phalle, Ultvedt, Spoerri, and Rauschenberg) were invited to spend three weeks constructing a 'Dynamic Labyrinth' in two galleries of the museum. The result was a total or synaesthetic art recalling Kurt Schwitters' Merzbau construction, as well as the extravagant interior decorations of International Surrealist Exhibitions from 1938 on. In many of these demonstrations abstract kinetic art is fused with New Realism – an approach pioneered by Tinguely and, theoretically, by Klein.

The European *avant-garde* is a migratory group, with Paris the centre and increasingly large numbers shuttling between there, London, and New York. The present Ecole de Paris is as internationally heterogeneous as the one of Cubist days. The exhibition network is widespread, and a successful artist may show in Paris, Milan, Amsterdam, Düsseldorf, and Copenhagen within a year's time. The development of influences and trends is consequently complex and uncontained by national boundaries. The American Peter Saul, who from 1956 to 1964 lived in Holland, Paris, and Rome, is a case in point. His Gorky-esque expressionist paintings with fantastic *mélanges* of Pop and Surrealist images (*Ill. 74*) had a pervasive influence outside the New Realist sphere, primarily on the work of Hervé Télémaque, Bernard Rancillac, and the Italians Valerio Adami and Silvio Pasotti. Rancillac made his 'ani-

71 (*opposite*) HERVÉ TÉLÉMAQUE
resent, where are you? 1965.
nameloid on canvas,
59×98

172 BERNARD RANCILLAC
The Tribulations of a Telephone 1965.
Oil on canvas, *c.* 78×78

mated cartoon' paintings (*Ill. 172*) before moving into the *nouvelle figuration* category, but Télémaque developed his own style with a strong sense of design rare in Paris today. A Haitian who lived in New York in 1957–60, he has been in Paris since 1961. Télémaque's images are truly Pop, although the sources are Disney cartoons rather than the 'heavy' dramas of Lichtenstein (*Ill. 171*). Lately his iconography has included more 'adult' figures, with an emphasis on soldiers, pin-ups, and a great deal of underwear. Télémaque's fragmented style recalls Rosenquist, Fahlström, and Allen Jones, but more important is his fusion of Anglo-American Pop and New Realism, which he achieves without relinquishing the brilliant colour and formal éclat of the former or the mysteriousness of the latter.

This is a narrative trend, based on comic-strips, rather than advertising images. Adami's iconography leans more heavily towards Surrealism than Télémaque's but for the first time a Surrealist imagery has been crystallized into a harsh commercial style. Although he worked in London and Paris in 1961–64, a 1963 painting – *Invito al Crash* – seems derived from Lichtenstein. Now Adami has evolved a distinctive style of his own – pastel colours, hard outlines, and raw patterns. A unique vocabulary of hybrid creatures – fleshy, unnamed forms and huge fingers – convey a sense of danger and sexuality all the more potent because of the rigid handling (*Ill. 173*). The title of his autumn 1965 exhibition in Milan was 'Private Massacres' taken from W.H. Auden: 'Behind each sociable home-loving eye the private massacres are taking place.' Adami's is the typical post-Surrealist viewpoint. Metamorphosis is his goal, yet he too talks about employing 'the absolutely clear terms' of advertising art, 'understood by everybody, a language which assails you wherever you go'. Unlike his American colleagues, Adami is not concerned with formal advancement so much as a New Realism: 'The important thing,' he has written, 'is not to work out "new" visual possibilities, but to organize the reality in which we live into a narrative.... For a painter whose aim is a narrative one, it is truly difficult to define his own way of being *realist*.... Time and space spread out into a new psychic action.'[11]

Aldo Mondino, a young Turinese, makes double-panel paintings of colouring-book images on graph paper – the upper panel usually just outlined, the lower one filled in with colour, the two connected by an actual box of crayons or child's paintbox attached to the surface (*Ill. 174*). These have a clarity and rigour seldom seen in Italy, although the banality of the images

VALERIO ADAMI *Le Stanze a cannocchiole* 1965.
loid on canvas, *c.* 32 × 39

174 ALDO MONDINO *Penguins* 1963–64.
Plastic paint on masonite with object, 51 $^1/_4$ × 70 $^5/_8$

is neither overcome nor exploited to a high degree. Mario Schifano has fre-
quently worked in a tangential Pop style apparently based on slides, since
most of his images are enclosed in round-edged rectangles on a white,
screen-like ground. Around 1961–62 he used blown-up fragments of adver-
tisements such as the Coca-Cola lettering, but rendered in a very elegant
dripped and brushed style. Since then he has painted landscapes in the same
manner, sometimes labelled in imitation stencil writing ('large detail of the
Italian landscape in colour'), and quite Abstract Expressionist paintings in-
cluding automobiles, arrows, and other commercial signs, and a series of
Dine- and Rivers-like drawings of Boccioni after a famous Futurist group
photograph. Schifano's choice of 'touristic' subject matter is shared by other
Italians, who are not reacting against Americanization so much as against
their own monumental past, which has plagued the Italian *avant-garde* since
the Futurist days. Both Tano Festa and Lucio del Pezzo, while contributing
nothing new to current art, take as their subjects the old masters, the magni-
ficent architecture, and indirectly, the tourist business. In 1963–64 Festa

187

175, 176 (right) MARCEL DUCHAMP *Fresh Widow* 1920. Painted wood and waxed leather, 30 1/2 × 17 5/8
and (left) LUCIO DEL PEZZO *Large White Interior* 1963. Paint and plaster on canvas, *c.* 57 × 45

painted a series of labelled 'slides' of Michelangelo's Sistine Chapel (*Ill. 158*), and in 1965, black outlined pin-ups. He also made panels of architectural details (mainly windows reminiscent of Duchamp's *Fresh Widow* [*Ill. 175*]), not as exquisite as del Pezzo's similar reliefs (*Ill. 176*), but of equally minimal importance. Silvio Pasotti's sweetly coloured commercial images, whirling in an expressionist phantasmagoria in which the washing machine is a central image, derive from Saul, but are among the more imaginative fusions of Surrealism and Pop Art.

The man many Italians claim as the father of Pop Art is Enrico Baj, whose 'nuclear art' since 1952 bears more comparison to Dubuffet's figures or to the Chicago 'Monster School'. His rough wallpaper and furniture assemblages and his screaming generals are passionately committed and this has made him a salient figure in postwar Italy, where abstraction is largely pallid and backward-looking. His ferocious men inhabit the world of science fiction, not the down-to-earth realism of Pop Art, although he did make one

177 ENRICO BAJ *Adam and Eve* 1964. Collage and oil on canvas, *c.* 45 × 57. A grotesque
deity expels Adam and Eve from Paradise in a modern version of Masaccio's masterpiece

series that juxtaposed grotesque little robots with highly realistic nudes
copied from cheap men's magazines (*Ill. 177*). The major proto-Pop painter
in Italy is actually Mimmo Rotella, a charter member of Restany's Nouveaux
Réalistes and one of the major exponents of the 'lacerated poster' trend.
Though preceded by French *affichistes* Raymond Hains and Jacques de la
Villeglé, who had been working in this medium since the 1940's, Rotella
was apparently the first to use it in a Pop manner – concentrating on a single
advertisement torn from a city wall (*Ill. 178*), rather than the fragmented
abstractions that they had all made before. The surfaces of Rotella's ads are
still torn, tattered, aged; the fact that they depend on this for part of their
effect, brings him and his French colleagues Hains, Villeglé, and François Du-
frêne closer to Kurt Schwitters (with a *tachiste* touch) than to, say, Wessel-
mann, with his pure use of collaged commercial sources. The art of *décollage*
or *affichisme* has attracted disciples in each country in Europe. Among the
Italians is Alberto Moretti, whose posters are often overpainted with fig-

178, 179 (*left*) MIMMO ROTELLA *Flask of Wine* 1963. Torn poster, *c.* 35 × 26.
(*Right*) MICHELANGELO PISTOLETTO *Two People* 1964. Painted paper on polished
steel, *c.* 78 × 47. The third person is a spectator, reflected in the surface

ures, providing a background rather than the focal point. Since Italy's walls
are liberally adorned with political tracts as well as advertisements, these
appear in the work of her *affichistes*, lending a touch of political satire re-
miniscent of Berlin Dada to the blandly smiling faces of the milk drinkers
or bucolic landscapes. Giuseppe Romagnoni and Gianni Bertini have both
diverged from the poster towards blurred photographic montages derived
from Rauschenberg, whose acquisition of the grand prize at the 1964 Venice
Biennale was a *cause célèbre* and, according to Giorgio de Marchis, established
'the revelation of North American Pop Art as an important new event'.[12]

Others working in a more or less Pop-New Realist vein in Italy are the
Gruppo 70 in Florence (Luciano Ori, Alberto Moretti, Alfonso Frasnedi,
Raffaele, Marisa Bonazzi), Fabio Mauri, Umberto Bignardi, Renato Mam-
bor, Titina Maselli, Antonino Titone, Mario Ceroli, Giosetta Fioroni, Franco

Angeli, Sergio Lombardo, Giuseppe Guerreschi, Giancarlo Ilifrandi, and Cesare Tacchi. Many of them use photographic techniques or images rather than commercial emblems; the most interesting of these is Michelangelo Pistoletto. His greyed figures on a highly polished metal surface, approximating mirror, change mood, scale, and composition depending on their reflected surroundings. Each of Pistoletto's paintings is potentially an infinite number of different paintings. The figures are often seen from the back or side, in casual poses (*Ill. 179*), and they may be joined by a single viewer or by a whole crowd at a *vernissage*. Their appearance alters again when they are moved from the elegance of a gallery to the clutter of a studio or the intimacy of a bedroom. They can be Realist and Surrealist. Pistoletto has written that the first real figurative experience man has is when he recognizes his own image in a mirror; in his own work, 'aesthetics and reality can be identified, but each remains in its own autonomous life.'[13]

'Quibb art is no German version of Pop Art, New Vulgarism, Junk Culture, Nouveau Réalisme or Neo-Dada,' stated H. P. Alvermann's and Winfred Gaul's *First Quibb Manifesto*, dated Düsseldorf, 30 January 1963: 'We do not work with cardboard knives. We work with a butcher's knife. Our art is no excursion to Disneyland.' Yet they also sound the note of 1960's urbanism that is common to all of the manifestations discussed here: 'Surrealism constructed its monsters. We find them on the street. We do not want to shock. The things shock us.' The objects and paintings on which these two

180 WINFRED GAUL
Highway of the Sun
1962. c. 82 × 106
Gaul was only beginning his sign and symbol style at this point; the figurative references in the upper corners were soon to disappear in favour of a rigorous geometry

artists collaborated, and Alvermann's own work, are vehicles of protest. The 1963 *Portrait of an Electric Pater* (*Ill. 162*) needs little explanation. The hostility shown toward 'good design' and the frigidity of a modern luxury life can be viewed as a particularly postwar German reaction. Gaul, however, later turned to a geometric abstraction based on traffic signals and signs which is striking in its very simple imagery and brilliant colour (*Ill. 180*). His non-objective use of the target and stripe motifs inherent in this subject matter bring him very close to Kenneth Noland, but his art corresponds to that of Robert Indiana and Allan d'Arcangelo in its bold hard-edge treatment. Some of the 1963 paintings, such as *Verboten*, were more symbolic in their use of signs, but by 1965 Gaul had become an almost completely non-objective artist.[14] Peter Brüning, until recently an accomplished *tachiste*, makes aerial abstractions featuring targets, dotted lines, and patches of solid colour derived from road maps; Fritz Köthe, in Berlin, has made road signs surrealistically placed on lonely streets or in landscapes. The Autobahn, or superhighway, seems to play an inordinately important role in the new Germany. 'Traffic signals are omnipresent and omnipotent,' Gaul has written. 'They command and forbid. They direct us here or there.'[15]

It was in Germany that Dada had many of its most memorable moments, and the 'new objectivity' of Pop Art would seem to be appealing to the Teutonic mind. Nevertheless, as John Anthony Thwaites has pointed out: 'Pop Art proper exists in Germany only in the world of its epigones. Quite possibly, Pierre Restany is right: Pop is a product of the megalopolis, and since the loss of Berlin, Germany has no super-cities to inspire it.'[16]

181 KONRAD LUEG *Triptychon BDR 63* 1963. *c.* 41 × 94

182 GERD RICHTER
Pedestrians 1963. Oil on canvas, *c.* 59×78

183 KONRAD KLAPHECK
Proud Women 1961. *c.* 31×25

Konrad Lueg and Gerd Richter, however, who collaborated in 1963 on an event called 'Demonstration for Capitalist Realism', can really be called Pop, if not very original Pop. Both utilize the photographic image, Richter in a fast-motion, out-of-focus manner that owes something to Francis Bacon as well as to the Futurists (*Ill. 182*), and Lueg in a stylized negative–positive reduction (*Ill. 181*) also used by the American Robert Stanley. Sigmar Polke makes black-and-white paintings derived from Roy Lichtenstein. Others working in a related idiom – often via photomontage – are Siegfried Neuenhausen, Sarah Schumann, Lothar Quinte, Siegmund Lympasik, Manfred Kuttner, Herbert Kaufmann, Ferdinand Kriwet, Siegfried Kischko, Horst Hödicke, Klaus Brehmer, Josef Beuys, and Bazon Brock. Peter Klasen, who lives in Paris, makes paintings reminiscent of Richard Hamilton, featuring articles of clothing, lines, geometric areas of colour, and objects. The Swiss artist Peter Staempfli paints common objects and advertising scenes in a totally Pop deadpan style, and his compatriots Eric Beynon and Samuel Buri should also be noted. Finally, Konrad Klapheck of Düsseldorf occupies a unique position which is tangentially related to Pop. His precisely painted pipes and machines return to Léger and Picabia for inspiration, but have a curiously contemporary austerity and impersonal mien. He started painting machines as a student in 1965, beginning with typewriters, and now, by subtle distortions of parts or close-ups of details, has created his own style and image reflecting the cold materialism of an urban society (*Ill. 183*).

The entire picture of European New Realism would demand a book of its own to describe. There are various isolated figures and small groups of Pop-oriented artists in every country, among them the Benelux group in Holland and Belgium, which includes Assemblagists like Vic Gentils, Hans van Eck, Paul von Hoeydonck, Michel Ansel Cardenas, Woody van Amen, and Wim Schippers. Pol Mara (Belgium) has made photographic paintings of timely subject matter. Sweden has been highly receptive to American Pop Art, and undoubtedly there are artists throughout Scandinavia who are not widely published but should be included in a full coverage of the subject. Jan Hendrikse in Curaçao, Ushio Shinohara, Nobuaki Kojima, and Keiichi Tanaami in Japan,[17] Sansegundo, René Bertholo, and Lourdes Castro of Spain and Portugal and many Latin Americans could be included in a broad survey, to say nothing of the Americans and British who are not Pop but are 'New Realistically' inclined. Many artists have exhibited or their works have been reproduced so little that they are not known abroad. Suffice it to say that the European scene is a lively and a varied one. If many younger artists are making their pilgrimages to New York and London, it is not because the European cities are provincial, but because the art world has always needed a headquarters. Art feeds on art, and 'New Realities' are discovered only by art.

Canadian artists also tend to gravitate toward America, and since three of those included here now live in New York, Canada cannot be said to be much of a Pop Art centre. Despite the fact that it is an affluent, partially Anglo-Saxon nation, it lacks the urban concentration that is necessary not only to Pop, but to any active *avant-garde*. All of these artists are from Toronto – the heart of the central Canadian art world; it was there, at the David Mirvish Gallery, in October 1963, that the first full-scale Pop exhibition in Canada took place (a second was held in 1964 at the University of British Columbia in Vancouver). The Mirvish show included Americans and English, and can be considered a significant exposure. Since then three Toronto galleries have represented Pop artists: Mirvish, Isaacs, and the Jerrold Morris International Galleries.

Armand Flint is the only prototypal Pop artist I know of in Canada. His *The Queen and Sherbourne* (*Ill. 184*), with its Sweet Caporal advertisement, speech balloon and comic-strip 'Zip!', was painted in 1950, and shown that year at the Art Gallery of Toronto. It was also the last painting Flint did for

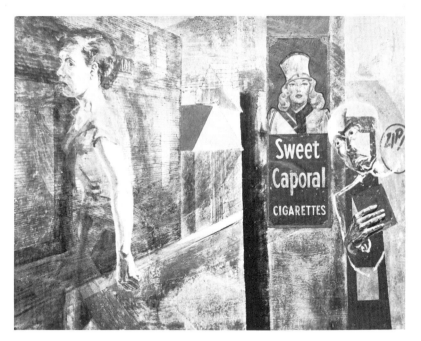

184 ARMAND FLINT *The Queen and Sherbourne* 1950.
Oil on canvas, 37×48. The woman is a prostitute and the man a distributor of religious tracts

almost ten years, and when he resumed, his style, while still incorporating bold numbers, was less popularly oriented. Michael Snow, Canada's best-known tangential Pop artist, has been living in New York for several years. He first employed his ubiquitous Walking Woman motif in a cut-out form (*Ill. 186*) in the autumn of 1960; since then he has manipulated this 'mass produced' image in innumerable ways, steadfastly rejecting any particular 'personal' style in favour of the variety suggested by that single figure. Many of Snow's paintings are strictly Pop; an equal number are not. 'Repetition; trademark, my trade, my mark,' he has written. 'Mock mass production? Art the only "cottage industry" left.'[18]

Actually, such mockery is the least important part of Snow's ideas. He has solved for himself a dilemma about figure painting after 'several years of worrying about where the figure is or could be or would be... by removing the figure from *where* and putting it *here*, on the wall or in the room'.[19] The Walking Woman has since been taken out on the street, into the subway, cast in metal, dressed and undressed, swelled and shrunk; she has acted in films, and still has a future. She is, typically, in a hurry, and despite the

195

185 DENNIS BURTON
Rolled Hose Chick 1965.
Oil on canvas,
60 × 60

Dada aspects of her career, she is basically a product of modern commercialism. So are the lip paintings of Sunao Urata, whose show at the Jerrold Morris Galleries, in May 1965, was titled 'Acrylic Kisses' (*Ill. 187*). Groups of small panels, many adorned with identical images of disembodied lips in various 'lipstick' shades, benefited from the inventive range of cosmetic colours and from the blatant eroticism of subject matter and harsh treatment. Frankly synthetic, they were made according to the Warhol principle of mass production: the panels cost $60 each, but bargain prices applied if more than one was purchased. 'Everything is so clean and icy and slick, the lips and the lipsticks are sensuously full, the colours subtly lush, like a hothouse seen through sunglasses,' wrote one impressed reviewer. 'The effect is rampant decay, suddenly arrested by refrigeration.'[20]

If Pop Art had not come along, Joyce Wieland would probably have been using the same devices with the same kind of wit anyway. A film-maker in her own right, since around 1963 she has been exploiting a sequential film or comic-strip scheme for her compartmented paintings, many of which deal with disaster – crashing planes, sinking ships – and sex. The rendering is not slick, like that of hard-core Pop, and she frequently works in construction, or assemblage, as well. *Young Woman's Blues* (*Ill. 161*) has a photograph of Elizabeth Taylor wrapped around a beer can inside a heart-shaped box, as a plane wings its way off; *The First Integrated Film, with a Short on Sailing* depicts three cliché steps of a kiss between a blonde girl and a Negro

186 MICHAEL SNOW *Five Girl-Panels* 1964. Enamel on canvas, 84 × 120

187 SUNAO URATA *Acrylic Kisses.*
View of exhibition at the Jerrold Morris International Gallery, Toronto, 1965

man; the frames are separated by a charming *non-sequitur* of a sailboat moving along. About her disasters, Wieland has written from New York, where she now lives: 'There is the American fascination with disaster and grotesque happenings, in the newspapers and on TV, for instance, and it has come out in the work I've been doing.'[21]

Les Levine, also in New York now, has turned from his 'New Realist' heaps of furniture tightly shrouded in plastic to what he calls 'small environments' of movable plastic-masked objects set into shallow boxes – all of which is reminiscent of Christo rather than of Pop Art. Other Toronto artists bear more relation to the British brand of Pop, such as Dennis Burton's unequivocal enlargements of breasts or spread legs (*Ill. 185*), which owe something to Allen Jones. Gordon Rayner's subject matter is more ambiguous; Greg Curnoe's main connection with Pop Art is his flat rendering of figures and the frequent but unobtrusive 'caption' across the top, but he has treated more popular subjects in a looser style, such as *The Greatest Profile in the World* (*Ill. 188*). If there are other Pop artists in Canada, they have not yet emerged internationally.

188 GREG CURNOE *The Greatest Profile in the World* 1963. Oil on canvas, 48 × 72

1 *Collage*, No. 3–4, 1965.

2 *Artforum* (Los Angeles), October, 1963.

3 *Fernand Léger* (University of Illinois Press, Urbana, Ill., 1953), p. 77.

4 *Modern Art in Advertising* (Art Institute of Chicago, 1945), pp. 4–5.

5 'The New Realism Goes On', *Art Front* (New York), February 1937, pp. 7–8.

6 'A New Realism – The Object', *The Little Review* (New York), Winter, 1926, pp. 7–8 (written in December, 1925).

7 The cover of *Rongwrong* (1917) was a match book, adorned with two dogs 'greeting' each other; the cover of *New York Dada* (1921) was a perfume bottle labelled 'Belle Haleine' with Duchamp's face as the protagonist. The same issue included on page 2 a solidly printed sign, 'Keep Smiling'. Other contemporary proto-Pop jokes by Duchamp were the advertisement for the 'Archie Pen Co.'; the 1920 *Fresh Widow* and the 1921 *Bagarre d'Austerlitz* (both object window frames); the 1923 *Wanted*, a poster offering \$2,000 reward with Duchamp's picture attached and his aliases noted: Hooke, Lyon, and Cinquer; the 1924 Monte Carlo bonds; and, of course, the 1917 urinal. Picabia's object portraits, mentioned above, were also products of New York Dada.

8 Tape recording by Bruce Glaser for WBAI, New York, 1964.

9 'Where Are We Going and What Are We Doing?', *Silence* (Middletown, 1961), p. 222.

1 A motive for this kind of hostility is art critics' traditional fear of art quantified by reproduction techniques and twentieth-century distribution patterns. Two writers who discuss the implications and the processes, respectively, of the quantification of art are André Malraux (in the *Musée Imaginaire* section of *Psychologie de l'art*) and William M. Ivins, jun., in *Prints and Visual Communication* (London, 1954). It is essential to distinguish between such writers and those who merely *contribute* to the mass media, e.g., newspaper critics. Journalists are habitually as conservative and *élite*-minded as critics in small-circulation journals (though they may aim at different *élites*). For objections to quantification see E. Wind, *Art and Anarchy* (London, 1963; New York, 1964); and Harold Rosenberg, The *Anxious Object* (New York, 1964; London, 1965).

2 Jasia Reichardt, 'Pop Art and After', *Art International* (Lugano), VIII, No. 2 (1963).

3 *London: The New Scene* (Walker Art Center, Minneapolis, 1965).

4 Alan Solomon, 'The New American Art', *Art International*, VIII, No. 2 (1963).

5 Ronald Alley, catalogue notes in Sir John Rothenstein, *Francis Bacon* (London and New York, 1964).

6 The reputation of Victor Pasmore is in some ways an exception to the split between the generations: his wayward experimentalism as he gave up painting and adopted a version of constructivism (1951–54) was discussed, though not emulated, by younger artists.

7 Alison and Peter Smithson, 'But Today We Collect Ads', *Ark* (London), XVIII, 1957.

8 For urban folk art as craft, see John Piper's study of engraved glass in Victorian pubs, *Buildings and Prospects* (London, 1949); also Barbara Jones arranged an exhibition 'Black Eyes and Lemonade' (Whitechapel Art Gallery, 1951), gathering folk art and working-class *objets d'art*. For a pre-Independent Group discussion of the exhibition, see *Athene*, the Journal of the Society for Education in Art (London), August 1951. This area is separated from Pop Art by a tendency to view Victoriana as something bizarre and amusing, whereas Pop artists use newer if not absolutely current objects and images. They view popular culture straight, not nostalgically; in London, Peter Blake is the main exception to this rule, attracted to old valentines as well as to (in 1959) the Everly Brothers.

9 Robert Melville has stated, in 'The Durable Expendables of Peter Blake', *Motif* (London), 1962, that Blake 'attended many meetings of the IG at the ICA', but this is not so. Blake was younger than most of the IG members (he was born in the 1930's, instead of the 1920's as they were) and had his own interests in the circus, music halls, wrestling (not on TV) – indigenous but, to the IG, rather archaic entertainments.

The ICA, incidentally, often mentioned in connection with Pop Art in London, is a non-profit exhibition and lecture centre in what was once Lady Nelson's London drawing room. Sir Herbert Read is president, as he was in the 1950's. After the IG faded, I worked there (1956–60) as assistant, deputy, and programme director (each change of title indicating another phase in the power struggle). Robert Freeman worked on the programme after I left, and after him James Mellor (see the Cambridge Group, below). During our time, themes of popular culture were constantly discussed.

The criticism of a new generation takes the form of ascribing historical remoteness or numerical inadequacy to the ICA. For example, Allen Jones has dismissed it because it 'wasn't known outside a very small community'. It 'wasn't enough to generate the kind of response that would create its own critical self-awareness and out of that the critics'. (Bruce Glaser, 'Three British Artists in New York', *Studio International* [London], CLXX, No. 871 [1965].) However, it is the purpose of this paper to argue that the conceptual premises of the IG within the ICA about art and the environment have not been replaced, by Jones or any other British painter. Perhaps more knowledge about the recent past would have enabled the painters to stop unconsciously living by earlier ideas. In fact, some modifications of these ideas are due if British painters are to demonstrate the vigour traditionally attached to a new generation.

10 *Man Machine and Motion* (ICA, London, 1955). The only analogy I know to Hamilton's exhibition is a show 'commemorating the fiftieth anniversary of Powered Flight' at the Dayton Art Institute, 1953-54, 'Flight: Fantasy, Faith, Fact'. It mingled engravings of Montgolfier's balloon ascents, sketches for Baroque ceilings, and winged figures from Assyrian myths in a compound of the weird and the technical which, though lacking Hamilton's sense of fact, reveals a comparable 'liberated technological imagination'.

11 *Magda Cordell* (Hanover Gallery, London, 1956).

12 Reyner Banham, 'The New Brutalism', *Architectural Review* (London), December, 1955.

13 *L'Art brut* and *l'art autre* were only vaguely differentiated in London at this time. M. Tapié's *Un art autre* (Paris, 1952), which reproduced Dubuffet, Paolozzi, Ossorio, and Matta, encouraged the link; it lasted until we knew more about Tapié.

14 Eduardo Paolozzi, 'Notes from a Lecture at the ICA, 1958', *Uppercase* (London), n.d. (1958).

15 *Ibid.*

16 *Ibid.*

17 Lawrence Alloway, 'The Arts and the Mass Media', *Architectural Design* (London), February, 1958.

18 Clement Greenberg, 'Avant Garde and Kitsch', *Art and Culture* (Boston, 1961).

19 Lawrence Alloway, 'The Arts and the Mass Media'.

20 Lawrence Alloway, 'Notes on Abstract Art and the Mass Media', *Art News and Review* (London), XII, No. 3, February, 1960. This footnote was never intended for public enlightenment (unlike the ones here); it was more like a code message to forty or fifty readers. TIT means 'This Is Tomorrow'; *Ark* is the journal of the Royal College of Art, London, which, under the editorship of Roger Coleman, 1957–58, Nos 18–20, brought the news of IG ideas to the College, or filled the College in with more detail; and 'Talk', held at the ICA in 1960, was intended as a painter's version of the IG. It was too big and bogged down in spectator passivity.

21 *Ibid.* The Cambridge Group is discussed below. The 'soft' side of Pop Art was the frivolous, nostalgic, graphic-design trend of Royal College of Art students after the Smith-Denny-Blake-Coleman generation, also discussed below.

22 Even Reg Butler's winning maquette was of environmental type, physically open to the spectator. Paolozzi's entry was somewhere between Stonehenge and a Jungle Gym.

23 A sign of the unanimity of IG interest in Pop culture is that I had separately reviewed *Forbidden Planet* on the BBC Third Programme. Hamilton borrowed a model of the robot, called Robbie, from MGM to open TIT. Unfortunately the speech I wrote was too long, and Robbie's great domed head steamed up, dimming his banks of flashing lights, as the man inside sweated it out.

24 A physical participative space, rather than a visual one exclusively, underlies Paolozzi's two fountains in Hamburg (1954); Turnbull's plaques with movable elements (1950) and permutation sculptures (1956–59), the latter reproduced in *Uppercase*, No. 4 (1960); Pasmore's use of reflecting materials in his reliefs after 1954 dramatized spectator movement as well as light-shifts: *Victor Pasmore Retrospective*, text by Ronald Alley (Tate Gallery, London, 1965); John McHale made sculptures expressly for spectator intervention, 1954–55: Lawrence Alloway, 'L'Intervention du Spectateur', *Aujourd'hui* (Boulogne-sur-Seine), November, 1955.

25 Richard Hamilton, 'Richard Hamilton Paints a Picture', typescript, 1964.

26 Richard Hamilton, 'Hommage à Chrysler Corp', *Architectural Design*, March, 1958, and 'Urbane Image', *Living Arts* (London), No. 2, 1963.

27 Lucy R. Lippard, 'Richard Smith: Conversations with the Artist', *Art International*, VIII, No. 9 (1964).

28 *Ibid.*

29 Reproduced in Lawrence Alloway, 'Artists as Consumers', *Image* (Cambridge), No. 3, 1961.

30 *Richard Smith* (Green Gallery, New York, 1961). (Bert Stern, by the way, never could see any connection.)

31 Richard Smith, 'Trailer: Notes Additional to a Film', *Living Arts*, No. 1, 1963.

32 'Baby Is Three' (a triptych, of course), is the title of a Theodore Sturgeon story and Gully Foyle the hero of Alfred Bester's novel *The Stars My Destination* (English title, *Tiger, Tiger*). Various other references to science fiction can be found in the literature of English art of the 1950's, such as this by Hamilton: 'Scale drifts, that echo Van Vogt's pendulum swings of time; fulcrums of visual fixity that Penn engages with the twist of a knurled knob' ('Urbane Image', *Living Arts*, No. 2, London, 1963). Van Vogt: science-fiction writer given to elaborate play with time and space puzzles. One IG meeting during the Pop run was on 'Dada as Non-Aristotelian Logic'; dissatisfaction with existing accounts of Dada (as destructive, nihilistic, illogical, protesting) led the IG to try another account, and we used for approach the term derived from Korzybski, via Van Vogt's novel, *The World of Null-A*.

33 Sulphuric acid, intended to burn into thick bituminous clots, simply formed poisonous pools on the masonite panels on the studio floor.

34 Ralph Rumney, 'The Shape of Heads of To Come', typescript written for *Number*, a magazine of artists' texts that was never published, planned by Roger Coleman and myself in 1958 (*Gazette*, Nos 1 and 2 [1961], edited by William Turnbull, Gordon House, and myself, was a slim descendant of the original project, inasmuch as the artists were writers).

35 *Place* (ICA, London, 1959). Text by Roger Coleman.

36 Robert Freeman was editor of *Cambridge Opinion* in 1960. Under his editorship the art and technology preoccupation of the IG was continued.

37 What is called in England a tack-board and in the US a bulletin board became more significant in studios after World War II. Certainly this is so in England and perhaps elsewhere. Studios always contained diverse objects and images, but there was, I think, a stepping-up in the 1950's of the number of tack-boards carrying vivid, expendable images (girls, A-Bomb explosions, jellyfish, anything) and of lavatory walls pasted with them. Pleasure in haphazard heaps of imagery relates to pro-Pop culture ideas obviously. A possible influence is Roland Penrose's exhibition and book *The Wonder and Horror of the Human Head* (ICA, 1953), which was somewhere between an illustrated supplement to *The Golden Bough* and a random sample from the 'Head' drawer in a photographic agency.

38 *Young Contemporaries 1961* (RBA Galleries, London, 1961).

39 John Coplans. 'An Interview with Allen Jones', *Artforum*, April, 1965. Actually Jones' early work (*The Battle of Hastings*, 1961, for instance) was influenced by Kitaj, and so were the paintings of Phillips and Boshier. Jones' references to 'professionalism' touches on a real problem in England, where there is little sense of solidarity among artists and where only careerists know more than a few 'cells' of people. The exhibition 'Situation' (RBA Galleries, 1960), a co-operative of abstract

painters, was, in part, an attempt to create a larger and less fragmented art scene.

40 R.B. Kitaj, 'On Associating Texts with Paintings', *Cambridge Opinion* (Cambridge), No. 37, 1964.

41 Eduardo Paolozzi, 'Notes from a Lecture at the ICA'.

42 Peter Phillips, in *The New Generation: 1964* (Whitechapel Art Gallery, London).

43 *Image in Progress* (Grabowski Gallery, London, 1962). For an account of the diaristic origins of a particular work, see David Hockney, 'Paintings with Two Figures', *Cambridge Opinion*, No. 37, 1964.

44 Derek Boshier, in *The New Generation: 1964.*

45 Anthony Donaldson, *ibid.*

46 Derek Boshier, *ibid.*

47 John Coplans, 'An Interview with Allen Jones'.

48 For two personal retrospective looks at the field, see Reyner Banham, 'Who Is This "Pop"?', *Motif*, No. 10, 1962; and 'The Atavism of the Short-distance Minicyclist', *Living Arts*, No. 3, 1964.

49 Larry Rivers and David Hockney, 'Beautiful and Interesting', *Art and Literature* (Paris), No. 5, 1964.

1 Henry Geldzahler's phrase.

2 Walter Hopps, 'An Interview with Jasper Johns', *Artforum*, March, 1965, p. 35.

3 John Rublowsky, *Pop Art* (New York, 1965), p. 61; and Bruce Glaser, 'Pop Art', a tape-recorded discussion on WBAI, New York, 1964; this was made with Oldenburg, Lichtenstein, and Warhol. Quotations from it are frequent in the following text and will not be further footnoted. They were taken from a transcript which was later edited by Glaser and revised with the co-operation of all the participants; the final version was published in *Artforum*, February, 1966.

4 *Time*, 2 February, 1962, p. 44.

5 'Franz Kline: Painter of His Own Life', *Art News* (New York), November, 1962, p. 31.

6 John Coplans, 'An Interview with Roy Lichtenstein', *Artforum*, II, No. 4 (1963), p. 31. For additional material on the Reuben Gallery group, see Lawrence Alloway's catalogue, *Eleven from the Reuben Gallery* (Solomon R. Guggenheim Museum, New York, 1965); my review of the show in *Art International*, IX, No. 3 (1965), 51; and the Bianchini Gallery's

Ten from Rutgers University (New York, 1965–66), preface by Allan Kaprow; and, of course, Kaprow's own writings.

New York Pop

7 *Art News*, Summer, 1961, p. 16.

8 See Lawrence Alloway's essay, above, for discussion of Smith's importance to the development of British Pop Art, and Smith's own statements in *Living Arts*, No. 1, 1963.

9 Statement read to the International Association of Plastic Arts at the Museum of Modern Art, New York, in a symposium on 'Mass Culture and the Artist', 8 October, 1963. Reprinted by Gimpel Fils Gallery, London, May, 1964.

10 The Wesselmann and Rosenquist quotations in this paragraph are both taken from G.R. Swenson's important interviews entitled 'What is Pop Art?', published in two parts in *Art News*, LXII, No. 7 (November, 1963), and No. 10 (February, 1964); the participants were Dine, Indiana, Lichtenstein, Warhol, Durkee, Johns, Rosenquist, and Wesselmann. These interviews are quoted frequently in this text and will not be further footnoted.

11 For reactions to the New Realists exhibition see Section II of the bibliography.

12 *Vogue* (New York), 1 March, 1965, p. 185.

13 'A Symposium on Pop Art', *Arts* (New York), XXXVII, No. 7 (April, 1963), 36–45. The symposium took place at the Museum of Modern Art, New York, 13 December, 1962.

14 See Lawrence Alloway's *Six Painters and The Object* (Solomon R. Guggenheim Museum, New York, 1963), p. 2.

15 Coplans, *op. cit.*, note 6.

16 See Erle Loran, 'Pop Artists or Copy Cats?', *Art News*, September, 1963, pp. 48–49, 61; and 'Cézanne and Lichtenstein: Problems of "Transformation"', *Artforum*, September, 1963, pp. 34–35. Richard Hamilton, in turn, enlarged a detail of a weeping girl's head and called it *A Little Bit of Roy Lichtenstein*. This could have been carried still further if he had worked from a Lichtenstein 'Picasso'.

17 Leo Steinberg, in 'A Symposium on Pop Art' (see note 13).

18 *Americans 1963* (Museum of Modern Art, New York, 1963), pp. 74–75. Reprinted from the Martha Jackson Gallery's *Environments, Situations, Spaces, 1961*.

19 *Newsweek*, 9 November, 1964, p. 96.

20 *Prospectus aux amateurs de tout genre* (Paris, 1946).

21 John Gruen, 'Art: A Quiet Environment for Frozen Friends', *New York Herald Tribune*, 22 March, 1964, p. 32.

22 Boris Lurie, 'Anti-Pop', mimeographed manifesto on the occasion of his No-Poster exhibition, Gallery Gertrude Stein, New York, February, 1964.

23 Michelle Stuart, 'No is an Involvement', *Artforum*, September, 1963, p. 36.

24 Lawrence Alloway, *Jim Dine* (Martha Jackson Gallery, New York, 1962).

25 Bruce Glaser's second taped dicussion on Pop Art included Dine, Rosenquist, and Indiana (WBAI, New York, 1964).

26 Max Kozloff, 'Art', *The Nation*, 27 January, 1962.

27 *Americans 1963* (see note 18).

28 'New Talent', *Art in America*, L, No. 1 (1962), 37.

29 'The Artists Say', *Art Voices* (New York), Summer, 1965, p. 62.

30 Quoted in Rublowsky, *Pop Art*, p. 137.

31 *Art News*, November, 1962, p. 15.

32 Jean Reeves, interview with James Rosenquist, *Buffalo Evening News*, 19 November, 1963.

33 Rosenquist's ideas do not coincide with most of the generalizations made about Pop Art in this text; his art is more complex than most and his statements more obscure. For further material on his work, see G. R. Swenson's interview, 'The F-111: An Interview with James Rosenquist', *Partisan Review*, Autumn, 1965; and my article, 'James Rosenquist; Aspects of a Multiple Art', *Artforum*, December, 1965.

34 Still others who have worked in related idioms are Al Hansen, Tania, Joe Raffaele, Paul Thek, Malcolm Morley, George Wardlaw, George Deem, John Fischer, Sante Graziani, Pat Jensen, Elaine Sturtevant, Ray Donarski, Dorothy Grebenak, George Amato, Mara McAfee, Dalia Ramanauskas, John Durham, Kendall Shaw, Kate Millett, Robert Stanley, David Porter, Betty Thomson, Raoul Middleman, Tom Strobel, Howard Jones, Mary Inman, and Marina Stern. The list could go on and on.

35 'Dissimulated Pop', *The Nation*, 30 November, 1964, pp. 417–19.

36 For broader discussions of this sensibility, see Barbara Rose, 'ABC Art', *Art in America*, October–November, 1965, pp. 57–69, and my 'The Third Stream', *Art Voices*, Spring, 1965, pp. 44–49.

1 For further discussion of these attitudes, see John Coplans, 'Wally Hedrick: Offense Intended', *Artforum*, May, 1963, p. 28.
2 'Nature and Homer', *Fables of Identity* (New York, 1963), pp. 48–50.
3 Among the most notable of these artists are Robert Irwin, Larry Bell, Kenneth

Price, and Llyn Foulkes. Phil Leider, in an interesting article entitled 'The Cool School', *Artforum*, Summer, 1964, discusses some relevant issues.
4 'Is a Lollypop Tree Worth Painting?', *San Francisco Sunday Chronicle*, 15 July, 1962, as quoted by Lawrence Alloway in the catalogue to 'Six More'.

Pop Art in California

1 See Alfred H. Barr, jun., *Picasso: Fifty Years of His Art* (New York, Museum of Modern Art, 1946), p. 209; also *Portrait*, 1938, p. 215.

2 See Jasia Reichardt, 'Pop Art and After', *Art International*, VIII, No. 2 (1963).
3 See my article, 'Why Not Pop Art?', *Art and Literature*, No. 4, Spring, 1965.

Pop Icons

1 'Paris Letter', *Art International*, VIII, No. 9 (1964), 59.
2 See *Mythologies Quotidiennes*, catalogue of an exhibition at the Musée d'Art Moderne, Paris, July–October, 1964.
3 The Restany quotations in this discussion were taken from several sources: 'La Réalité dépasse la fiction' (Galerie Rive Droite, Paris, July, 1961); 'Excerpts from a Metamorphosis in Nature' (Sidney Janis Gallery, New York, 1 November – 1 December 1962); 'Le Nouveau Réalisme à la conquête de New York', *Art International*, VII, No. 1 (1963), 29–36; 'The New Realism', *Art in America*, LI, No. 1 (1963), 102–4; 'Nouveau Réalisme: que faut-il en penser?' (Palais des Beaux-Arts, Brussels, February–March, 1965).
4 John Ashbery, introduction to The New Realists (Sidney Janis Gallery, New York, November–December, 1962).
5 'The Avant-Garde Stance', *Arts*, XXXIX, No. 9 (May–June, 1965), 22.
6 *Yves Klein* (Alexander Iolas Gallery, New York, 5–24 November, 1962).
7 *Arman* (Stedelijk Museum, Amsterdam, September–November, 1964).
8 'A Game of Character', *Art and Literature*, No. 3 (1964), p. 225.
9 'Oyvind Fahlström', *ibid.*, p. 219.

10 'The Snare-Picture as Picture, Spectacle and Interrogation', typescript, December, 1961 – December, 1962.
11 *Adami* (Galleria Schwarz, Milan, October–November, 1965).
12 'The Significance of the 1964 Venice Biennale', *Art International*, VIII, No. 9 (1964), 21.
13 *Pistoletto* (Gian Enzo Sperone arte moderna, Turin, October, 1964).
14 See Gillo Dorfles, 'I "Verkehrszeichen und Signale" di Gaul', *Art International*, IX, No. 3 (1965), 30–33.
15 Quoted in Rolf-Günter Dienst, *Pop Art* (Wiesbaden, 1965), p. 91.
16 John Anthony Thwaites, 'Germany: Prophets without Honor', *Art in America*, LIII, No. 6 (December, 1965), 110–15.
17 See Ichiro Hariu, 'Pop Art in Japan', *Art Voices*, Autumn, 1965, pp. 50–53.
18 The artist, quoted in Arnold Rockman, 'Michael Snow and His Walking Woman', *Canadian Art*, November–December, 1963, pp. 345–47.
19 *Ibid.*
20 Barrie Hale, 'Love Stifled and Kisses Cool ... In Acrylic', *The Telegram* (Toronto), 22 May, 1965, p. 22.
21 *Canadian Art*, September–October, 1964, p. 278.

Europe and Canada

Selected Bibliography

I Exhibition Catalogues

(*Arranged chronologically*)

Parallel of Life and Art. Institute of Contemporary Art, London, 1953.

Man Machine and Motion. Institute of Contemporary Art, London, 1955. Text by Richard Hamilton and Lawrence Gowing, notes by Reyner Banham, organized by Hamilton.

This Is Tomorrow. Whitechapel Art Gallery, London, 1956. Text by Lawrence Alloway.

Place. Institute of Contemporary Art, London, 1959. Text by Roger Coleman.

New Forms New Media I. Martha Jackson Gallery, New York, October, 1960. Texts by Allan Kaprow, Lawrence Alloway.

Nouveaux Réalistes. Galleria Apollinaire, Milan, 1960. Text by Pierre Restany. First manifesto of New Realism.

Le Nouveau Réalisme. Galerie Rive Droite, Paris, 1960. 'La réalité dépasse la fiction', by Pierre Restany.

Young Contemporaries. R.B.A. Galleries, London, 1961. Text by Lawrence Alloway.

A 40° au-dessus de Dada. Galeria J., Paris, May, 1961. Text by Pierre Restany.

Environments, Situations, Places. Martha Jackson Gallery, New York, 1961. Texts by the artists, including Oldenburg, Dine, Kaprow.

The Art of Assemblage. Museum of Modern Art, New York, Oct. 2 – Nov. 12, 1961. Book by W. C. Seitz, bibliography by Bernard Karpel.

New Paintings of Common Objects. Pasadena Art Museum, 1962. Text by John Coplans. Reprinted *Artforum* (Los Angeles), VI, No. 3 (1962), 26–29.

Dylaby (Dynamisch Labyrint). Stedelijk Museum, Amsterdam, September, 1962. (Spoerri, Raysse, Rauschenberg, Ultvedt, Saint-Phalle, Tinguely.)

Art 1963 – A New Vocabulary. Arts Council of the YM/YWHA, Philadelphia, October 25 – November 7, 1962. Statements by the artists.

New Realists. Sidney Janis Gallery, New York, October 31 – December 1, 1962. Texts by John Ashbery, Pierre Restany, S. Janis.

My Country 'Tis of Thee. Dwan Gallery, Los Angeles, November 18 – December 15, 1962. Text by Gerald Nordland.

Six Painters and the Object. Solomon R. Guggenheim Museum, New York, March 14 – June 12, 1963. Text by Lawrence Alloway, bibliography. (Dine, Johns, Lichtenstein, Rauschenberg, Rosenquist, Warhol.)

Pop Goes the Easel. Contemporary Arts Association of Houston, April, 1963. Text by Douglas MacAgy.

The Popular Image. Washington Gallery of Modern Art, Washington, D.C., April 18 – June 2, 1963. Text by Alan Solomon, phonograph record of statements by the artists.

Popular Art. Nelson Gallery – Atkins Museum, Kansas City, Mo., April 28 – May 26, 1963. Text by Ralph T. Coe.

Six More. Los Angeles County Museum, July 24 – August 25, 1963. Text by Lawrence Alloway (a companion to *Six Painters and the Object*). (Bengston, Goode, Hefferton, Ramos, Ruscha, Thiebaud.)

Pop Art USA. Oakland Art Museum, September 7–29, 1963. Text by John Coplans. Reprinted *Artform*, II, No. 4 (1963), 27–30.

The Art of Things. Jerrold Morris Gallery, Toronto, October 19 – November 6, 1963.

Signs of the Times. Des Moines Art Center, December 6, 1963 – January 19, 1964. Addison Gallery of American Art, Phillips Academy, Andover, Mass., February 15 – March 22, 1964. Text by Thomas S. Tibbs.

Amerikansk Pop-konst. Moderna Museet, Stockholm, February 29 – April 12, 1964. Texts by Hultén, Solomon, Fahlström, Klüver, Oldenburg, Jouffroy, Rosenquist, Chell, Buffington, Segal, Geldzahler.

The New Art. Davison Art Center, Wesleyan University, Middletown, Conn., March 1–22, 1964. Text by Lawrence Alloway, statements by the artists.

Neodada, Pop, Décollage, Kapit. Realismus. Galerie René Block, Berlin, September 16 – November 5, 1964. Text by La Monte Young.

Pop, etc. Museum des 20. Jahrhunderts, Vienna, Sept. 19 – Oct. 31, 1964. 'Die Kunst der Kunstlosigkeit', by Werner Hofmann; 'Amerika, der Tod und die Kunst', by Otto Antonia Graf; documentation; artists' biographies; anthology of quotations; brief bibliography.

Nieuwe Realisten. Gemeente Museum, The Hague, Autumn, 1964. Texts by Reichardt, Wijsenbeek, Beeren, Restany. (This exhibition travelled to Berlin.)

Pop Art, Nouveau réalisme, etc. Palais des Beaux-Arts, Brussels, February 5 – March 1, 1965. Texts by Jean Dypréau, Pierre Restany.

The New American Realism. Worcester Art Museum, Worcester, Mass., February 18 – April 4, 1965. Texts by Daniel Catton Rich and Martin Carey, statements by the artists.

Pop Art and the American Tradition. Milwaukee Art Center, April 9 – May 9, 1965. Text by Tracy Atkinson.

ABRAMSON, J. A. 'Tom Wesselmann and the Gates of Horn', *Arts* (New York), May, 1966, pp. 43–48.

ALFIERI, BRUNO. 'U.S.A.: Towards the End of "Abstract" Painting?', *Metro* (Milan), No. 4–5, 1962, pp. 4–13.

ALLOWAY, LAWRENCE. 'The Arts and Mass Media', *Architectural Design* (London), Feb., 1958.

——. 'Notes on Five New York Painters', *Albright-Knox Art Gallery Notes* (Buffalo), Autumn, 1963, pp. 13–20. (Dine, Indiana, Johns, Wesselmann, Weber.)

——. *Pop Art.* Scheduled for publication in 1966, by Harry N. Abrams, New York.

——. '"Pop Art" Since 1949', *The Listener* (London), LXVIII, No. 1761 (1962), 1085–87. (Broadcast on BBC Third Programme, November 8, 1962.)

ALVERMANN, H. P., and GAUL, WINFRED. *First Quibb Manifesto.* Düsseldorf, January 30, 1963. Broadside in German, French, and English.

AMAYA, MARIO. *Pop As Art: A Survey of the New Super-Realism.* Studio Vista, London, 1965; under the title *Pop Art... And After*, published by Viking Press, New York, 1966. Brief bibliography.

ANTIN, DAVID. 'D'Arcangelo and the New Landscape', *Art and Literature* (Paris), No. 9, 1966, pp. 102–15.

BANHAM, REYNER. 'The Atavism of the Short-Distance Mini-cyclist', *Living Arts* (London), No. 3, April, 1964, pp. 91–97.

——. 'Who Is This "Pop"?', *Motif* (London), No. 10, 1963, pp. 3–13.

CALAS, NICOLAS. 'Why Not Pop Art?', *Art and Literature*, No. 4, Spring, 1965, pp. 178–84.

CANADAY, JOHN. 'Pop Art Sells On and On—Why?', *The New York Times Magazine*, May 31, 1964, pp. 7, 48–49.

COPLANS, JOHN. 'An Interview with Allen Jones', *Artforum*, April, 1965, pp. 19–21.

DIENST, ROLF-GÜNTER. *Pop Art: eine kritische Information.* Limes Verlag, Wiesbaden, 1965. Artists' statements, extensive bibliography.

DORFLES, GILLO. 'I "Verkehrszeichen und Signale" di Gaul', *Art International* (Lugano), IX, No. 3 (1965), 31–33.

FAHLSTRÖM, ÖYVIND. 'A Game of Character', *Art and Literature*, No. 3, 1964, pp. 220–26.

FRY, EDWARD FORT. 'Roy Lichtenstein's Recent Landscapes', *Art and Literature*, No. 8, 1966, pp. 111–19.

GELDZAHLER, HENRY. 'Andy Warhol', *Art International*, VIII, No. 2 (1964), 34–35.

GLASER, BRUCE (ed.). 'Oldenburg, Lichtenstein, Warhol: A Discussion', *Artforum*, February, 1966, pp. 20–24. Tape-recorded discussions moderated and edited for publication by Glaser, originally heard as 'Art Forum', WBAI-FM, New York, 1964. ('Pop Art II', with Dine, Rosenquist, Indiana, forthcoming.)

——. 'Three British Artists in New York', *Studio International* (London), November, 1965, pp. 178–83. (Taped discussion with Smith, Phillips, and Jones, originally broadcast on WBAI-FM, New York.)

HAHN, OTTO. 'The Avant-Garde Stance', *Arts*, May–June, 1965, pp. 22–28.

HAMILTON, RICHARD. 'Urbane Image', *Living Arts*, No. 2, June, 1963, pp. 44–59.

HESS, THOMAS B. Editorial, 'Pop and Public', *Art News* (New York), Nov., 1963, pp. 23, 59.

HOPKINS, HENRY. 'Edward Kienholz', *Art in America* (New York), October–November, 1965, pp. 70–93.

IRWIN, DAVID. 'Pop Art and Surrealism', *Studio International*, May, 1966, pp. 187–91.

JOHNSON, ELLEN H. 'Is Beauty Dead?', *Allen Memorial Art Museum Bulletin* (Oberlin, Ohio), Winter, 1963, pp. 56–65.

——. 'The Living Object', *Art International*, VII, No. 1 (1963), 42–44. Oldenburg.

JOHNSTON, JILL. 'The Artist in a Coca-Cola World', *Village Voice* (New York), Jan. 31, 1963.

JONES, PETER. 'Arman and the Power of Objects', *Art International*, VII, No. 3 (1963), 40–43.

KARP, IVAN C. 'Anti-Sensibility Painting', *Artforum*, September, 1963, pp. 26–27.

R. B. KITAJ. Marlborough Fine Art, Ltd., London, February, 1963. Text by the artist.

KOZLOFF, MAX. 'Dissimulated Pop', *The Nation*, November 30, 1964, pp. 417–19.

——. 'Pop Culture, Metaphysical Disgust and the New Vulgarians', *Art International*, VI, No. 2 (1962), 34–36.

Kunstwerk (Baden-Baden), April, 1964 (special issue on 'Pop-Art Discussion'), pp. 1–32. Letters from European artists, writers, and dealers.

LÉGER, FERNAND. 'The New Realism' and 'The New Realism Goes On', *Art Front* (New York), December, 1935, p. 10; February, 1937, pp. 7–8.

LEIDER, PHILIP. 'Saint Andy', *Artforum*, February, 1965, pp. 26–28. Includes a statement by Larry Bell and an excerpt from a Pop novel.

LIPPARD, LUCY R. 'James Rosenquist: Aspects

of a Multiple Art', *Artforum*, December, 1965, pp. 41–45.

MELVILLE, ROBERT. 'The Durable Expendables of Peter Blake', *Motif*, No. 10, Winter, 1962–63, pp. 14–35.

———. 'English Pop Art', *Quadrum* (Brussels), No. 17, 1964, pp. 23–38.

NORDLAND, GERALD. 'Marcel Duchamp and Common Object Art', *Art International*, VIII, No. 1 (1964), 30–32.

OLDENBURG, CLAES. 'Extracts from the Studio Notes (1962–64)', *Artforum*, January, 1966, pp. 39–41.

RAGON, MICHEL. 'Exhibitionnisme et le scandale dans l'art contemporain', *Problèmes* (Paris), No. 79, December, 1961, pp. 24–35.

REICHARDT, JASIA. 'Pop Art and After', *Art International*, VII, No. 2 (1963), 42–47.

———. 'Will You Be My Gorgonzola Baby?', *Metro*, No. 7, 1962, pp. 18–23.

RESTANY, PIERRE. 'The New Realism', *Art in America*, No. 1, 1963, pp. 102–4.

RICHETIN, RENÉ. *Le Pop et l'aristo*. Éditions de Beaune, Paris, 1965.

ROCKMAN, ARNOLD. 'Superman Comes to the Art Gallery', *Canadian Art* (Toronto), January-February, 1964, pp. 20–22.

ROSE, BARBARA. 'Dada Then and Now', *Art International*, VII, No. 1 (1963), 22–28.

———. 'Pop Art at the Guggenheim', *Art International*, VII, No. 5 (1963), 20–22.

ROSENBERG, HAROLD. 'The Game of Illusion', *The New Yorker*, November 24, 1962, pp. 161–67. (On Janis 'New Realists'; reprinted, with revisions, in *The Anxious Object*. Horizon Press, New York, 1964, pp. 60–75.)

ROSENBLUM, ROBERT. 'Pop Art and Non-Pop Art', *Art and Literature*, No. 5, Summer, 1965, pp. 80–93.

———. 'Roy Lichtenstein and the Realist Revolt', *Metro*, No. 8, 1962, pp. 38–45.

ROSENSTEIN, HARRIS. 'Climbing Mt. Oldenburg', *Art News*, Feb., 1966, pp. 22–25, 56–59.

RUBLOWSKY, JOHN, and HEYMAN, KEN. *Pop Art*. Basic Books, New York, 1965. Foreword by Samuel Adams Green; includes statements by the artists.

RUDIKOFF, SONYA. 'New Realists in New York', *Art International*, VII, No. 1 (1963), 39–41.

RUSCHA, EDWARD. *Twenty-Six Gasoline Stations*. Alhambra, Calif., 1963.

SANDLER, IRVING. 'The New Cool-Art', *Art in America*, No. 1, 1965, pp. 99–101.

SECKLER, DOROTHY GEES. 'Folklore of the Banal', *Art in America*, Winter, 1962, pp. 56–61. Includes statements by the artists.

SELZ, PETER. 'Pop Goes the Artist' ('The Flaccid Art'), *Partisan Review* (New York), Summer, 1963, pp. 313–16.

SMITHSON, ALISON and PETER. 'But Today We Collect Ads', *Ark* (London), No. 18, pp. 48–50.

SORRENTINO, GILBERT. 'Kitsch Into "Art": The New Realism', *Kulchur* (New York), Winter, 1962, pp. 10–23.

SWENSON, G.R. 'The F-111: An Interview with James Rosenquist', *Partisan Review*, Autumn, 1965, pp. 589–601. First published as catalog, *James Rosenquist: F-111*, Moderna Museet, Stockholm, September 29–October 18, 1965.

———. 'The Horizons of Robert Indiana', *Art News*, May, 1966, pp. 48–49, 60–62.

———. 'The New American Sign Painters', *Art News*, September, 1962, pp. 45–47, 61–62.

———. 'What Is Pop Art?' (Part I), *Art News*, November, 1963, pp. 24–27, 61–65; (Part II) February, 1964, pp. 40–43, 62–66. (Interviews with Dine, Indiana, Lichtenstein, Warhol, Durkee, Johns, Rosenquist, Wesselmann.)

SYLVESTER, DAVID. 'Art in a Coke Climate', *Sunday Times* (London), January 26, 1964, pp. 14–23.

'A Symposium on Pop Art', *Arts*, April, 1963, pp. 36–45. (The Symposium took place at The Museum of Modern Art, New York, December 13, 1962, with P. Selz, H. Geldzahler, H. Kramer, D. Ashton, L. Steinberg, S. Kunitz participating.)

TILLIM, SIDNEY. 'Further Observations on the Pop Phenomenon', *Artforum*, November, 1965, pp. 17–19.

———. 'Month in Review', *Arts*, November, 1962, pp. 36–38. (On Janis 'New Realists' and Oldenburg.)

———. 'The Underground Pre-Raphaelitism of Edward Kienholz', *Artforum*, IV, No. 8 (1966), 38–40.

TUCHMAN, MAURICE. 'A Decade of Edward Kienholz', *Artforum*, IV, No. 8 (1966), 41–45.

VOSTELL, WOLF (ed.). *Decollage – Bulletin aktueller Ideen*. Periodical published in Cologne from June 1962 to 1964.

WALDMAN, DIANE. 'Thiebaud: Eros in Cafeteria', *Art News*, April, 1966, pp. 39–41, 55–56.

WESCHER, HERTA. 'Die "Neuen Realisten" und ihre Vorläufer', *Werk* (Zurich), August, 1962, pp. 291–300.

List of Illustrations

**Pop
Icons**

213

214

215